BECOMING BEING

BECOMING

New York · Paris · London · Milan

by
CINDY CRAWFORD

with Katherine O'Leary

For Presley and Kaia, who are just about to begin their journey—
here's what I've been up to for the last 30 years! I hope you see past the
pictures to the true beauty, which is life. And for Rande—having you
by my side makes it all so much sweeter.

CONTENTS

Model Behavior

Taking Chances

Shifting the Focus

Acknowledgments/Credits

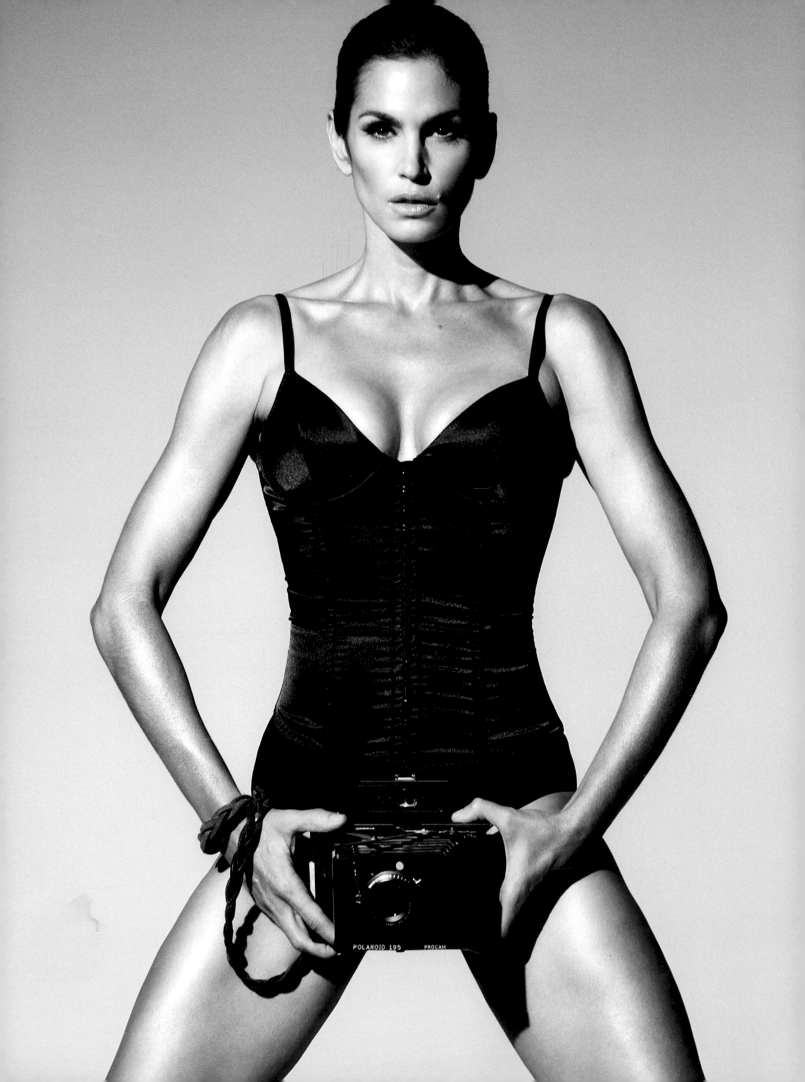

BEYOND THE LENS

Sometimes only through the lens of time can we see the things that truly matter —the choices that have helped shape us into who we are today. On the eve of my 50th birthday, some of the greatest lessons of my life began to come into focus.

Anyone who knows me well knows that I'm very literal. If you say you'll be ready for me in five minutes, I'll be ready in five minutes. Sometimes I tell my husband we need to leave at 7:07, and it drives him crazy. "Why can't you just say 7:00 or 7:15 like a normal person?" I can't. It's 7:07.

Words have a lot of power, and I like language that is very specific. I'm also interested in where words come from and how slang evolves. To this point, I've often wondered about the use of the word "girls" when people in the fashion business refer to models.

It is true that most of us models are still girls when we start out. But even now I catch myself asking, "Will there be any other girls on the shoot?" At a certain age (and I'm not sure where, exactly, the line is, but I know I've crossed it) I feel a bit ridiculous referring to myself as a girl. Yet asking "What other women will be at the shoot?" does kill some of the whimsy and, well, "girliness" of being a model.

At times I've worried that calling models girls is a subliminal way of keeping us from growing up and owning our power. In some ways, it even serves the "powers that be" to treat us like spoiled children—giving in to our demands of another latte from Starbucks or a bigger dressing room—while keeping the real power out of our hands.

I love being a model and so much of what it entails. But, as hard as I try not to, I am growing older. I'm also maturing and gaining insight, becoming more my authentic self. I want to honor and acknowledge the girl I once was while embracing the woman I am today, and I even look forward to the wise woman I hope I will become in future decades.

Maintaining this attitude can be challenging in our youth-obsessed culture. The process of compiling all these images and putting this book together has been an introspective journey for me. In looking back, I see how so much of the confidence I have now was gained through my life experiences. I've been working for a long time to get to the place where my interior self matches the exterior you see in these images. I, too, want to feel like the confident, strong, powerful woman I see on these pages. And even though I may look a little older than she does, I am starting to feel more and more like her every day.

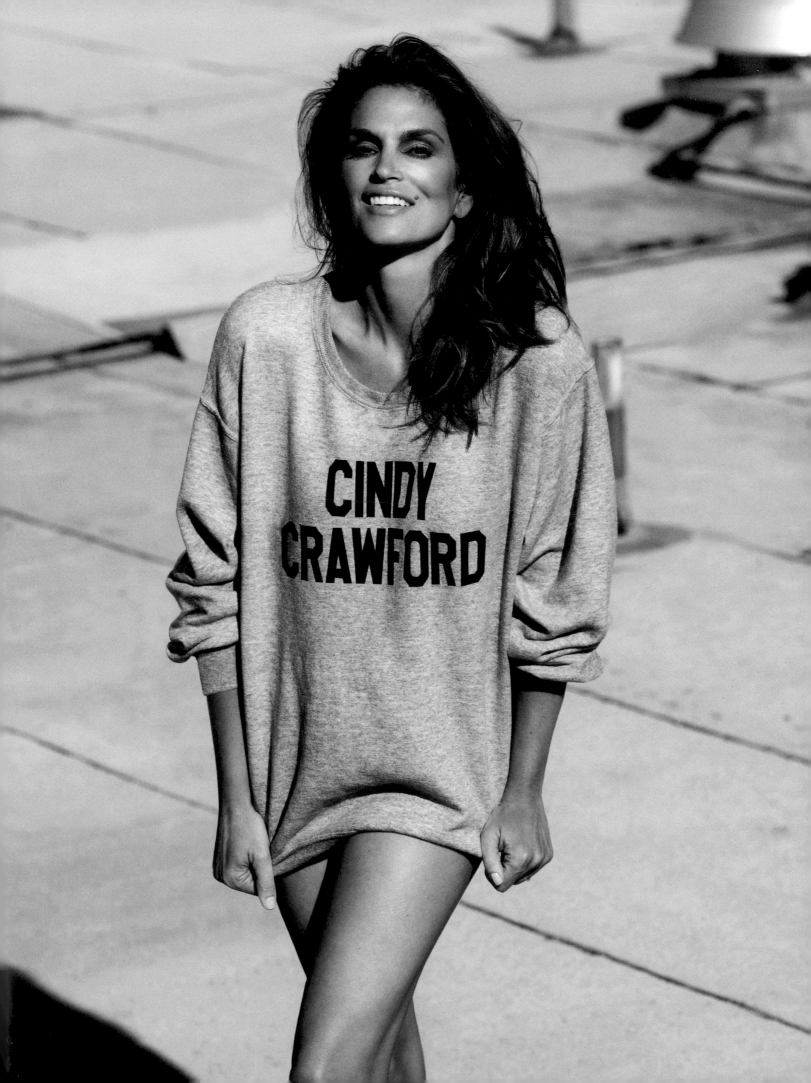

STAR
OUT

TING

I always say that Illinois is a great place to be from. So much of who I am today is rooted back in my hometown and I hope I never totally lose my Midwestern twang. It was there among those generous and hardworking people where I learned the value of kindness and keeping your word, and the satisfaction of a hard day's work.

SMALL TOWN GIRL

For a while I wanted to be a nuclear physicist and later I dreamed of becoming the first woman president—the two biggest jobs I could imagine.

Here's what you need to know about where I came from. I was born in DeKalb, Illinois, a small town sixty miles west of Chicago. I was raised the second oldest child of three girls and a baby boy, in a typical, all-American, blue-collar family. My father was a machinist, electrician, and glazier. My mother, married and pregnant at sixteen, was a house-wife and later worked in a doctor's office. My grandparents, aunts and uncles, and cousins lived nearby, which made our community feel like an extended family. We played softball outside until dark and never locked our doors. We had backyard barbecues and Fourth of July parades. It was a great way to grow up.

When I was eight, my brother, Jeff, was diagnosed with leukemia. He died two years later. It was a devastating loss to all of us. While the belief was unspoken, my sisters and I each thought it should have been one of us to die and not the only boy. After all, that's why my parents had decided to have a fourth child. We also silently agreed to try to not bring any more pain to our parents. We would be good girls and make them proud.

I'm not sure my family will ever get over Jeff's death, although we have all learned how to go on with life. I learned so much from watching my mother try to process her own grief. She allowed herself to actively grieve and then to try to heal. She was never bitter. She kept moving forward, helping me and my sisters focus on the gift of life. I eventually came to see Jeff's energy as a kind of rocket booster to

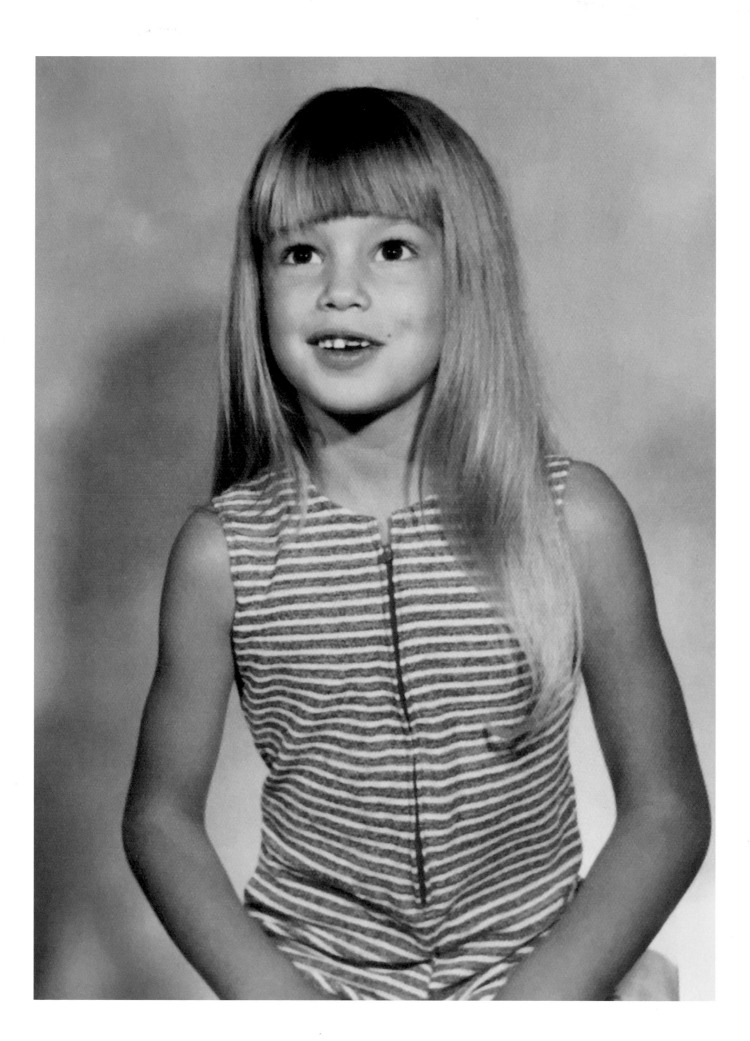

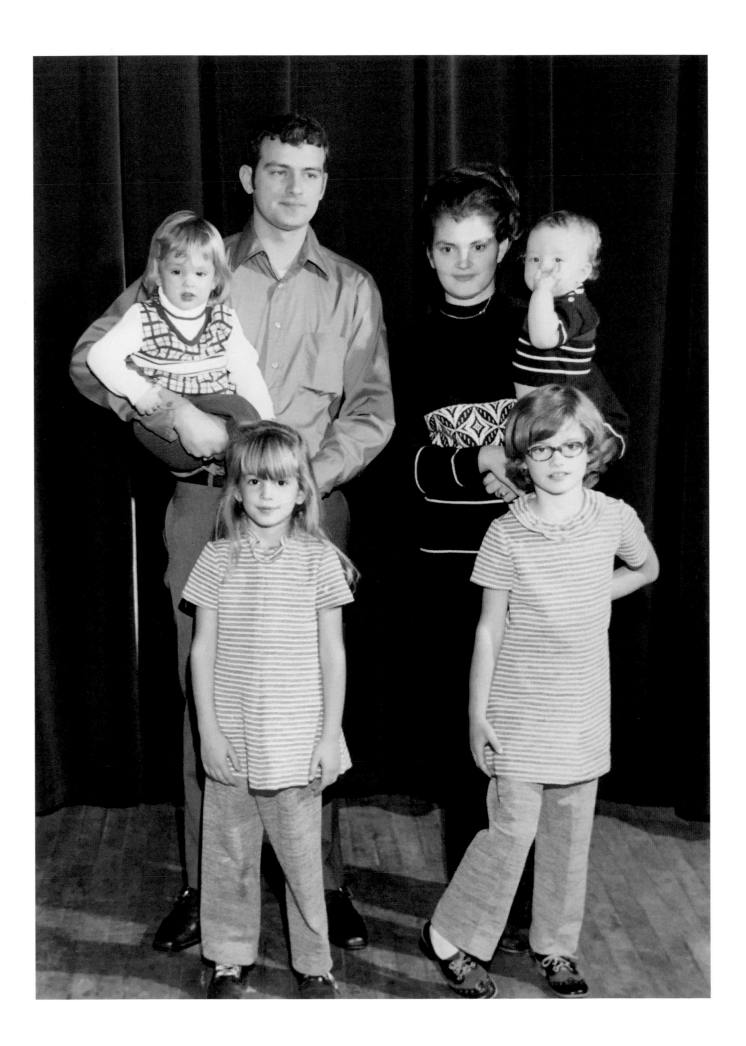

my life and my success. Unfortunately, my father had a harder time finding his way back from such a tragic loss. He had to go to work the day after Jeff's funeral, with all the feelings of not being able to save his only son buried deeply inside. It seemed to create an insurmountable burden for him to carry. My parents' divorce, four years later, was the second blow to the innocence of my childhood. Sadly, that outcome is all too common for parents who lose a child.

My childhood might not have been idyllic, but I loved my small-town upbringing. Yet I knew, even then, that somehow my path would take me beyond the comforts of that familiar place. For a while I wanted to be a nuclear physicist, and later I dreamed of becoming the first woman president—the two biggest jobs I could imagine. My fourth-grade student teacher dubbed me "Future Miss America," and while that wasn't really a role I aspired to, the idea that someone outside my family could dream so big for me was a revelation. It opened up my mind to possibilities far beyond DeKalb.

I always liked school—probably because I was good at it. In sixth grade I made a bet with my dad that I would never get a B on a report card. By the end of my senior year of high school I won the bet—and the $200 prize. I had also become valedictorian of my class and won a full academic scholarship to Northwestern University in chemical engineering. To this day I couldn't tell you what a chemical engineer does, but I knew that all the effort I had applied to my studies had paid off in a big way.

I loved my small-town upbringing. Yet I knew, even then, that somehow my path would take me beyond the comforts of that familiar place.

Carving pumpkins with Dad

Proud to be a Brownie

Slumber party under the tree

Christmas surprise

Birthday cake

Summer haircuts

Christmas was Mom's favorite holiday

Knee socks rock!

Got into the baby powder

Playing dress up with big sister Chris

Me and Jeff sharing a birthday cake

beating the summer heat

Cousins

I've always approached modeling as a job. It's what I do, not who I am.

I spent the summer after high school graduation modeling in Europe, and I returned to Chicago in the fall to begin my freshman year at Northwestern. I arranged my classes so that I would be able to model in the afternoons. In a way, it wasn't much different from my last year of high school, except the commute to downtown Chicago was shorter. About a month in, however, I started to realize that college required a lot more effort than high school had, and I felt as if I was burning the candle at both ends—taking early-morning classes until noon, driving into Chicago, working until five or six, and then returning for evening class or studying in the library. I decided to drop out after my first semester. I had never liked the feeling of not being able to give 100% and I realized that I couldn't do both school and modeling well. My decision to leave Northwestern was not an easy one —I had worked so hard to get there—but in the end, I knew I could always go back to school. Modeling wouldn't wait.

Before I started modeling, I had many different jobs, including cleaning my aunt's house (she even made me clean faucets with a toothbrush), babysitting, and folding sweaters in a clothing store. All these jobs—most for minimum wage—taught me the value of hard work and earning your own money. I think my reputation as a professional started back then. I've always approached modeling as a job. It's what I do, not who I am.

DESTINY AWAITS

Isn't it ironic that the very thing that made me most insecure turned out to be my trademark?

Contrary to popular belief, I was not discovered in a cornfield. I did spend every summer after eighth grade working in the fields, but so did almost every other kid who grew up in DeKalb. We would get picked up around 7:00 a.m., armed with sunscreen and a cooler full of food. We were each responsible for our own plot of about two hundred rows of corn. We would spend ten hours a day walking up and down each and every row performing various menial tasks, including detasseling, cutting back ear buds, and inoculating cornstalks. At one point, we even spread urea as fertilizer. Yuck!

It was hot, backbreaking work, but if you signed up for most of the summer, you could make about a thousand bucks—enough to cover back-to-school shopping, a new dress for homecoming, and plenty of Suave shampoo. Luckily, I was in an all-girls crew, so to stay cool we basically wore next to nothing: a bikini top, short shorts, and Elly May Clampett pigtails covered in dirt, sweat, and pollen. While all that might make for a compelling visual to accompany my "how I got discovered" story, that isn't how it happened.

When I was a sophomore in high school, I got a call from a local clothing store interested in hiring me to do some modeling for them. I had never dreamed of becoming a model and didn't even know it was a real job. I did read *Seventeen* magazine and knew who Phoebe Cates and Brooke Shields were, but that was the extent of my fashion knowledge.

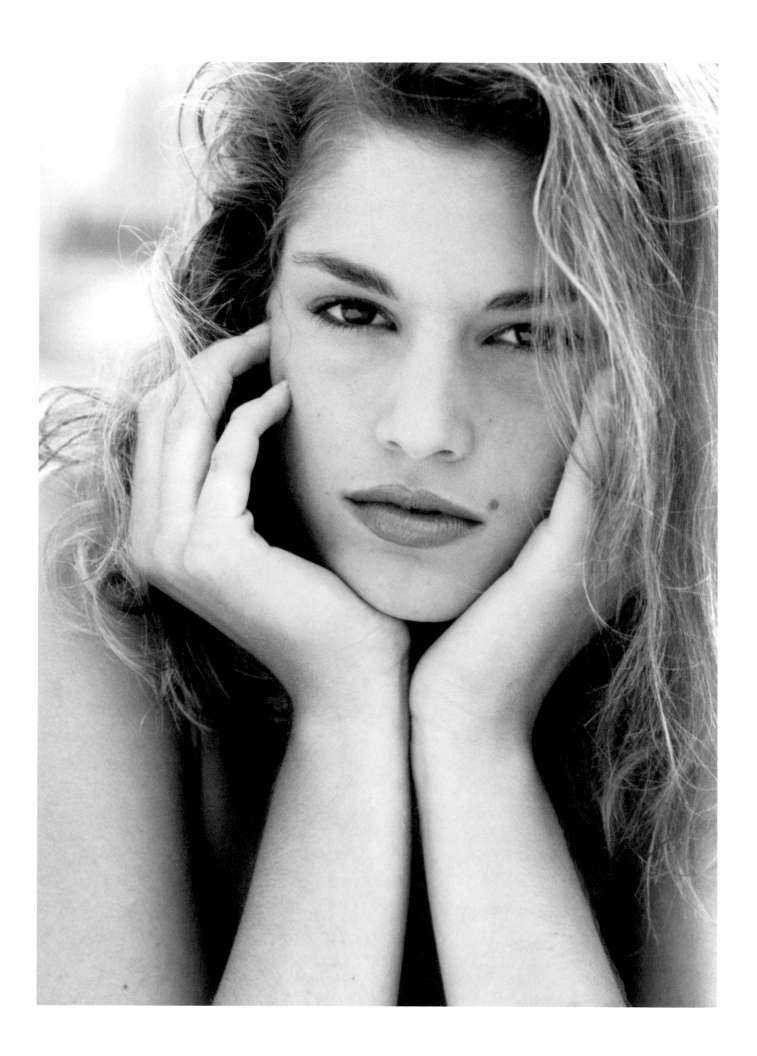

On the day of the meeting, I slid into my best Gloria Vanderbilt jeans, a cowl-neck sweater, and my Earth shoes. I set my hair on hot curlers and drove to DeKalb's version of Main Street. I walked into the store and told the girl at the cash register I was there for the modeling job. She looked at me with a blank stare. I asked to see the manager. Several minutes later the manager came out and apologetically told me she didn't know who had called me, but it definitely wasn't her. I felt all the air leave my body. I ran out of the store as fast as I could, only to see two girls from my high school standing on the corner laughing. I felt like I'd been punched in the stomach.

About a year later, a new clothing store opened and enlisted a group of high school girls to be its brand ambassadors (although I didn't know that term at the time). I felt lucky to be chosen—and thrilled with the 20% shopping discount they extended. We even did a fashion show and a shoot for the local newspaper!

Sometime during my junior year a local photographer named Roger Legel asked to take my picture for the Northern Illinois University paper. He covered all the major events in DeKalb, from high school football games to house fires. He also photographed a different college girl each week to be the featured coed in the *DeKalb Nite Weekly*. Even though I was still only in high school, he wanted me to pose for him.

My parents were rightfully suspicious. Roger assured them he was legitimate and invited them to accompany me to the shoot at a nearby park and at my boyfriend's backyard pool. That picture was my first cover.

I credit Roger with kick-starting my modeling career. He introduced me to a woman who did hair and makeup (when she wasn't busy at her day job). The three of us worked together on a few test shoots, and eventually she encouraged me to attend an open call for the Midwest Beauty Show in Chicago, where hairdressers needed models whose hair they could cut and style onstage. They paid $200. I was chosen along with a friend, and off we went.

Fortunately the hairdresser who worked on me, Carmine Minardi, didn't shave my head or give me a pink Mohawk. Instead, I got pretty waves and some good advice. He encouraged me to get an agent. The fact that he was a big-time New York hairdresser gave him credibility. He jotted down a couple of names and wished me luck.

I don't remember the name of the first agency I contacted, but I made an appointment to go in for a meeting. My parents took time off from work and drove me into Chicago. We all sat down across the desk from the agent. She had nice things to say, but she wasn't sure about the mole above my lip. She suggested I have it removed. In the meantime she would set up a test shoot.

DeKalb NITE Weekly
Vol. 8, No. 11 November 3, 1982

Communiversity Issue

"Reaching DeKalb, Sycamore & NIU readers"

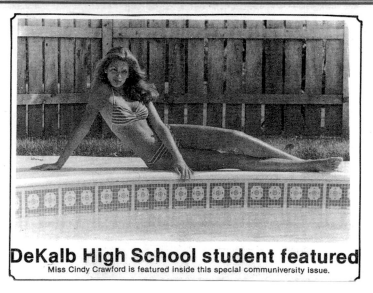

DeKalb High School student featured

Miss Cindy Crawford is featured inside this special communiversity issue.

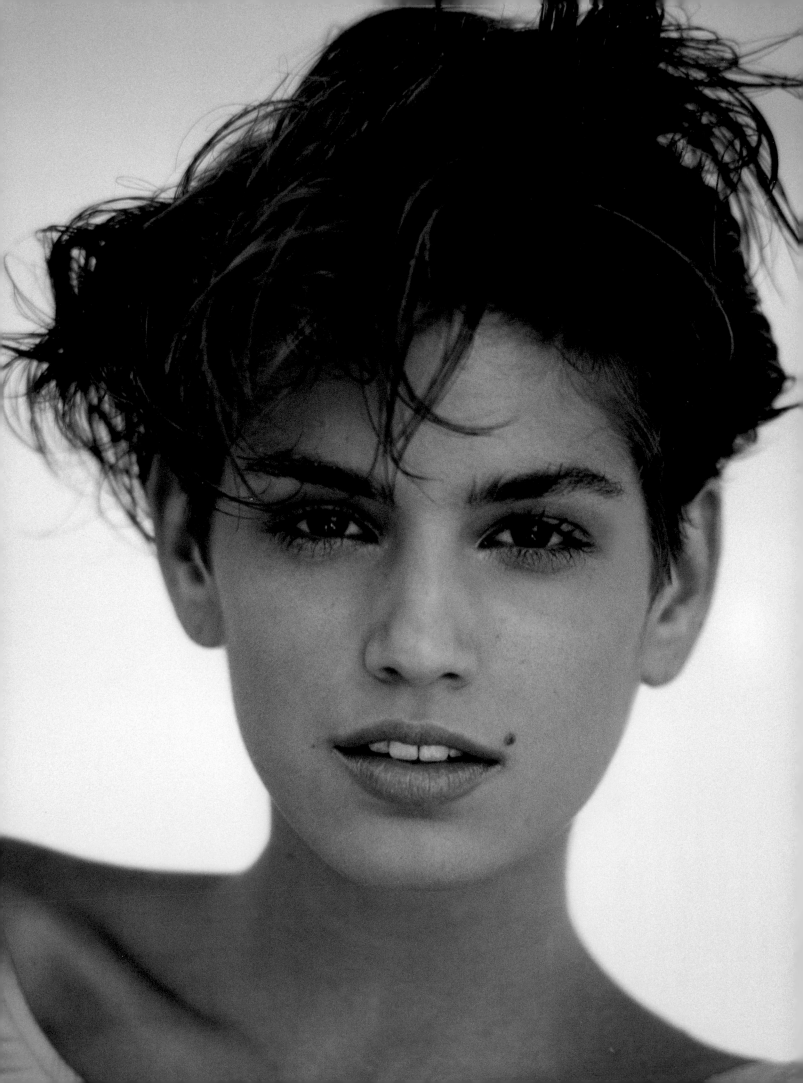

I had always been self-conscious about my mole (or *the mole* as it is referred to now). My sisters had me convinced—as only sisters can—that it could only be a beauty mark if it was on the right side of my face. They claimed that any mole on the left was simply an ugly mark. Worse, on my first day of high school I accidentally passed through senior-guys turf. All of them—especially the football players—hung out in the school's main stairwell. As I tried to sneak up the steps, hugging the wall, one of the football players shouted, "Hey, little Crawford, you have chocolate on your face!" I blinked back tears. It took me years to use those stairs again.

Many times throughout my childhood I had talked to my mom about getting my mole removed. She always said the same thing: "You can have it removed if you want, but you know what your mole looks like. You don't know what a scar will look like." Up until then her advice had comforted me, but now a modeling agent was telling me I should remove it!

My mole and I went ahead and did the test shoot, anyway. Those pictures have to be the cheesiest photos I have ever done. In one image I wear a short red kimono and yellow eye shadow while holding a parasol and a kitten. Not exactly America's Next Top Model. But I did make a connection with the hairdresser on that shoot. And, unbeknownst to me, he showed the Polaroids to his friend Marie Anderson. She was an agent at the Stewart Talent Agency, which later became Elite Model Management in Chicago. Marie saw something in me despite the bad makeup. She tracked me down, and asked me to come in to meet with her.

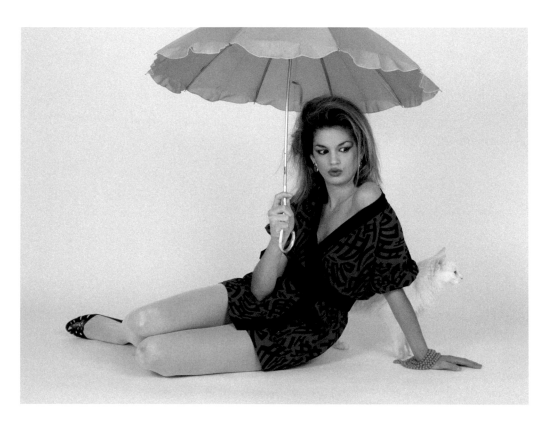

My very first paying job was a
newspaper ad for Marshall Field
wearing a cross-your-heart bra.
It appeared in the *Chicago Tribune*
and within hours it was plastered
all over my high school.

That experience was completely different from the meeting with the first agency. Marie loved my look and didn't say one word about my mole. She set up another test shoot right away with an up-and-coming Chicago photographer named Bob Frame. That was my first professional shoot. Bob shot me looking very natural, and for the first time I could see a budding young model in the image.

When I took the pictures to Marie, she was excited to put me to work. My very first paying job was a newspaper ad for Marshall Field's wearing some kind of Cross Your Heart bra. It appeared in the *Chicago Tribune* and within hours was plastered all over my high school. I think some of the kids were trying to embarrass me, but what did I care? I had made $150. Modeling sure beat working in the cornfields.

Once I started working, the mole issue rarely came up. A few times it was retouched out of photographs, and once a Japanese makeup artist tried to cover it with makeup. What a disaster. It looked like a giant pimple. After I appeared on the cover of American *Vogue*, mole and all, I never really thought about it again. If it was good enough for *Vogue*, it was good enough for everyone else. Isn't it ironic that the very thing that made me most insecure turned out to be my trademark?

THE
IMAG
MAK

GE
ERS

I feel incredibly lucky
to have had the opportunity
to work with the greatest
fashion photographers in
the world. Each one has
influenced my own work
and the lessons they have
taught me are priceless.
While each photographer's
style is unique, together
they add up to a body of
work that helped transform
a small-town girl into
Cindy Crawford.

THE MENTOR

Victor Skrebneski was a tough, but excellent first teacher. He taught me how to model, and more importantly, that modeling wasn't about me, the model.

He taught me how to hold my
body to best show off the clothes,
how to work with the camera,
and how to pay attention to the
light and to be still.

I remember the first time my agent told me I'd gotten called in on a
"go-see" for Victor Skrebneski. There were many catalogue photographers
in Chicago, but Victor Skrebneski was the only real high-fashion
photographer—a very big fish in a relatively small pond. I knew that
working with Victor could potentially change my career, opening the door to the
world of fashion outside Chicago. I get shy when I am nervous, so I'd hoped I'd
found the right outfit to make the best first impression. I took my portfolio with only
a few amateur images in it and headed to his studio on LaSalle Street. I drove my
1976 maroon Chevy Impala right up to the studio door.

When you are buzzed into the reception area at Skrebneski Studio, you don't
see a receptionist. What you do see is a very high counter. I stood there and waited.
Eventually Jovanna, Victor's studio manager, stood up and made herself known. She
looked me up and down and finally croaked, "You have a pimple." I didn't know how
to reply, so I said, "I'm seventeen."

I never made it past the front desk that day.

However, the studio called me back in several times, and eventually they
must have liked what they saw, because they finally booked me for an I. Magnin
catalogue shoot. At Skrebneski Studio we were expected to do our own hair and
makeup, so I showed up with my mom's Mary Kay blush/eye shadow combination
compact and a new mascara wand. I knew I was in over my head when I entered the
dressing room to find Iman and Dianne DeWitt fully made up. They were two of the
biggest models of the time and the embodiment of glamour. I did one shot with them,
a "triple," and when the picture finally came out, they looked like the legendary divas
they were, and I looked like a little girl playing dress-up.

When I finished my shot, Victor was nice enough to invite me to stay and watch the New York girls work. Iman and Dianne were incredible on the set. I remember how they moved their bodies and brought the clothes to life. I was in awe of their craft.

From that day on I was committed to learning how to be the best model I could be. I had always been a serious student, and Victor was a tough but excellent first teacher. He taught me how to model and, more important, that modeling wasn't about me, the model. It's about creating desire—desire for the jacket, the watch, the Pepsi, or whatever else it is. He taught me how to hold my body to best show off the clothes, how to work with the camera, how to pay attention to the light, and how to be still—all skills that have served me well.

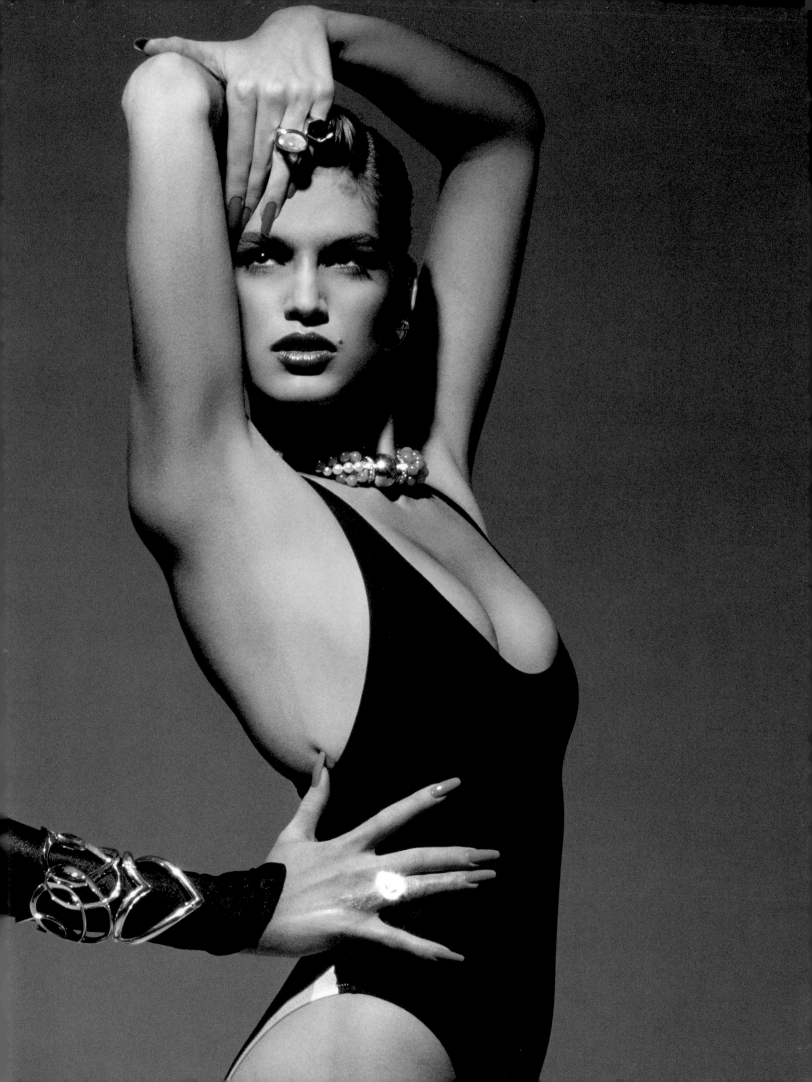

During my Chicago modeling days, in addition to doing our own hair and makeup, we also had to bring a bag of accessories to the shoots. Black pumps, nude and black stockings, belts, and earrings. This was Modeling 101. Most mornings I'd set my hair in hot curlers, pack up my "model" bag, and walk two blocks to Skrebneski Studio. His studio would book models for "9:00 a.m. RTW," which meant "Ready To Work"—dressed and on set, with hair and makeup already done, at 9:00 a.m. sharp. I usually arrived at 8:30 just to be safe. (This was probably when my reputation for always being on time began.)

Skrebneski Studio was a sterile, windowless, almost clinical environment with a lot of white lacquer. The hair and makeup room was tiny. In those days black coffee and a cigarette was the breakfast choice for many models. Forget a big buffet—especially at Skrebneski. On more than one occasion one of us would pass out on the set from lack of food and from holding a pose for a long time. Fainting was almost a rite of passage there, so, in addition to my modeling skills I also honed my baking skills during my Skrebneski years. Each morning, in order to make it through the day, I would bake lemon bread or banana muffins and bring a little basket of the goodies into the studio to share. (Fortunately I still had the metabolism of an eighteen-year-old!)

Deborah, Gerri, and Loretta were three of Victor's favorite local girls. They took me in like a little sister and showed me the ropes. I will never forget how nice they were to me. They believed in me even before I believed in myself. They taught me to dream big. "You're going to end up in New York and make it big there," they would say, even picking out the perfect boyfriend for me when I got there—either Richard Gere or John F. Kennedy Jr. At the time their friendship didn't seem out of the ordinary, but in hindsight it is remarkable to me that, as the new young favorite, I felt such support, encouragement, and camaraderie from this group of women.

We were the workhorses, the girls who showed up day in and day out. For special shoots Victor would fly in bigger-name, more famous models from New York, and they were treated like royalty. While the Chicago girls had a little lounge off the hair and makeup room where we would eat our lunch, the New York girls got to sit at the big table in the studio with Victor and the clients. During those two years that I worked with Victor I was never invited to sit at that lunch table.

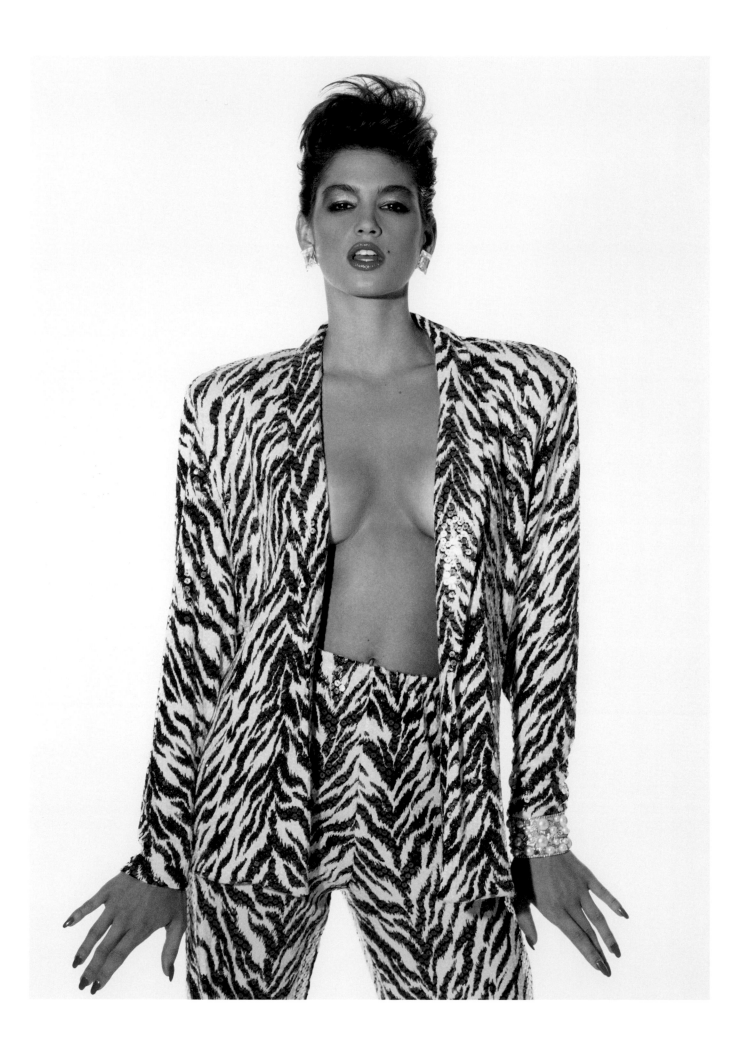

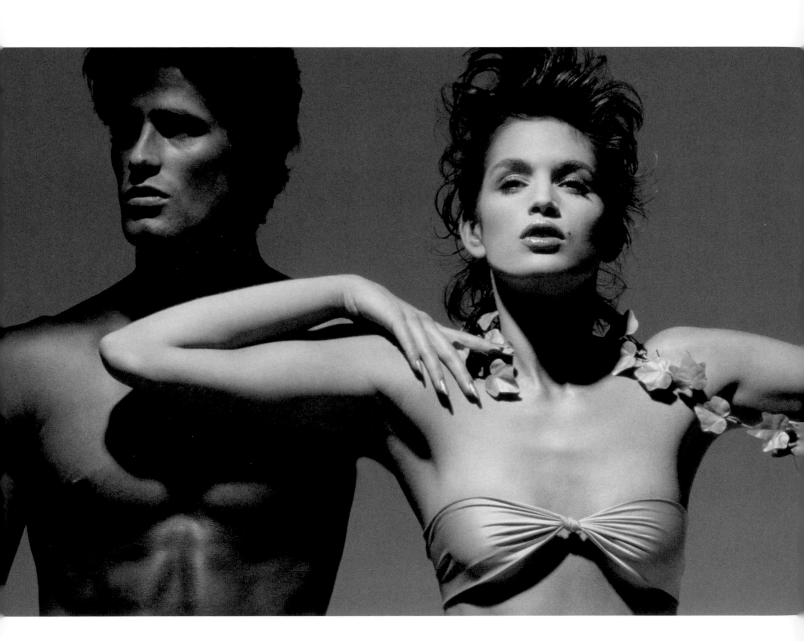

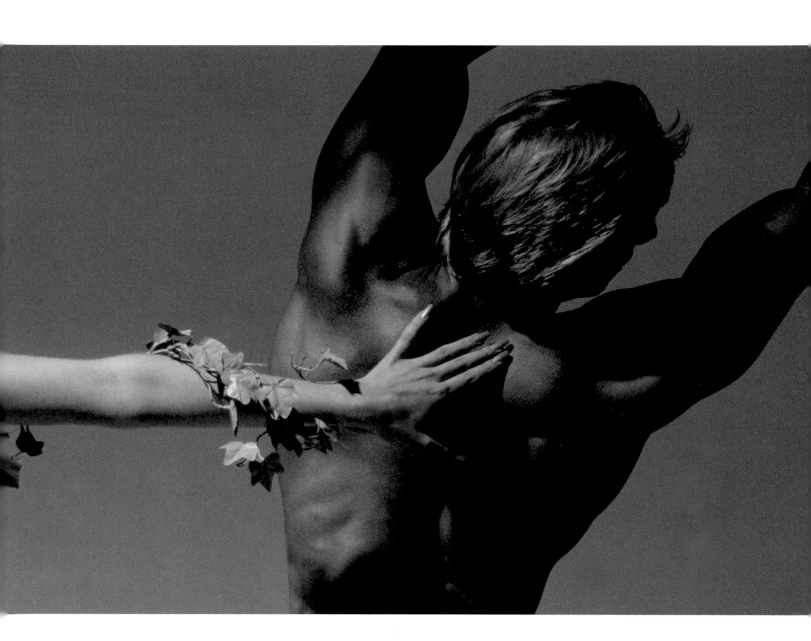

The New York girls not only got the respect; they also got better clothes, bigger ad pages, and lots more money. I figured out pretty quickly that that was what I wanted.

Being represented by Elite Model Management included an introduction to their sister agency in New York City. My booker in Chicago had entered me into Elite's Look of the Year contest while I was still in high school, and I made it to the finals in Acapulco. I didn't win (or even place in the top three), but I did make some important connections. After Acapulco, Monique Pillard and Oscar Reyes from Elite New York became my cheerleaders. They would call me constantly, trying to lure me to the big city.

I went during spring break and for a few weeks in the summer, but I was happy with my gig back in Chicago. For a while I had what I thought was the best of both worlds: the ability to dip my toe into the big leagues and then return home to the safety of a steady job with Victor.

One day in 1985 the New York agency called to propose a ten-day editorial shoot in Egypt. This wasn't the type of job that Chicago had to offer. My schedule was open, except for a half-day catalogue shoot Skrebneski was holding. My agent explained to Skrebneski's studio manager that this was a unique opportunity for me, and asked that they release the time they were holding. The answer came back no. I couldn't believe it. I had been scared to rock the boat but had hoped that the studio would be gracious and let me go. Instead, I was told that if I didn't do the catalogue shoot, Victor would never work with me again. Ever. Victor also told me that I didn't have an easy face to photograph and that he was the only photographer who knew how to make me look good. To this day, sometimes on set I still have to fight the thought that I don't have an easy face to photograph.

Victor also told me I didn't have an easy face to photograph and he was the only photographer that knew how to make me look good.

The two years of working with Victor Skrebneski had been invaluable. He had seen something in me, and I had always given him 100% in return. He had taught me so much. After all we'd done together, I couldn't imagine that he would dump me simply for not being available to him once in all that time. I felt betrayed.

I went to Egypt. And Victor remained true to his word. I guess I had hoped that he would eventually get over it, that he hadn't really meant ever. But he had. In retrospect, though, I'm grateful to Victor. Had he not exiled me from his studio, I might not have had the courage to make the move to New York. I remember talking to my mom about how scared I was. "What if it doesn't work out for me, and I end up having to come back to DeKalb? Everyone will know I failed." My mom said the only true failure would be in not trying. "Besides," she said, "what's so bad about coming home?"

By the way, the pyramids were amazing.

THE LEGEND

Richard Avedon was a pioneer of fashion photography and I always credit him with teaching me how to do a cover.

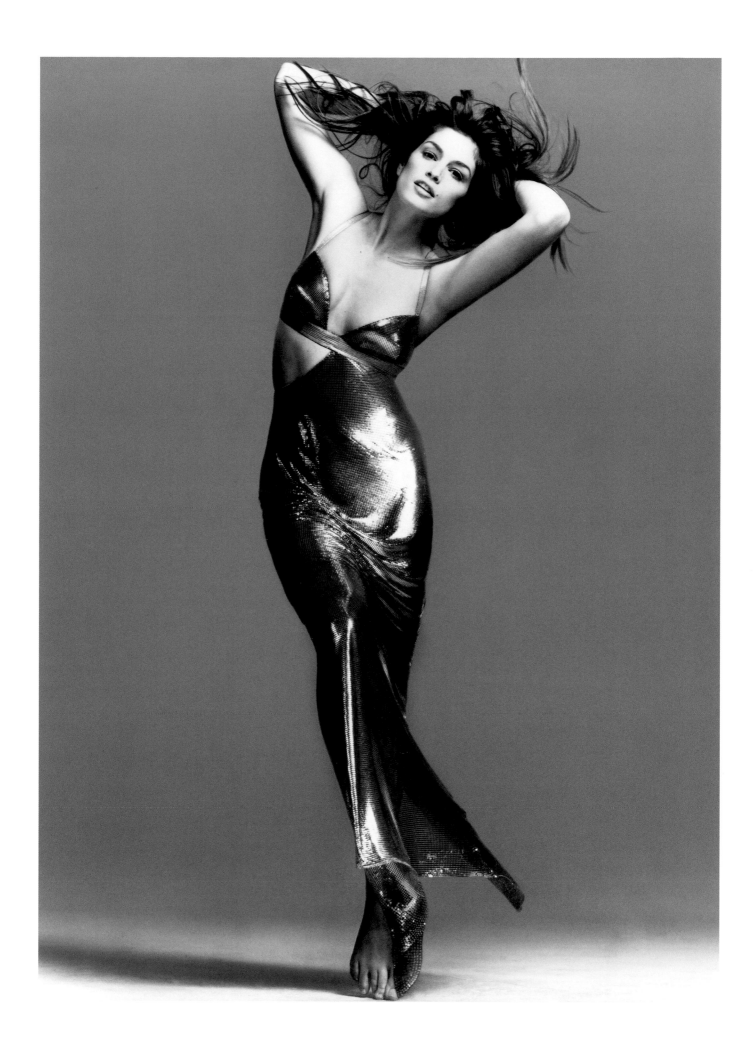

VOGUE

AUG.
$3.00

REAL ANSWERS

FASHION FOR THE BUSY LIFE

THE MOST-WANTED DAY LOOKS

stamina & success: 18 women at the top

ADDICTION: HOW TO FIGHT BACK

Liz Smith finds out about Diane Sawyer...

He insisted how important it
was that I, as the model, always
have an idea in my head when
I looked into the camera.

Not long after I moved to New York City, the legendary photographer Richard Avedon booked me for my first *Vogue* cover try. Avedon, along with Irving Penn, was a pioneer of fashion photography. The chance to work with him—as well as the possibility of a *Vogue* cover—was thrilling.

Avedon was in his early sixties at the time but still at the top of his career. He was a slight, elegant man with a shock of silver hair. He shot with an 8x10 camera—one of those big old-fashioned cameras where the photographer looks through the lens under a black cloth. He used it because the resulting images were sharp and detailed. When photographers shoot with smaller cameras, the pace is fast. But with an 8x10, it is much slower and requires tremendous precision. Modeling with Avedon wasn't just about your pose. Not only did you have to be able to "get it up" for that one moment, but you also had to be aware of the depth of field and know how to hit your mark every time. If you didn't get it right, your nose might be in focus, but the rest of your face wouldn't. There was a lot more to think about than just your smile.

Avedon became another mentor to me, taking the time to teach me skills I could take with me to the next shoot, as opposed to just giving directions—"Put your hand here." In order to help bring more life to each frame, Avedon had a way of sucking in his breath and rising up on his toes just before he clicked the shutter.

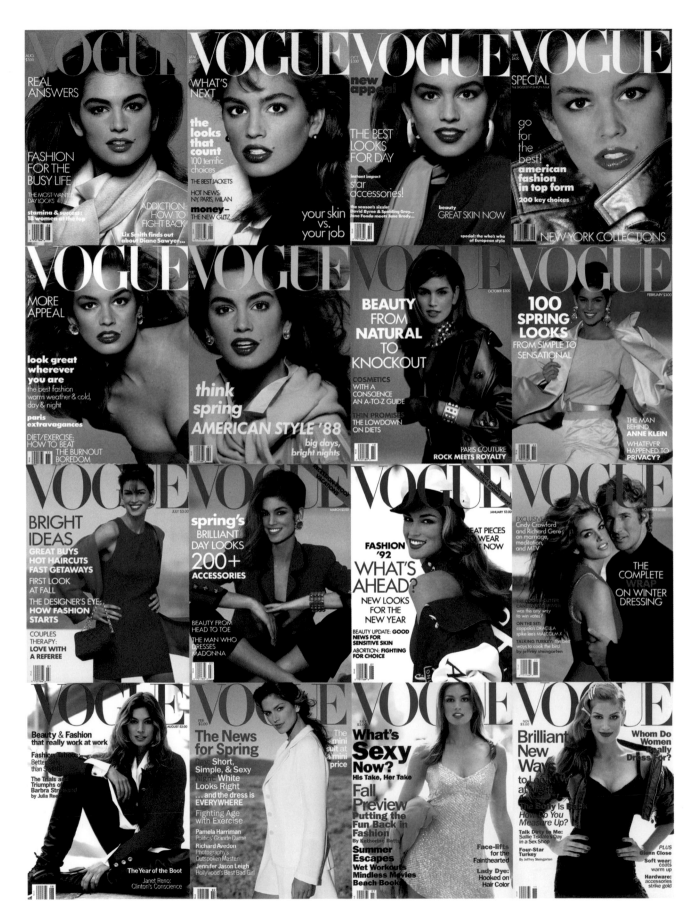

Avedon shot the First six of my 17 American Vogue covers. Others shot by Herb Ritts, Steven Meisel, & Patrick Demarchelier.

I think he hoped that he could infuse his subjects with his energy. I always credit Avedon with teaching me how to do a cover. He insisted how important it was that I, as the model, always have an idea in my head when I looked into the camera. He'd tell me to have a thought, even if the thought was simply "Buy me. I'm $3.00" (the price of *Vogue* at the time). He taught me to look away from the camera between each click and come back with a fresh thought. I still do that to this day. While a young girl's face can be pretty enough with a blank expression, Avedon didn't want blank. If you started to zone out, thinking about your grocery list, he knew it. He wanted to see the sparkle in your eyes looking back at him under his black cloth. And he knew it when he saw it. While Skrebneski had taught me all about holding a pose, Avedon taught me how to make that pose come alive. The first "cover" thought I used the day we shot this image was, "Look at me now, Victor!"

I remember how excited I was when my first *Vogue* cover finally hit the newsstands. At the airport on my way back to Chicago I picked up three copies to show my mom and excitedly approached the cashier, hoping she would recognize me. She didn't even look up as she tallied my purchases. All she said was, "You know you have three of the same magazine, right, honey?"

When I got home, my family and friends all congratulated me. One friend said, "Wow, you must have made a million dollars doing that!" And I said, "No, more like $150." You don't do *Vogue* for the money. Once your face graces the cover of *Vogue*, your agent's phone lights up, and you have your calling card to the world of high fashion.

Once your face graces the cover of *Vogue*, your agent's phone lights up and you have your calling card to the world of high fashion.

THE MASTER

For **Irving Penn**, every day in the studio was about making Art with a capital A.

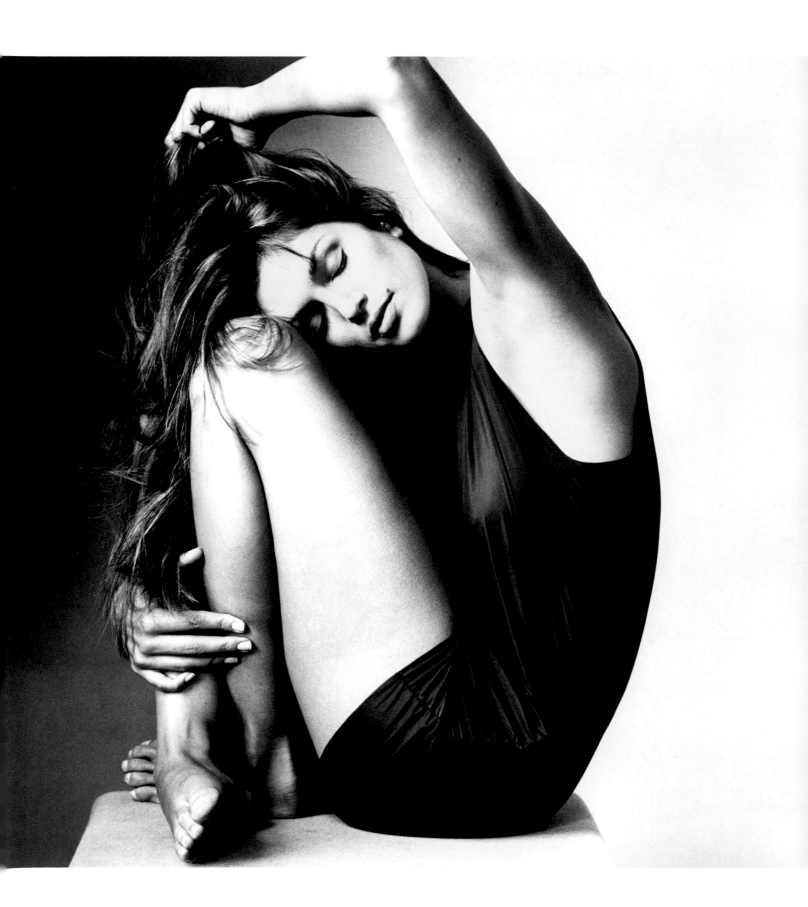

He photographed people the same way he photographed a still life, sometimes even physically arranging your arm or the angle of your head.

The word master comes to mind when I think about Irving Penn. From the moment you entered his immaculate studio, a calm enveloped you. You would be greeted by Mr. Penn (yes, Mr. Penn to you and just about everybody else) in a blue work shirt and perfectly pressed "dungarees" that somehow gave the same effect as a white lab coat. The mood in the makeup room was a more hushed version of the usual chitchat. Everyone got straight to work.

What was most striking inside the inner sanctum of the actual studio was the absence of music. At most shoots, the stereo would be blaring, setting the tone and helping create the atmosphere for the day's shoot. At Penn's studio, it was silent and the "set" was usually a white or gray backdrop. He photographed people the same way he photographed a still life, sometimes even physically arranging your arm or the angle of your head. He expected you to remain still and take direction. He wasn't overly complimentary, so when he did give a word of approval, he meant it.

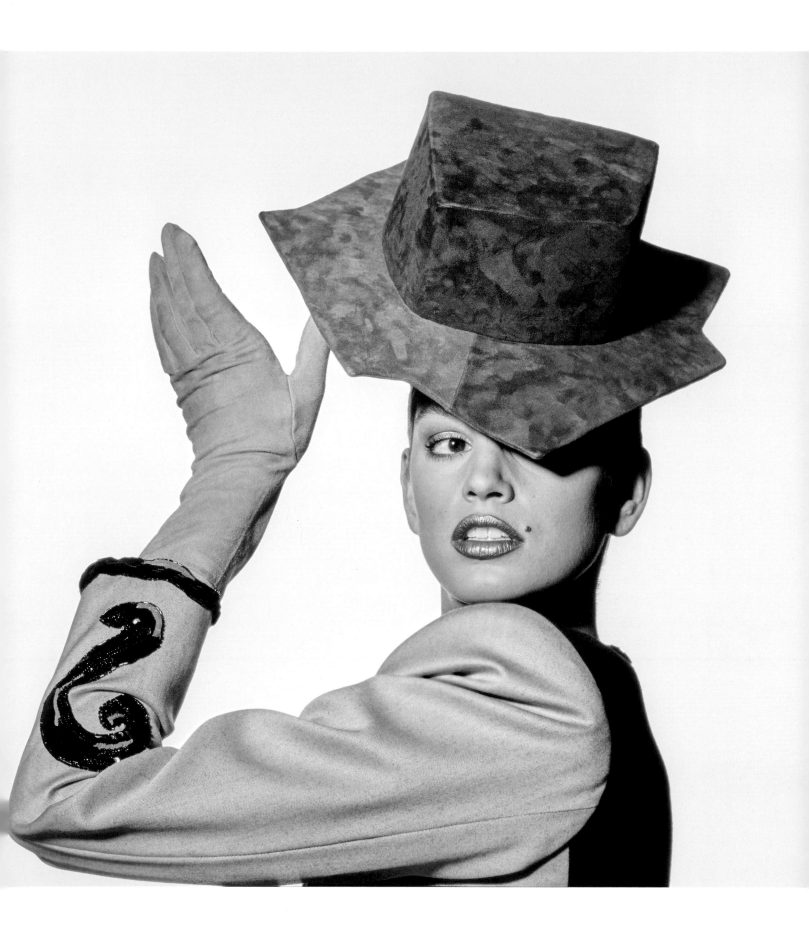

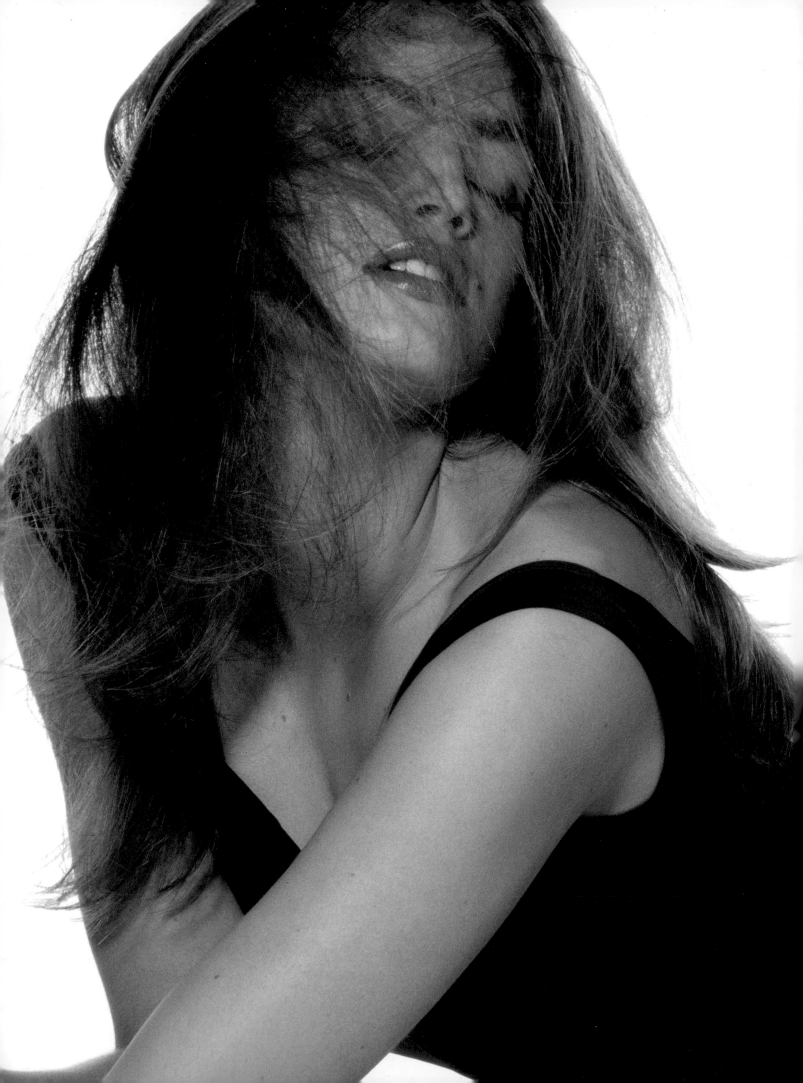

I can't say
working with
Mr. Penn was
a lot of fun.
More important
than fun, every
moment in front
of his lens was
a lesson.

I felt so honored to model for one of the founding fathers of fashion photography. But working with Mr. Penn was not about having fun. Every moment in front of his lens was a lesson. He was completely disciplined and understood fashion right down to the smallest seam. I loved watching him contemplate the clothes, distilling their essence until he found the most interesting element to bring to life. He was the definition of integrity. He needed to find value in everything he photographed—even some silly fashion trend—and wouldn't take the picture until he defined that value for himself.

One day at lunch we were talking about the fashion business. I told him what a treat it was for me to work with him and how I felt like we were creating something special. Although I always tried to make the most of every shoot I did, I had come to accept that some days a shoot was just a shoot. His response to my comment was impassioned; he simply couldn't understand my mentality. I think he almost felt sorry for me. For Mr. Penn, every day in the studio was about making Art with a capital A. Who else could see the beauty in a dying flower or even a cigarette butt?

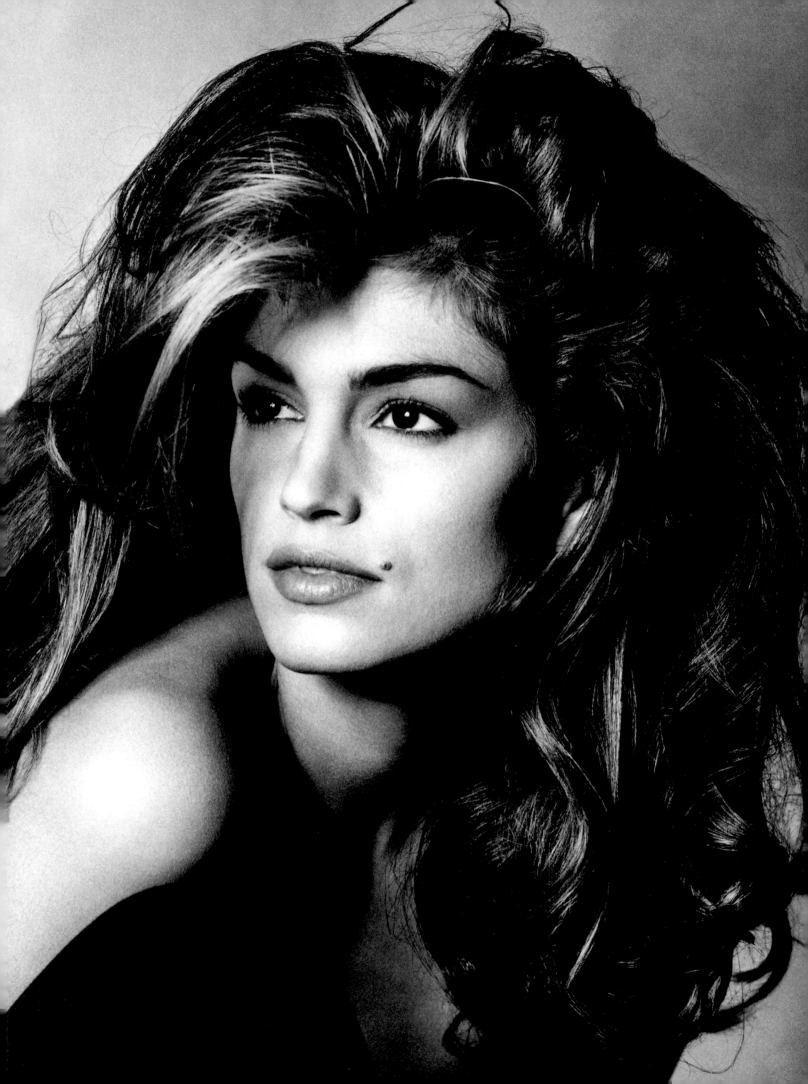

THE STORY-TELLER

There is a freedom in **Arthur Elgort's** style. He taught me how to dance and jump and laugh and be silly.

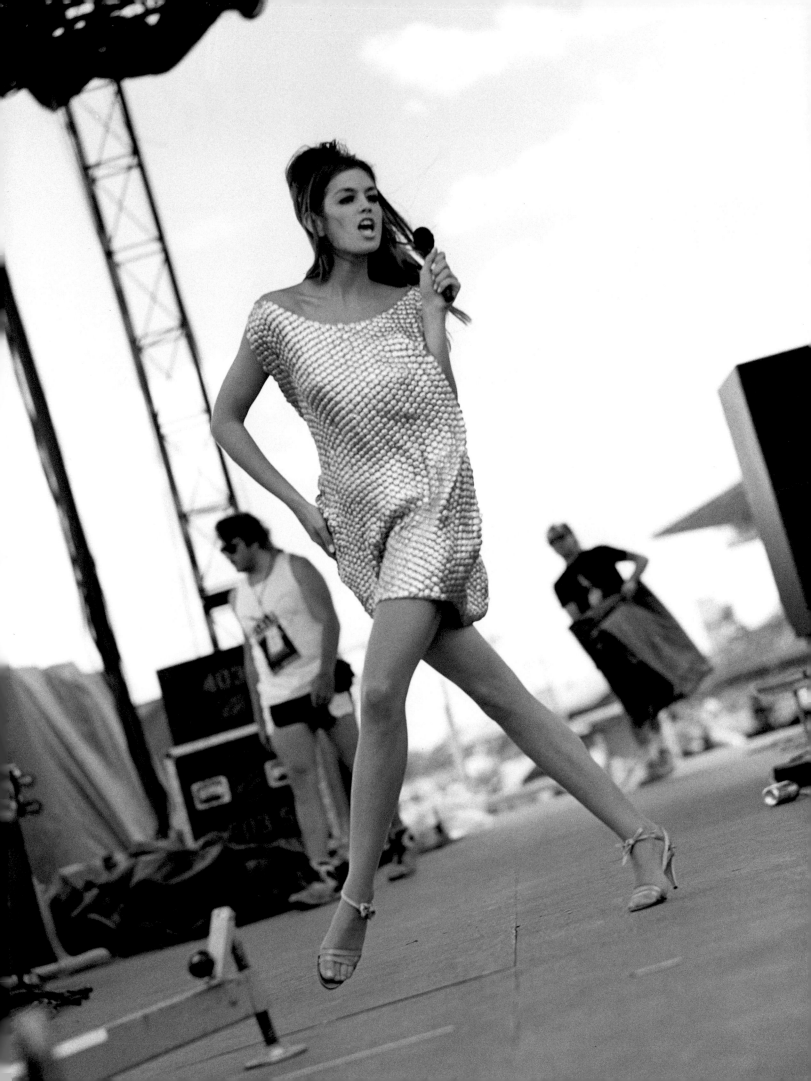

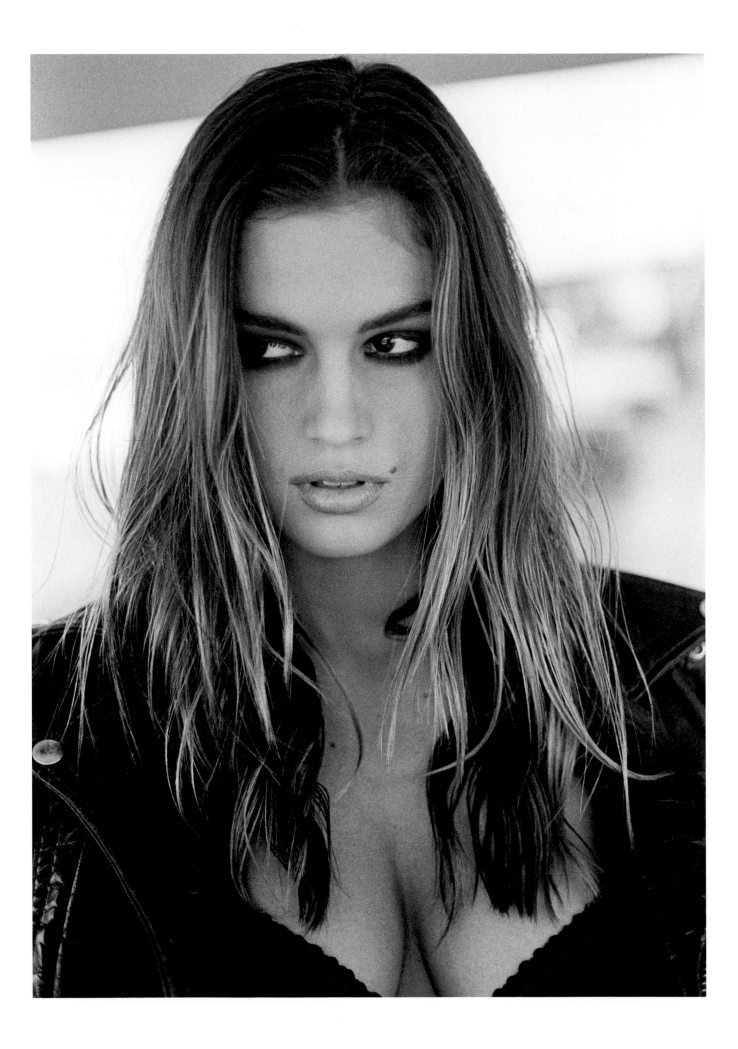

He taught me to throw
away everything I had
learned … to almost forget
the camera is there.

While Victor Skrebneski taught me how to be a mannequin and Richard Avedon taught me to have a thought behind my eyes, Arthur Elgort taught me to throw all that away. What does that mean to a model? It means to almost forget the camera is there. To trust that somewhere in all the shots Arthur would take (and he does shoot a lot) he would capture something beautiful. It might sound easy, but after my formal training, working for a photographer who simply wanted to shoot natural moments was nerve-racking.

In many ways each photographer's studio is an expression of themselves, from Victor Skrebneski's elegant Chicago Gold Coast studio to Mr. Penn's laboratory on lower Fifth Avenue. By contrast, Arthur Elgort's studio on a scrappy street near Chinatown only had a buzzer with his name on it. Once you were buzzed in, you pushed another button for the rickety elevator. After a few minutes a studio assistant would come down six floors and open the gate on the freight elevator. Upstairs, the doors opened into a tiny, crammed office space. Stepping through the chaos, you finally reached a huge open loft with beautiful light. It felt more like a dance space than a photo studio—probably because Arthur's wife was a dancer.

On stage at the Cheyenne Wyoming Rodeo

Some cowboys giving me a hand

Hell's Angel

Shooting for Vogue UK

Mommy Bliss

ith baby Presley

may now kiss the bride

VOGUE

DEC
£2.70

Cindy Crawford
fame and the single girl

Jemima Goldsmith
my life as Imran's wife

**What women really
wear at night**

Good and bad in bed:
the truth about frigidity

SUPERMODEL
STYLE
Naomi, Amber and Shalom
dress for themselves

Vogue's best beauty
buys of the year

MON 612

There was no specific area set aside for doing hair and makeup, just a table set up toward the back of the studio with a rolling cart and a portable mirror. The models would sit on a stool to get our hair and makeup done. Arthur would roam around the studio with his Leica camera around his neck, a pipe hanging from the side of his mouth. He would smile and talk to you, interested in hearing the details of your life and all the while shooting. For me, it was hard to get used to. I was accustomed to turning it on once I was "ready" on set. I felt extremely self-conscious with Arthur constantly clicking away. I was afraid he would capture me at a bad angle or with a weird expression.

It didn't help that Arthur has an obsession with models' hands—or maybe it was just my hands. Often, even if everything else was perfect, he would ask me to do "something different" with my hands. Well, you know how it is; the second someone points something out, you become self-conscious. I felt as if I had cartoon hands and would try to hide them by shoving them into my pockets or behind my back.

There is a freedom in Arthur's style. He taught me how to dance and jump and laugh and be silly. He took me to a dude ranch and a rodeo. He shot my wedding and photographed me with my husband, Rande, and our one-month-old son, Presley, at our home. I love Arthur's eye, his easygoing nature, and his ability to see the beauty in what is already there.

After my more formal training, working for a photographer who only wanted to shoot more natural moments was nerve-racking.

THE
MAGICIAN

If turning up to do a photo shoot is like going on a blind date, **Patrick Demarchelier** would be the perfect setup.

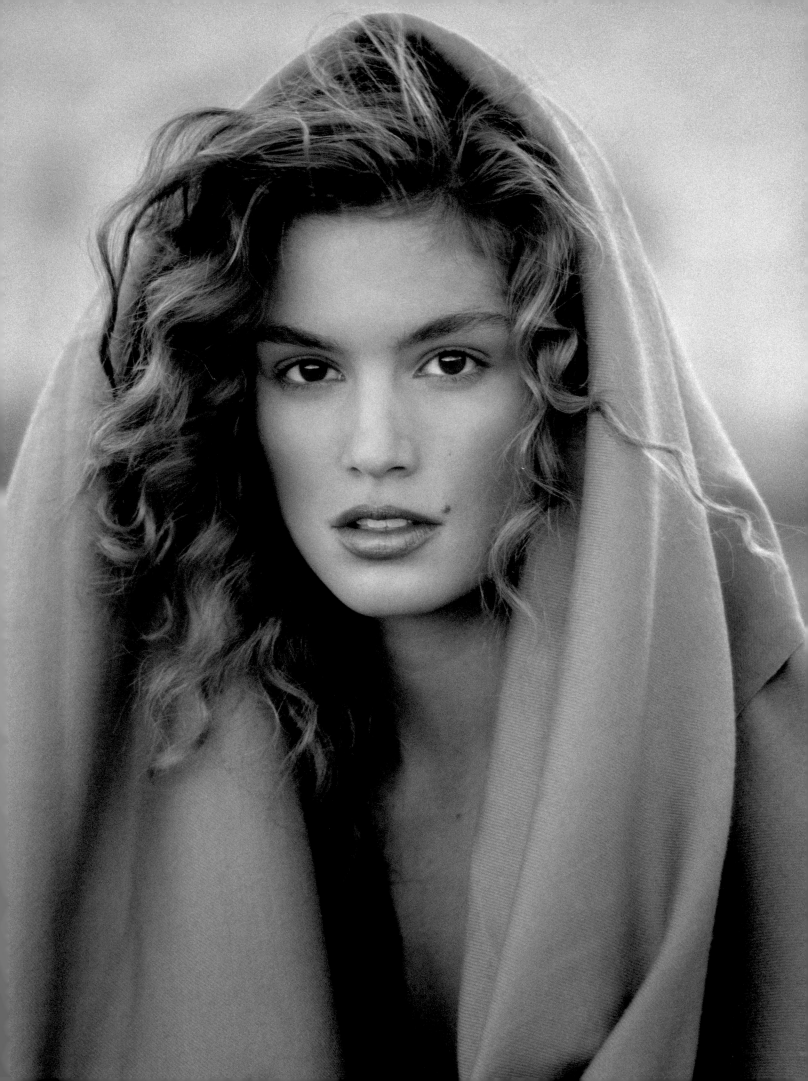

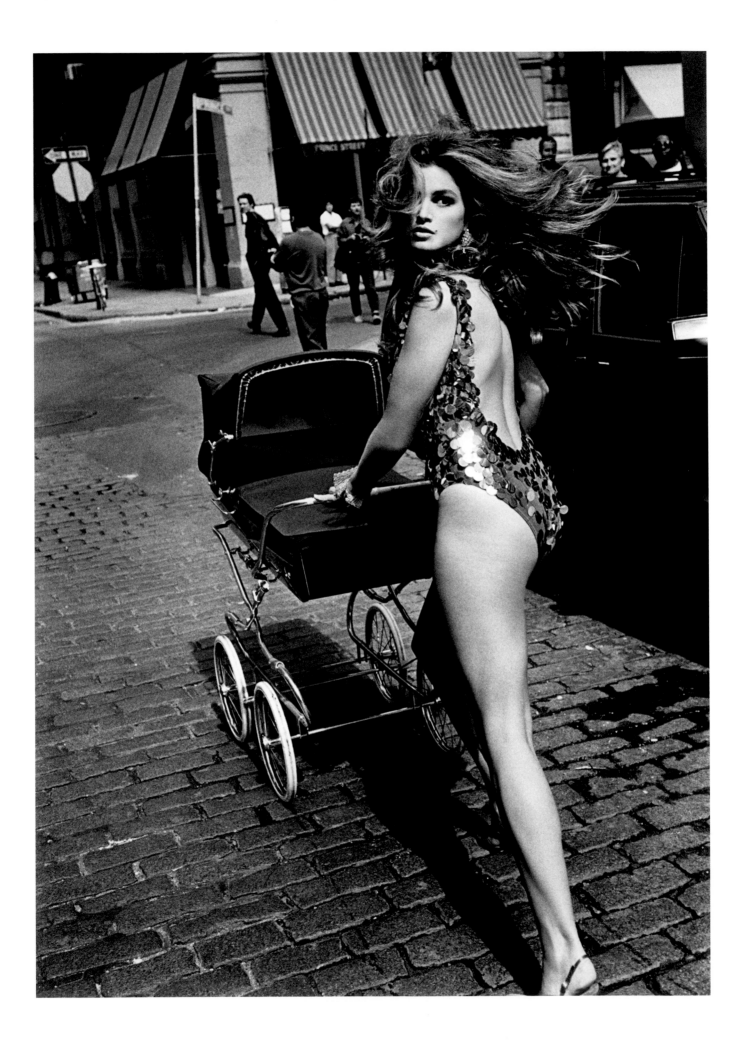

Patrick has enough
confidence in his
ability that he is like
a magician who could
create something
out of nothing.

If turning up to do a photo shoot is like going on a blind date, Patrick Demarchelier would be the perfect setup. Patrick is a handsome Frenchman who adores women. No matter what you are wearing, Patrick will make you look beautiful and woo you with his "Très jolie!" and "Ne bouges pas."

At first I thought that my provincial upbringing was what kept me from understanding 90% of what came out of Patrick's mouth, but after working with him for a while, I realized that he sounds the same in French—he simply doesn't open his mouth enough to clearly enunciate his words. Oh, well—c'est la vie!

I was fortunate to work with Patrick a lot, and I never once saw him lose his patience or seem remotely stressed out, even when he was dealing with demanding clients. Things were always laid-back with Patrick. He would come in to visit during hair and makeup and do just enough flirting to make every model feel like his favorite. While you were getting beautified, you might hear Patrick on the phone with Tony Shafrazi, his art dealer, or talking with the editor on set about the look for that day. He always surrounds himself with a great team, and he knows how to do beautiful and flattering lighting, so by the time you are ready, being in front of his camera is effortless.

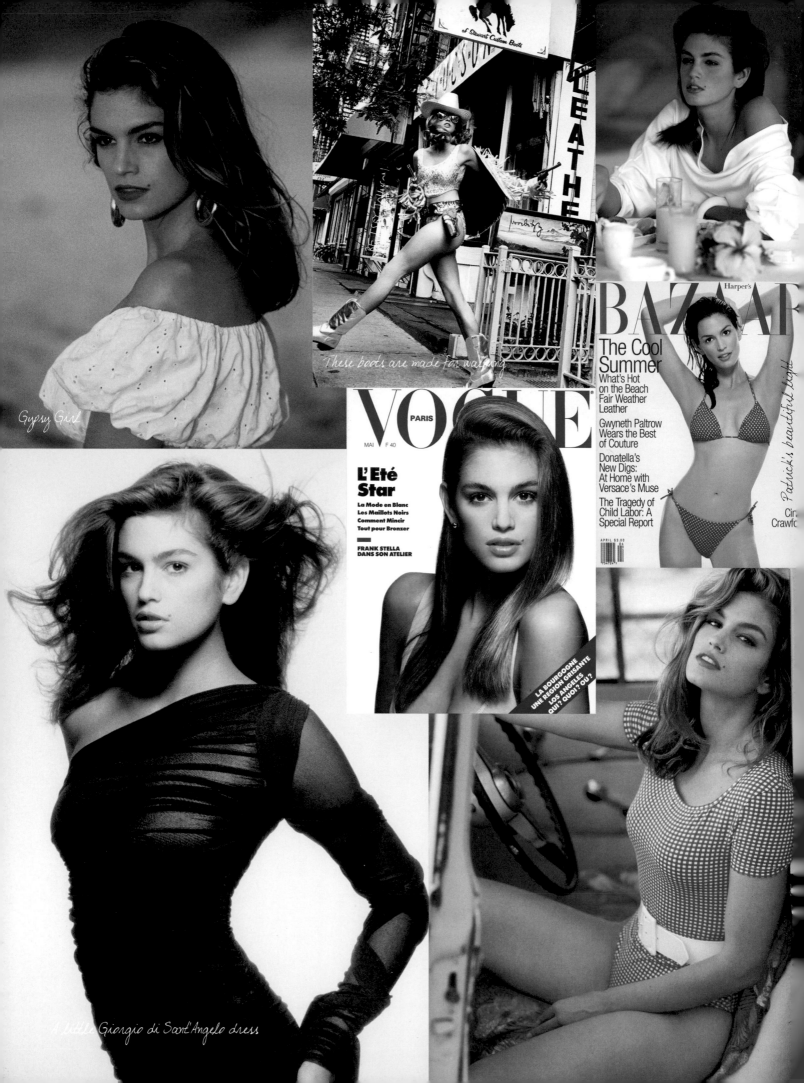

Gypsy Girl

These boots are made for walking

VOGUE
PARIS

MAI F 40

L'Eté Star

La Mode en Blanc
Les Maillots Noirs
Comment Mincir
Tout pour Bronzer

—

FRANK STELLA
DANS SON ATELIER

LA BOURGOGNE UNE REGION GRISANTE
LOS ANGELES OUI? QUOI? OÙ?

Harper's
BAZAAR

The Cool Summer

What's Hot
on the Beach
Fair Weather
Leather

Gwyneth Paltrow
Wears the Best
of Couture

Donatella's
New Digs:
At Home with
Versace's Muse

The Tragedy of
Child Labor: A
Special Report

APRIL $3.00

Patrick's beautiful light

Cir Crawfo

A little Giorgio di Sant'Angelo dress

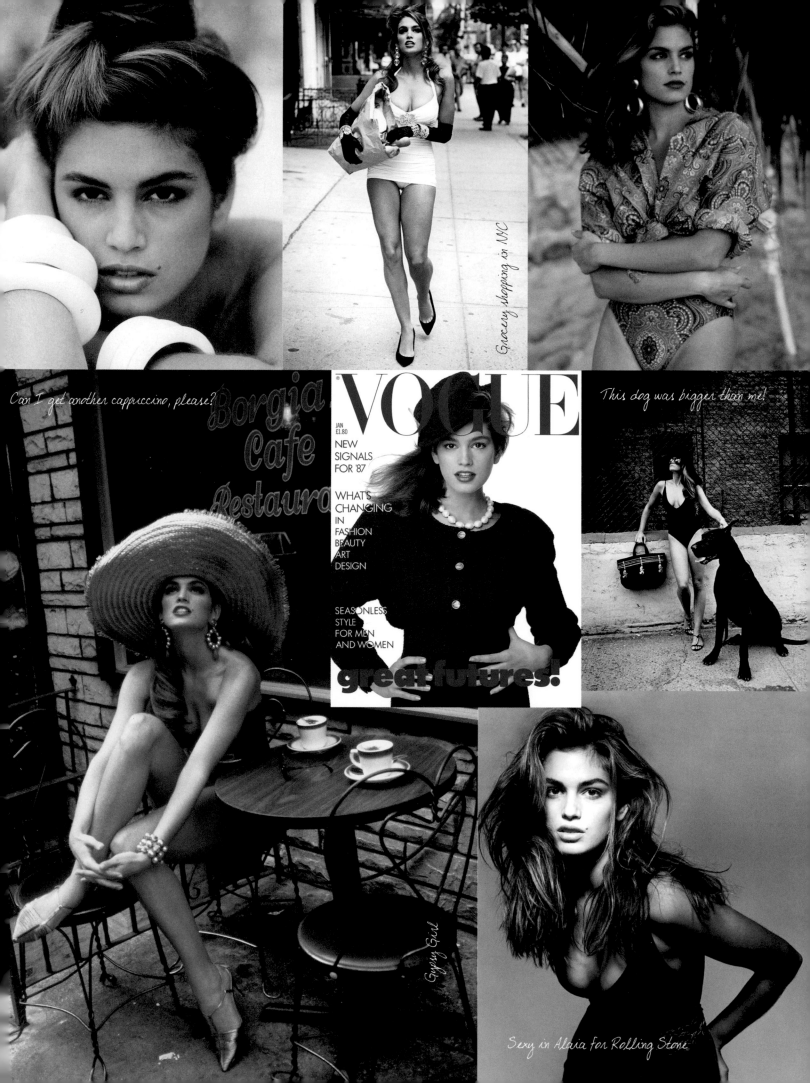

Grocery shopping in NYC

Can I get another cappuccino, please?

This dog was bigger than me!

VOGUE

JAN
£1.80

NEW
SIGNALS
FOR '87

WHAT'S
CHANGING
IN
FASHION
BEAUTY
ART
DESIGN

SEASONLESS
STYLE
FOR MEN
AND WOMEN

great futures!

Gypsy Girl

Sexy in Alaia for Rolling Stone

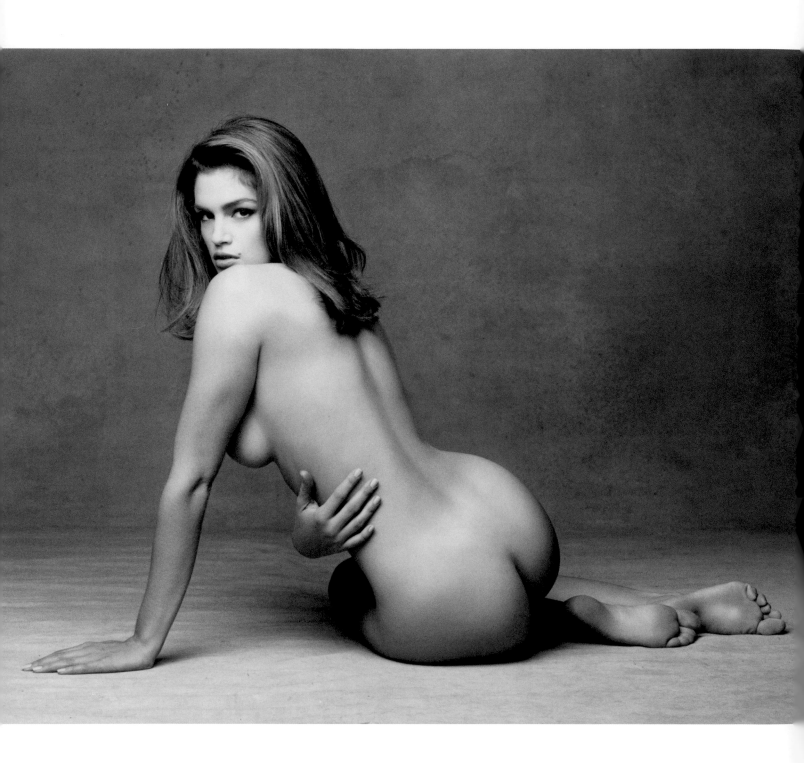

To an outside observer, Patrick makes a photo shoot look easy, but that isn't it at all. He is talented enough to not have to put on a big show. There was never any major production about finding the perfect background for a photo or drama about the hair not being exact. Patrick has confidence in his ability and makes anything look good. He is like a magician who can create something out of nothing.

Working with Patrick, each day has a particular rhythm: Get on set after two to three hours of hair, makeup, and styling; shoot a few pictures before lunch—usually the first one is the most important, because it establishes the look for the rest of the story (if you get the first one right, the rest of the day is usually a breeze, unless you are dealing with a particularly unruly outfit); after a few shots, break for a leisurely lunch—sometimes at one of Patrick's favorite Italian restaurants (I think Patrick realizes that a well-fed crew is a happy crew); after lunch, we would be back in the hair and makeup chair for touch-ups (if we were running ahead of schedule, which was often the case, Patrick would come in and whisper in our ears not to go too fast; otherwise, the clients would make us do more shots. He wanted us to time it just right to finish at around 4:30); and—voilà—home by five!

J'adore Patrick Demarchelier and being in front of his camera. If I were to choose anyone to shoot me today, I would choose Patrick. I know he would make me look beautiful and like myself, but, most important, the whole experience would be "que belle!"

Being in front of his camera is effortless and the whole experience is "que belle."

THE PROVOC- ATEUR

When working with **Helmut Newton**, you had to be ready to go along for the ride.

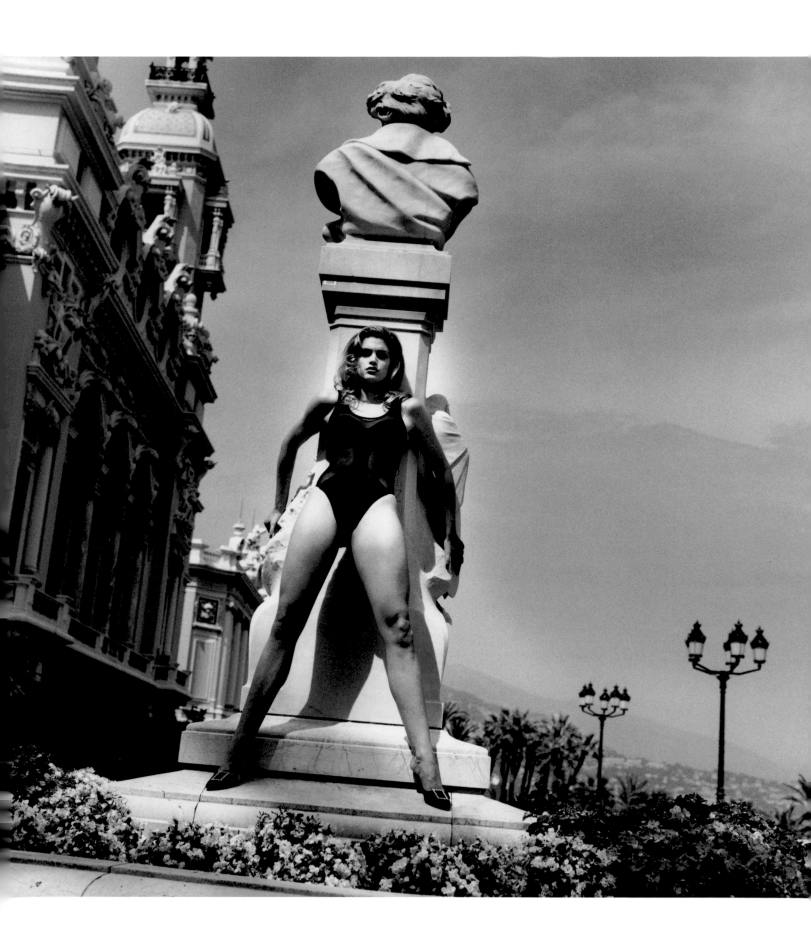

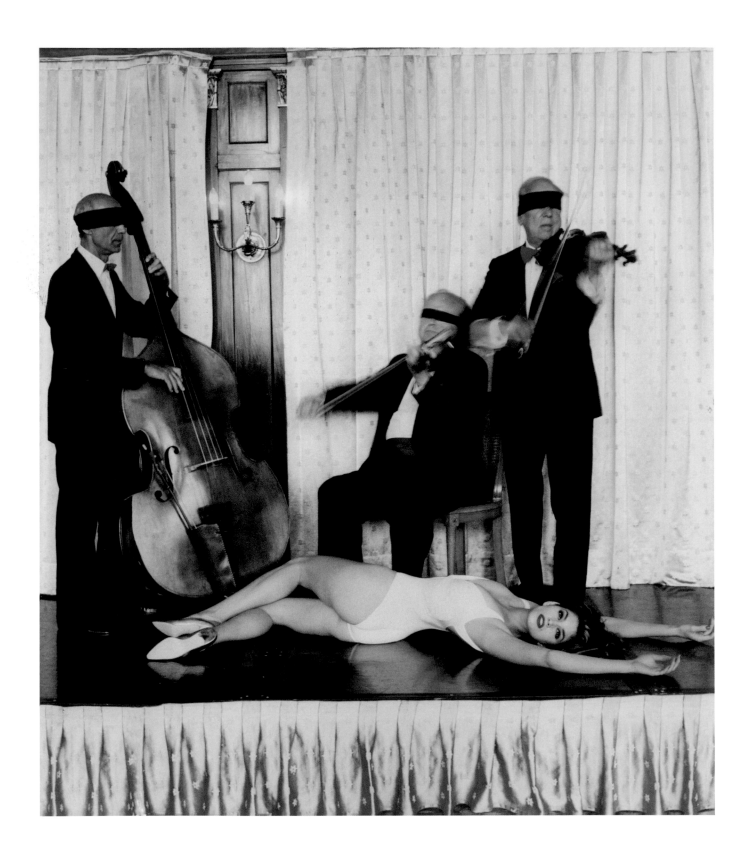

This shot of me is quintessential Helmut in all his unique, slightly twisted, and kinky genius.

Every time I've had the opportunity to work with a legendary photographer, I've hoped that we'd be able to create an iconic image together. By iconic, I mean a photo that embodies exactly whatever that photographer does best. That's the dream, at least.

This Helmut Newton shot of me with three blindfolded musicians is that kind of image: it is quintessential Helmut in all his unique, slightly twisted, and kinky genius. It's Helmut's vision, his world, his eye creating a compelling moment. We did this shoot for American *Vogue* in Monte Carlo in 1991. It was my first trip to the South of France, but Helmut lived there, so we were on his turf. Our makeup area was in a hotel room on the main square, right in front of a casino and a busy outdoor café. I knew it was going to be a great shoot, so I had asked if my crew from MTV could tag along. Having an audience brought out Helmut's showmanship. At one point, he had me in a bathing suit and heels—the Newton "uniform"—standing on a street corner. He put a hat on the ground and would offer every passerby a Polaroid shot with me in exchange for a hundred francs. It was a great deal—we played at this until we made enough money to buy lunch. Talk about singing for your supper!

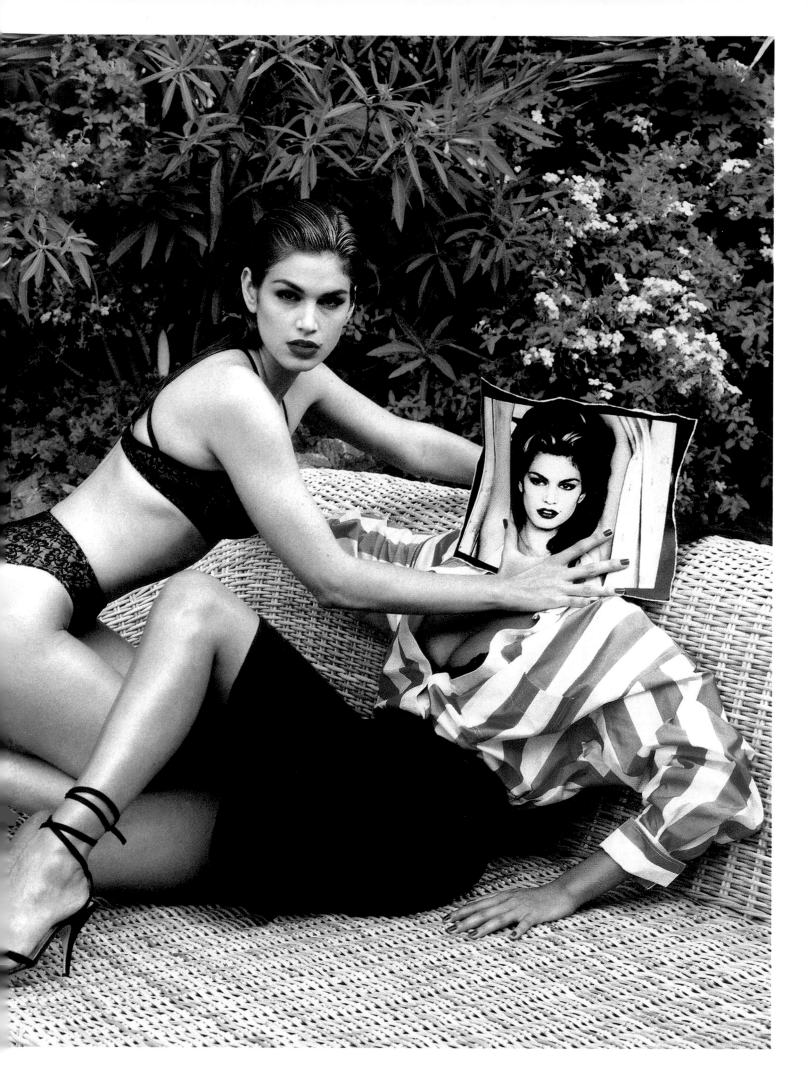

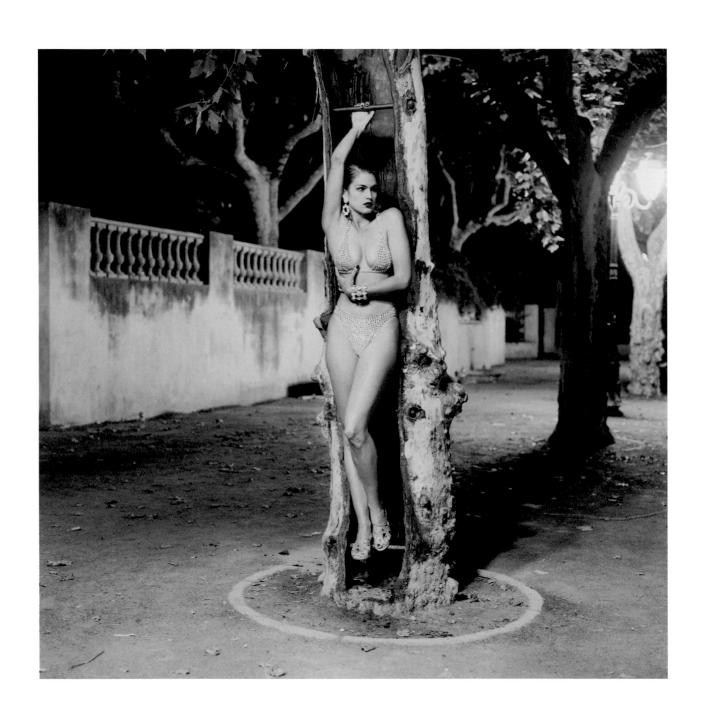

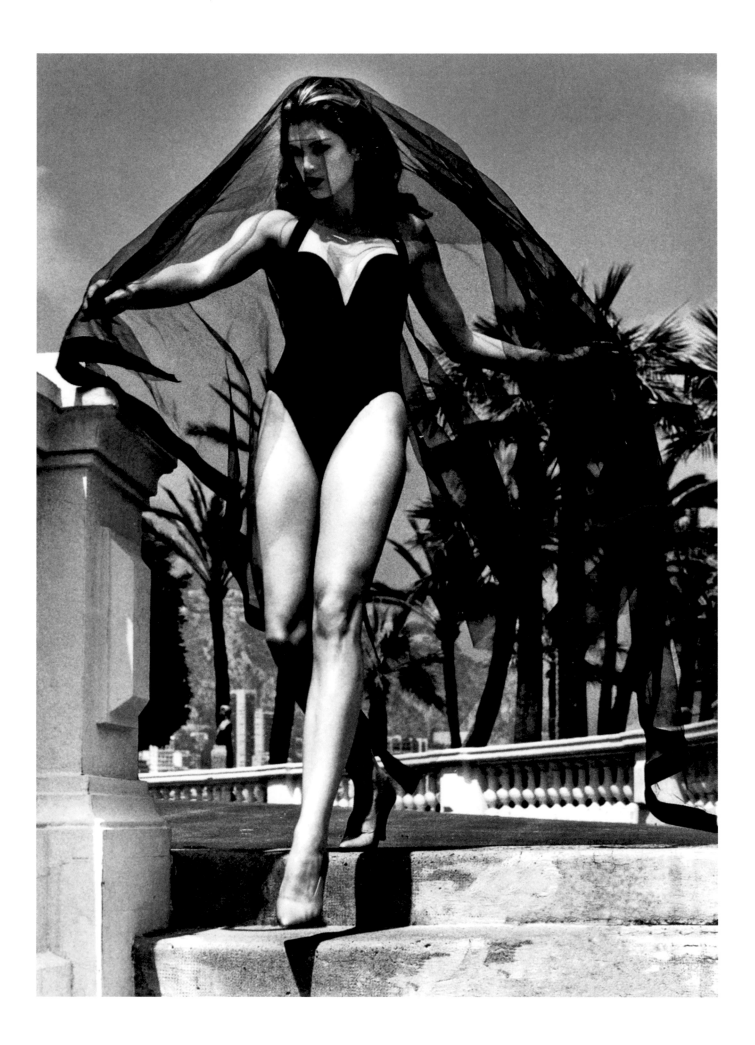

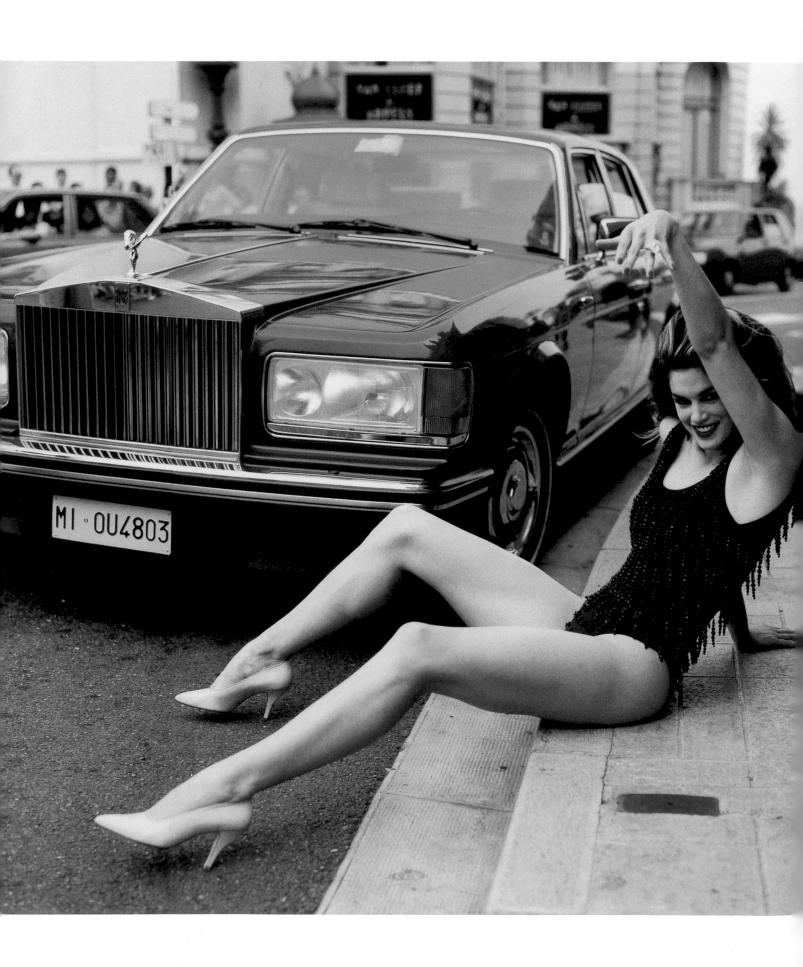

It was like a game of poker. He'd play with you, and you had to be ready to call his bet.

Much of Helmut's genius came directly from his imagination; there were no outside references for most of his images. Often, a photographer will come to the set with some kind of inspiration for the shoot: for instance, "Catherine Deneuve in *Belle de Jour,* " or "think of a modern Frida Kahlo." Shooting with Helmut was like a pathway straight into his highly staged and evocative world. He'd give you direction, in his thick German accent: "Cindy . . . you are a widow . . . (beat). But he was really rich and left you a lot of money . . . (beat). And you have a young, hot lover"—and he'd capture each thought as it registered on your face.

Even though his pictures were almost always sexually charged, the atmosphere on set never was. June, Helmut's wife of forty years, was always present, providing a surprisingly familial feeling, and, I always felt safe to bring Helmut's vision to life. It was like a game of poker. He'd play with you, and you had to be ready to call his bet. I'll see your three and raise you one. You're trying to shock me? Take this!

I didn't start working with Helmut until later in his career, but he always had a great sense of humor, and even though he was already seventy, he carried himself like a virile young man. When working with Helmut, you had to be ready to go along for the ride—Helmut's ride, epitomized by his iconic 1976 image of a saddled woman. There was nothing Midwestern about stepping into his world. In one setup, he'd have you as an unapologetic, overtly sexual, strong, and empowered woman. In the next image, you could be getting paddled. You never knew what was going to happen next, but you could trust Helmut's brilliance, knowing the end result would be something amazing and uniquely Helmut.

I always used to laugh with him and say, "Helmut, you're never putting that saddle on me!"

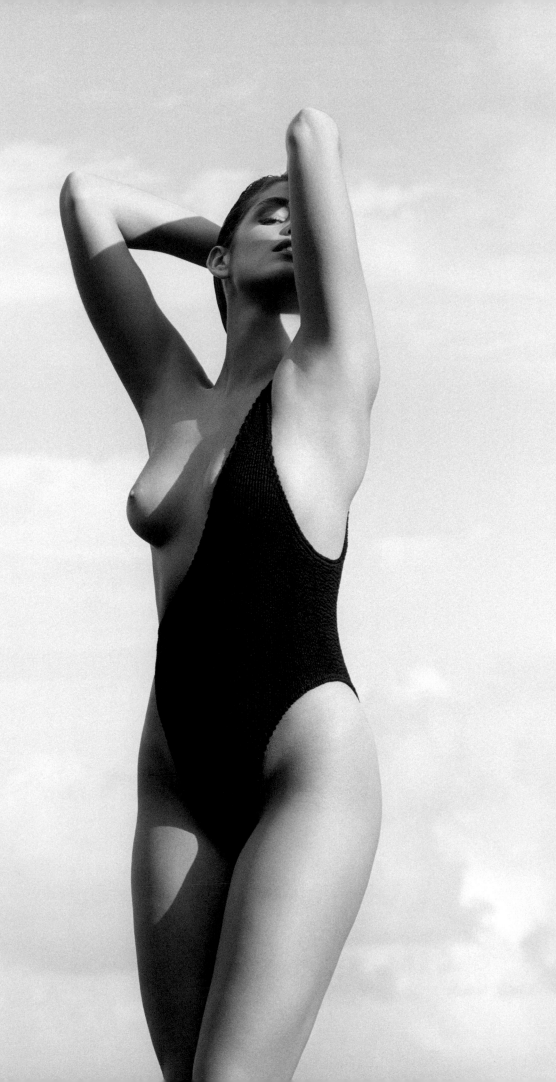

THE PURIST

Herb Ritts made me look the way I wish I looked when I woke up in the morning. He loved beautiful late afternoon light and I can't hear the words "golden hour" without thinking of him.

He truly saw the best version
of everyone. He wanted you to
be your best self, and I think that
comes across in his pictures.

When people ask me to name my favorite photographer, my first response is "for what?" I've been blessed to work with so many amazing and talented photographers that I could never pick just one. But if I did have to pick one, it would be Herb Ritts—not only because I love his photographs (and, luckily, he also happened to love photographing me), but also because of who he was as a person and the friendship that we developed from working together for fifteen years.

Herb was never bitchy or snarky. In all the years I knew him, I never heard him say a bad word about anyone. He truly saw the best version of everyone. He wanted you to be your best self, and I think that comes across in his pictures. I always say that Herb made me look the way I wished I looked when I woke up in the morning. He loved beautiful, late-afternoon light, and I can't hear the words "golden hour" without thinking of him.

We first worked together for Macy's in the late 1980s. We were both newcomers, and the shoot was forgettable. But shortly after that, Herb started booking me for shoots in Los Angeles, and that's when our working relationship started to heat up.

Unlike Arthur Elgort's work, for the most part, Herb's shots were very constructed. It was easy for me to draw on my training with Skrebneski, Penn, and Avedon and hold still, or just move incrementally, to help Herb achieve his vision.

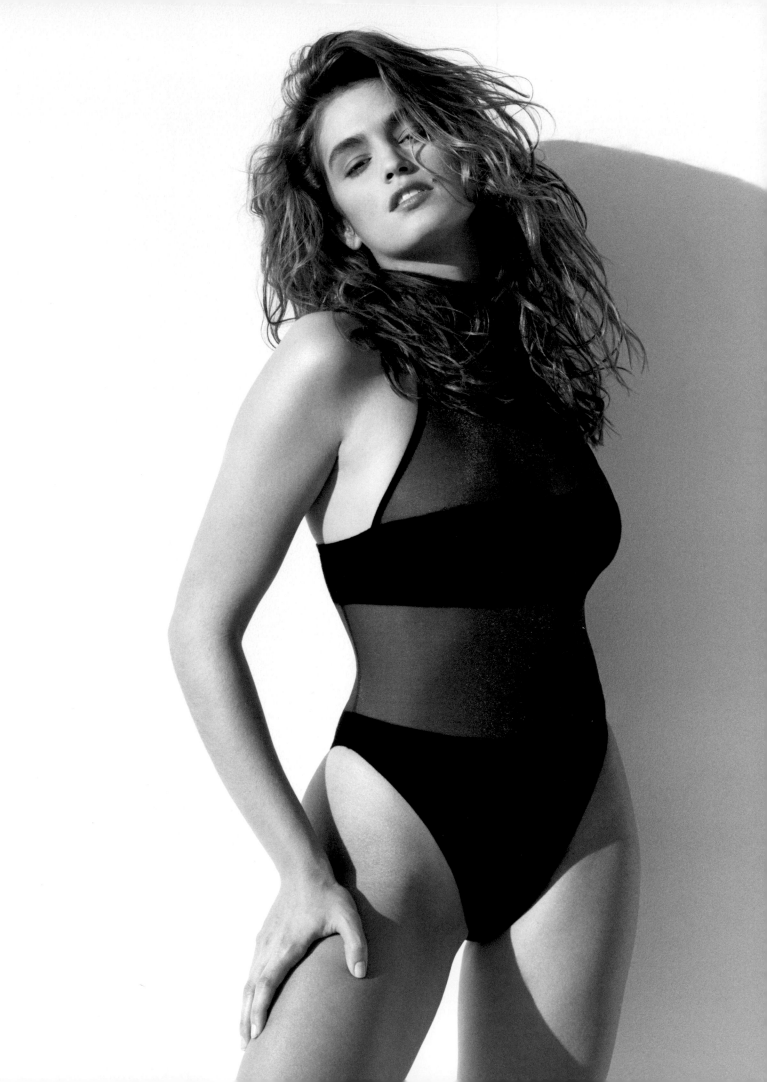

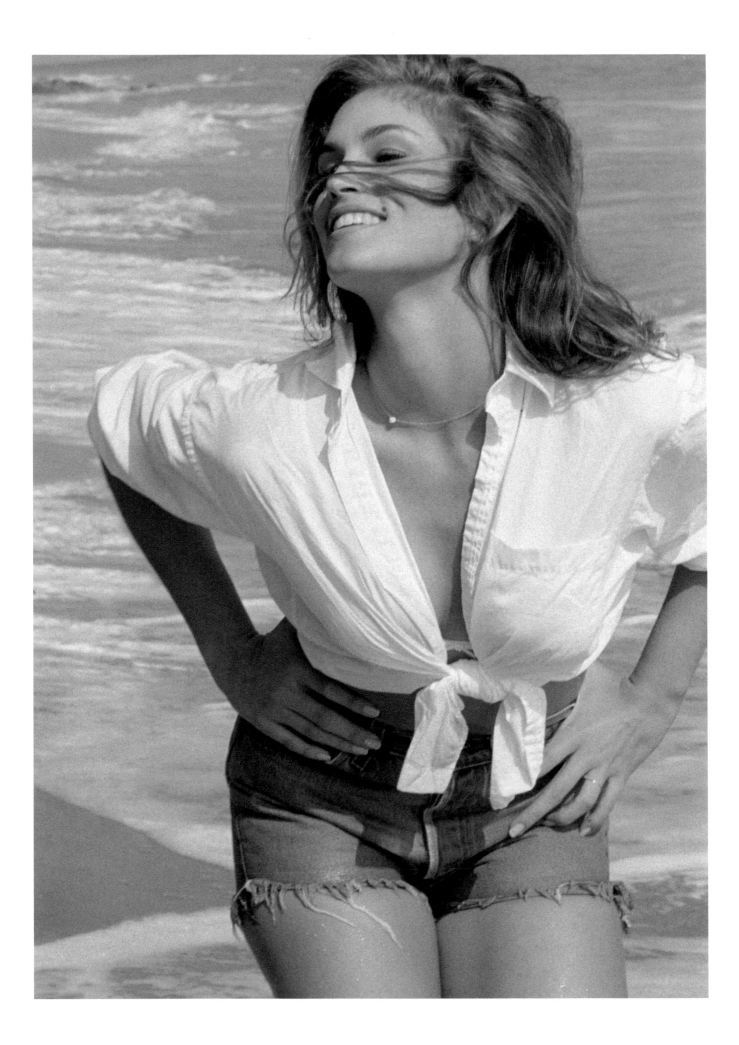

I trusted both his eye and his editing. When he told me it was good, I believed him.

Herb's aesthetic was developed from his exposure to design and architecture. His parents were in the furniture business, and he saw the body as a shape. I think he responded to the lines of my body—my muscles and my curves. He was a dream to work with, because he knew what he wanted and he knew how to get it. Some photographers will constantly say, "You look amazing," and eventually I stop trusting them, because, let's face it, not everything looks amazing. Herb wasn't like that. He would never say "amazing" unless it was. He would say, "Try this," and then, "Try it that way," until he saw what he was looking for. I trusted both his eye and his editing. When he told me it was good, I believed him.

I had the opportunity to do so many different kinds of shoots with Herb—editorial, advertising, and even catalogues and commercials. And while each job was different, some things never changed. For whatever reason, we rarely shot anything before lunch, no matter how early the call time. He always had an excellent team and a clear vision of the story. We always worked hard, but somehow it never felt like a job.

I don't think I would have considered myself a muse of Herb's when we were working together, but now, when I look back at some of my most enduring photos, many of them are by Herb. I am so grateful for all he taught me, but also for his talent and the way he showed me how to see my unique brand of beauty. He appreciated my strengths and my vulnerabilities.

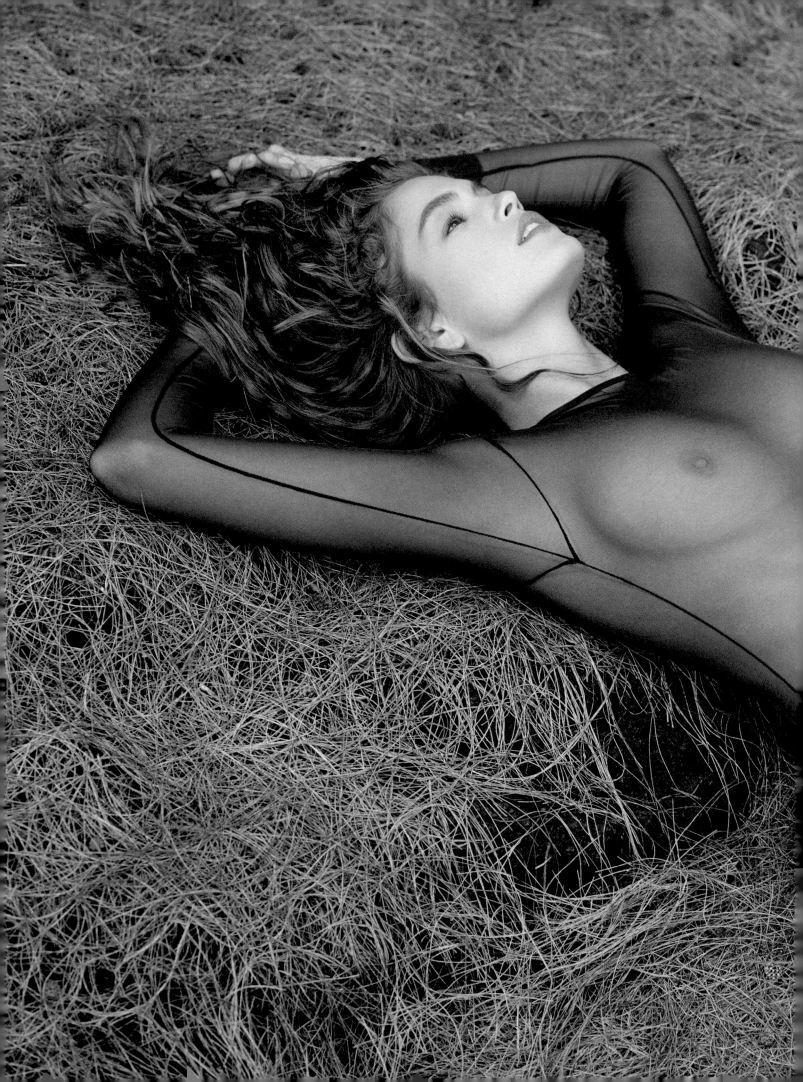

I also consider myself lucky to have had a deep friendship with Herb. I often stayed at his house in L.A. and spent many a Christmas Eve with him and his family. He was a great host and loved putting people together. You never knew who might be at one of his famous barbecues—Tracy Chapman, Warren Beatty, John F. Kennedy Jr., Janet Jackson, Arnold Schwarzenegger, Jack Nicholson, or Madonna. But even in a room full of superstars, Herb's mother, Shirley, was the center of attention. Shirley was a tiny woman with a big personality, and Herb absolutely adored her. Nothing gave Herb more pleasure than making his mom happy, and, as Herb's friends, we were all part of the entertainment.

We lost Herb far too early. He still had so much to offer, so much talent and vision and warmth. The work he did leave behind is full of light, humor, and a real love of his subjects. One of our first shoots together was in Malibu. We were shooting for Reebok, and I spent most of the day rolling down a hillside at Pepperdine University. I drive by that hill nearly every day. And every time I pass it, I think of Herb and smile.

He was a dream to work with, because he knew what he wanted and he knew how to get it.

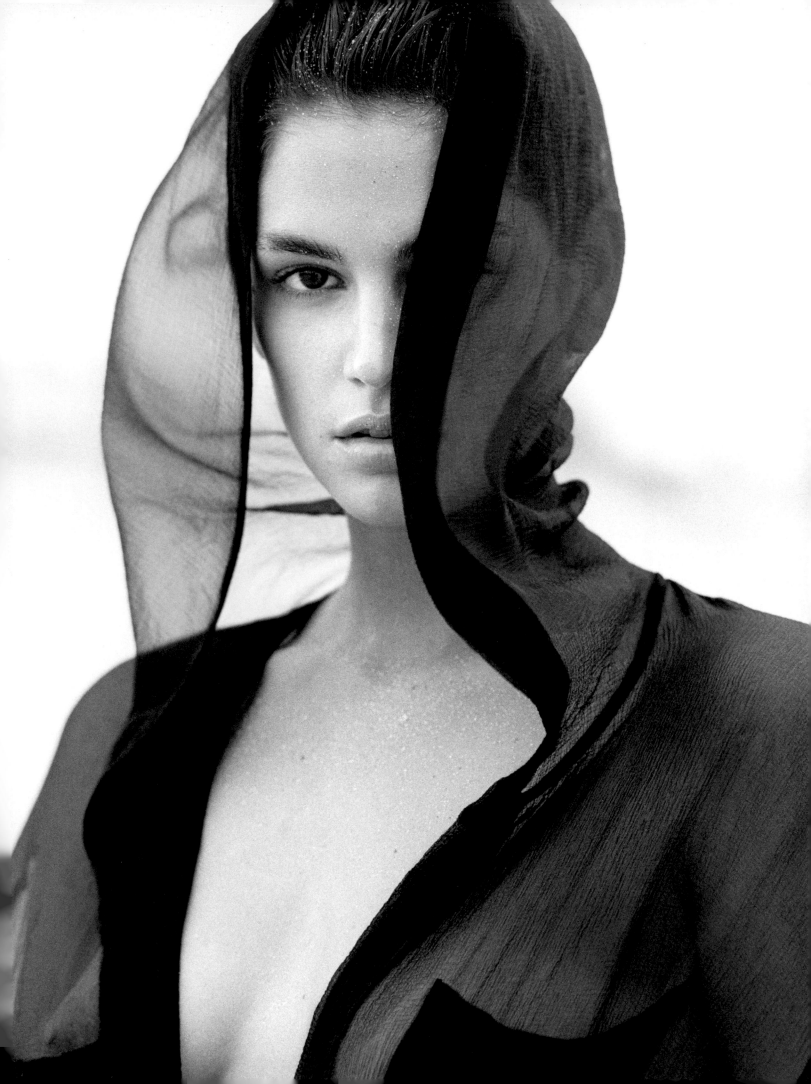

THE CINEMA-TOGRAPHER

I can spot a **Peter Lindbergh** photograph from a mile away. A cloudy overcast day that most photographers would have hated was heaven for Peter.

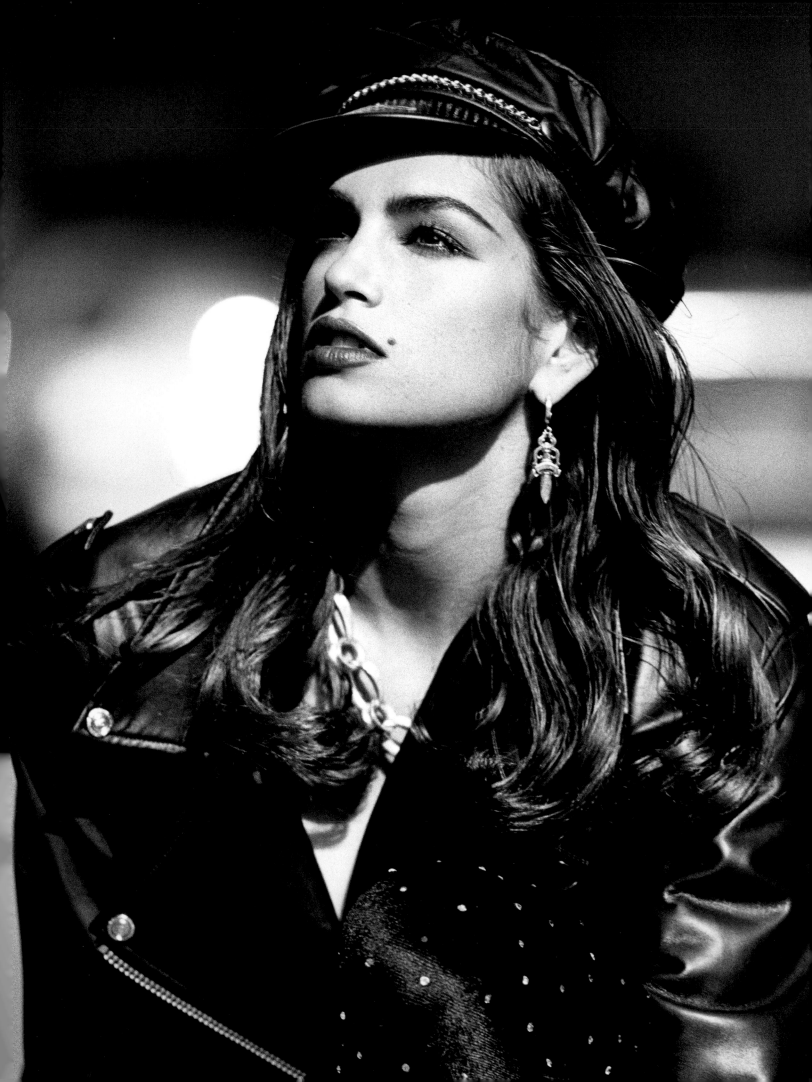

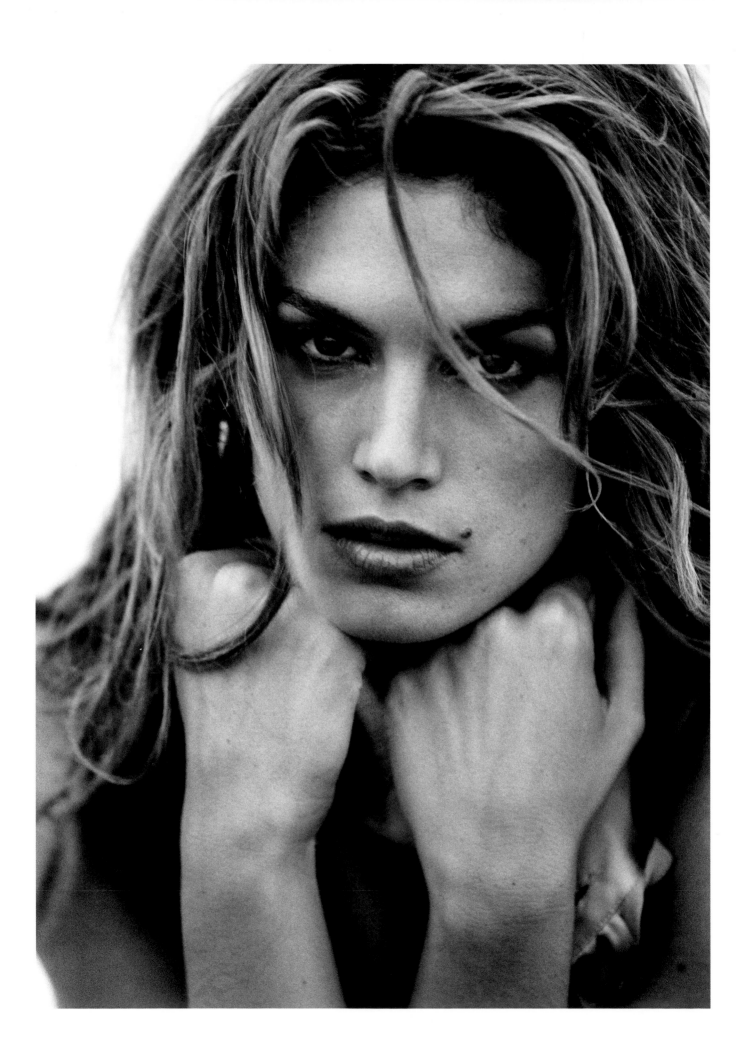

There is a rich texture to Peter's work. He loves to shoot in black and white, which gives his images both a modern and timeless quality.

Peter Lindbergh is a soft-spoken teddy bear of a man with a twinkle in his eye. The first time I noticed his work was a shoot he did with Linda Evangelista on the beach in Deauville. She looked incredibly beautiful, but there was also an intimacy there—a real woman with a story. His photographs made me want to know what Linda was thinking on the beach that day—and left me feeling like I almost could.

I can spot a Lindbergh photograph from a mile away. A cloudy, overcast day that most photographers would have hated was heaven for Peter. He loves the flat gray light that is the opposite of Herb Ritts's golden hour. Inside the studio, Peter works with strong tungsten lighting. His lighting is like that old Hollywood lighting that blasted away every pore or imperfection. It is hot as hell under those lights, but they bring out an intensity in the eyes that makes you feel as if you can see into the model's soul.

There is a rich texture to Peter's work. He loves to shoot in black-and-white, which gives his images both a modern and a timeless quality. There is a sensual beauty to his view of women. His images elicit emotion, and his women radiate strength and personality.

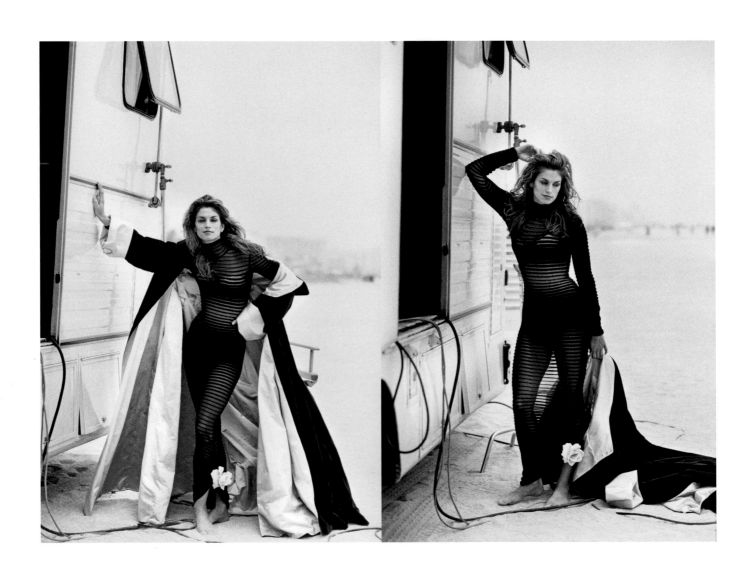

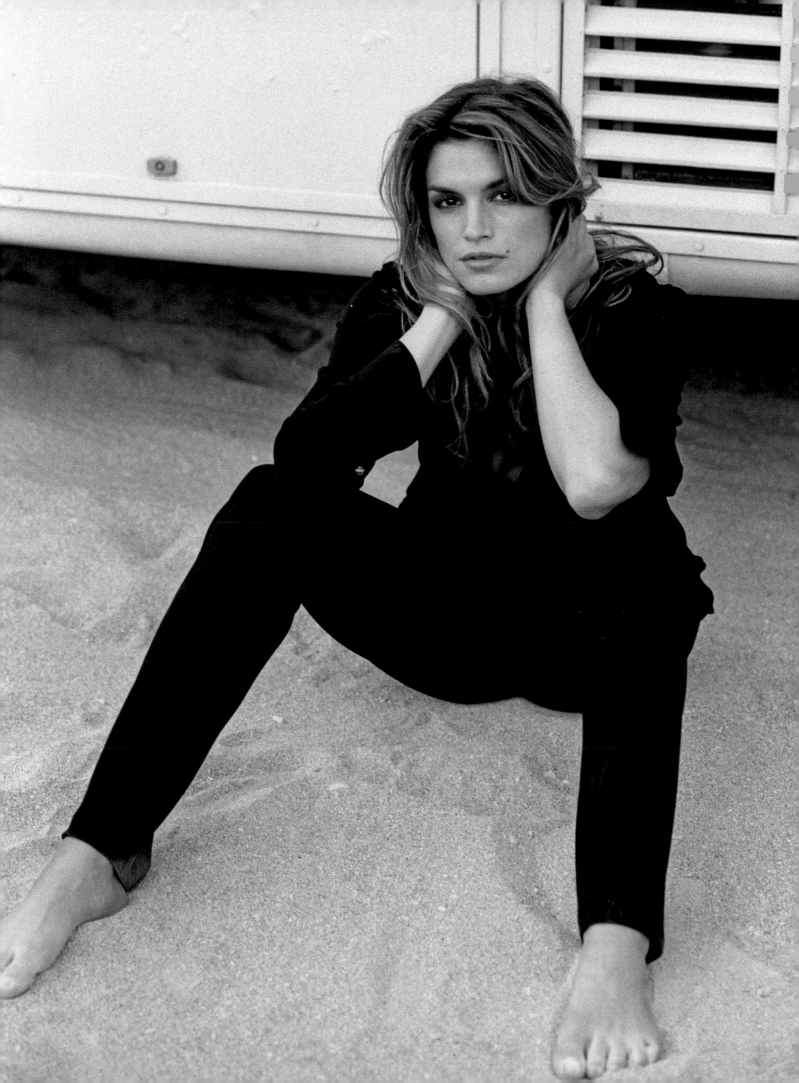

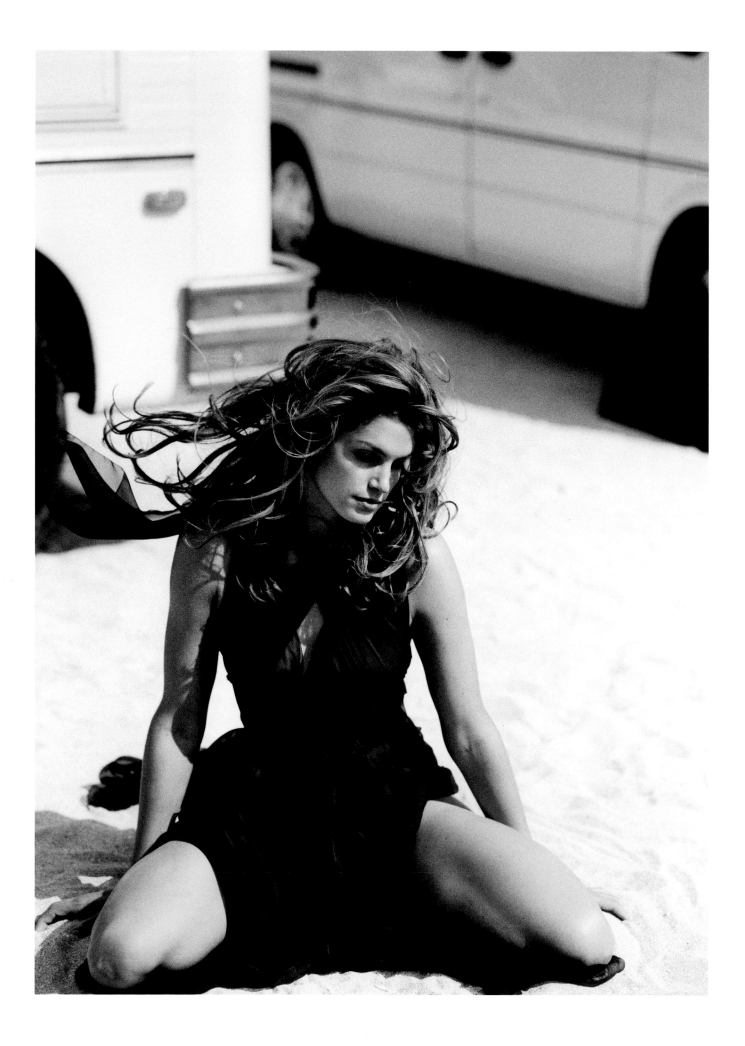

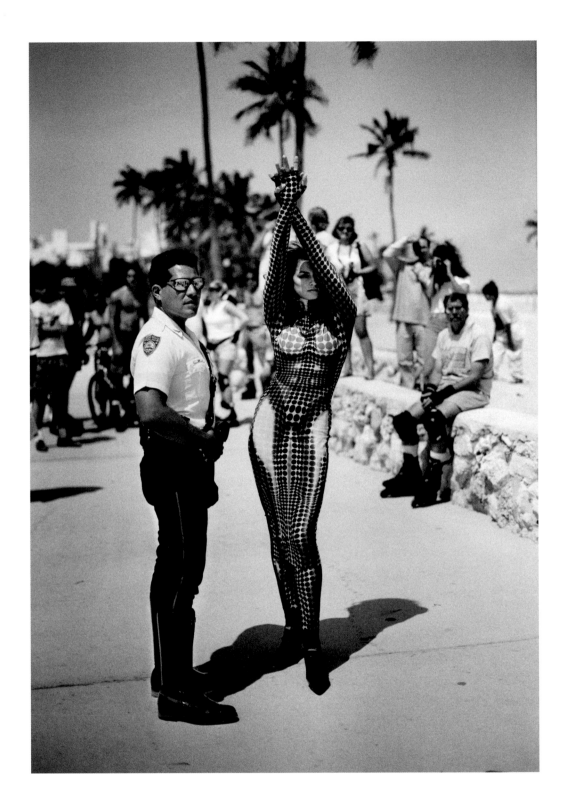

Working with Peter is relaxed—fun but not crazy, substantive without being overly serious. He makes you feel like a woman and has a way of turning your imperfections into something unique and beautiful.

Peter shoots a lot of fashion, yet even his fashion photos seem to focus more on the face. Emotion and drama are more interesting to him than just a pretty face. He knows what to say to help a model tap into the feelings he wants to see, almost like a director with a silent-film star.

THE SENSUALIST

Sante D'Orazio was a breath of fresh air in the fashion industry. He photographed women in a raw and sexual way.

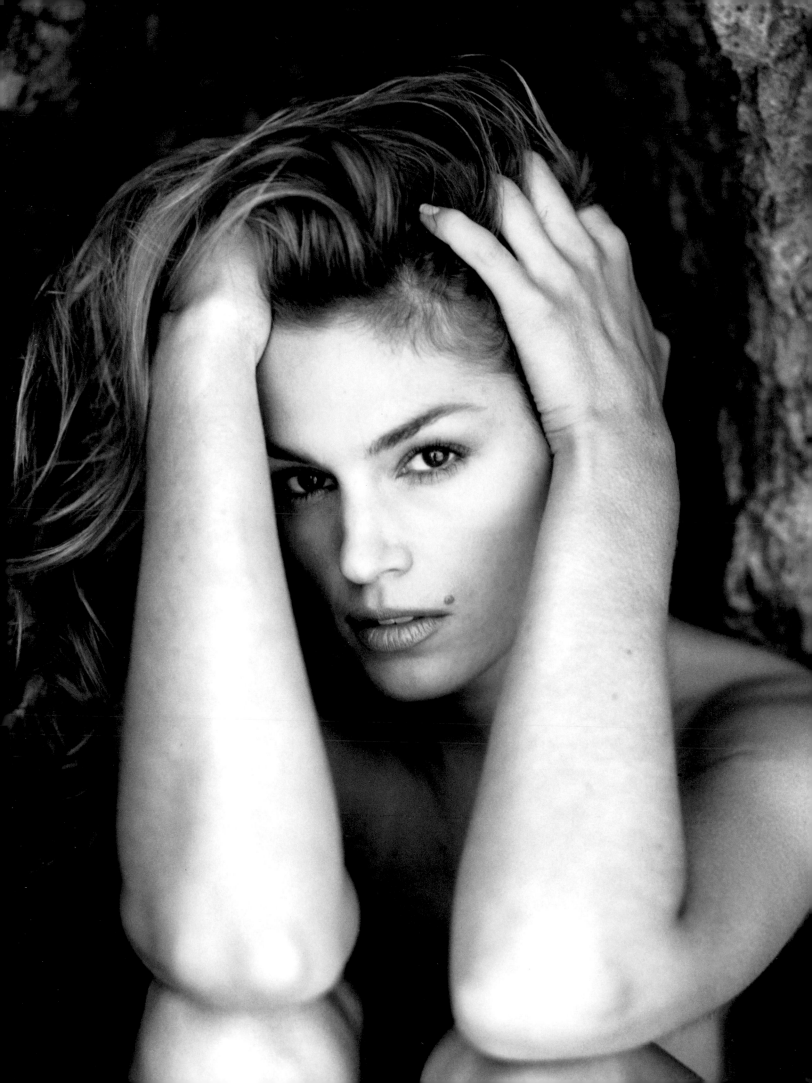

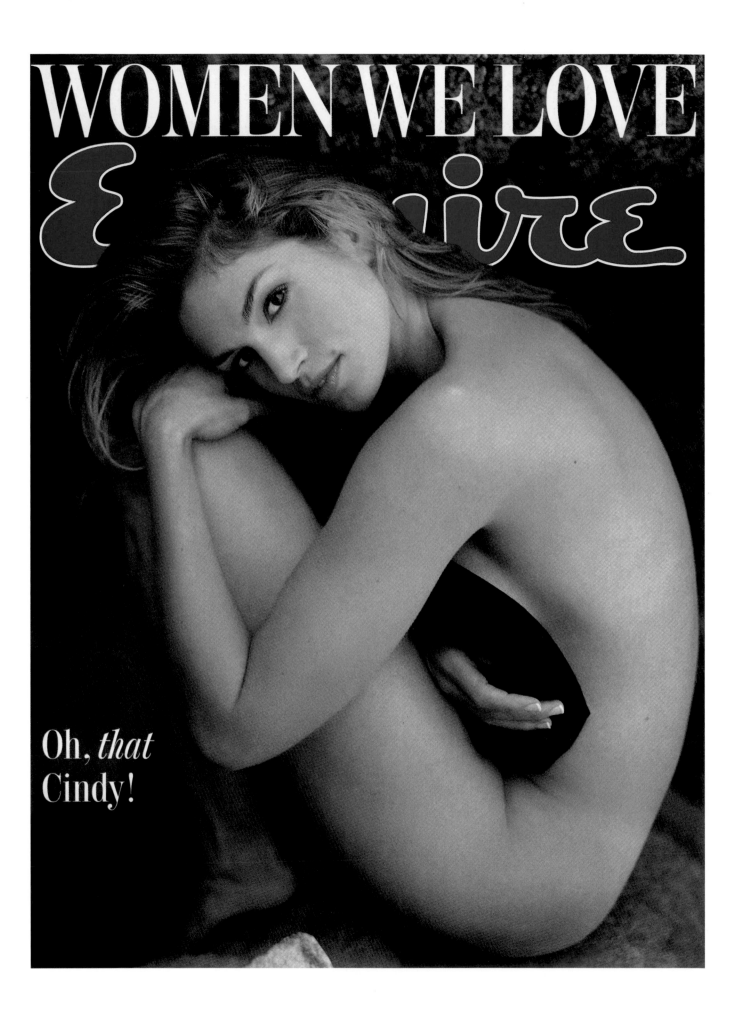

WOMEN WE LOVE

Oh, *that* Cindy!

Sante is part poet and part artist,
and there is a voyeuristic quality
to his photographs.

Photographers don't get much cooler than bad boy Sante D'Orazio. Good-looking and sexy, he would show up on set in a sleeveless leather vest and long black hair, looking like an off-duty rock star who had either just climbed out of bed or hadn't yet been to sleep.

In the early 1990's, Sante was a breath of fresh air in the fashion industry. He photographed women in a raw and sexual way. He took the "glamazon" models of the eighties—overtly sexual and powerful yet somehow untouchable—and brought us down off our pedestals. He shot us the way straight men want to see women, bringing a roll-around-in-bed approachability to our images.

Working with Sante felt different in other ways, as well. Because he was only ten years older than me, Sante was more like a peer than many of the other photographers I'd worked with. And, there was never any doubt about Sante's sexuality. As a result, being in front of his camera felt more charged. In some ways, the heightened atmosphere brought out another side of me, but at other times it made me more self-conscious.

Sante is part poet and part artist, and there is a voyeuristic quality to his photographs. He embraced the idea of raw and real captured moments long before the advent of selfies and Instagram. He is the type of guy who, if he were your boyfriend, would take beautiful and sexy photos of you while you were asleep or just waking up, suggestively wrinkled sheets and all.

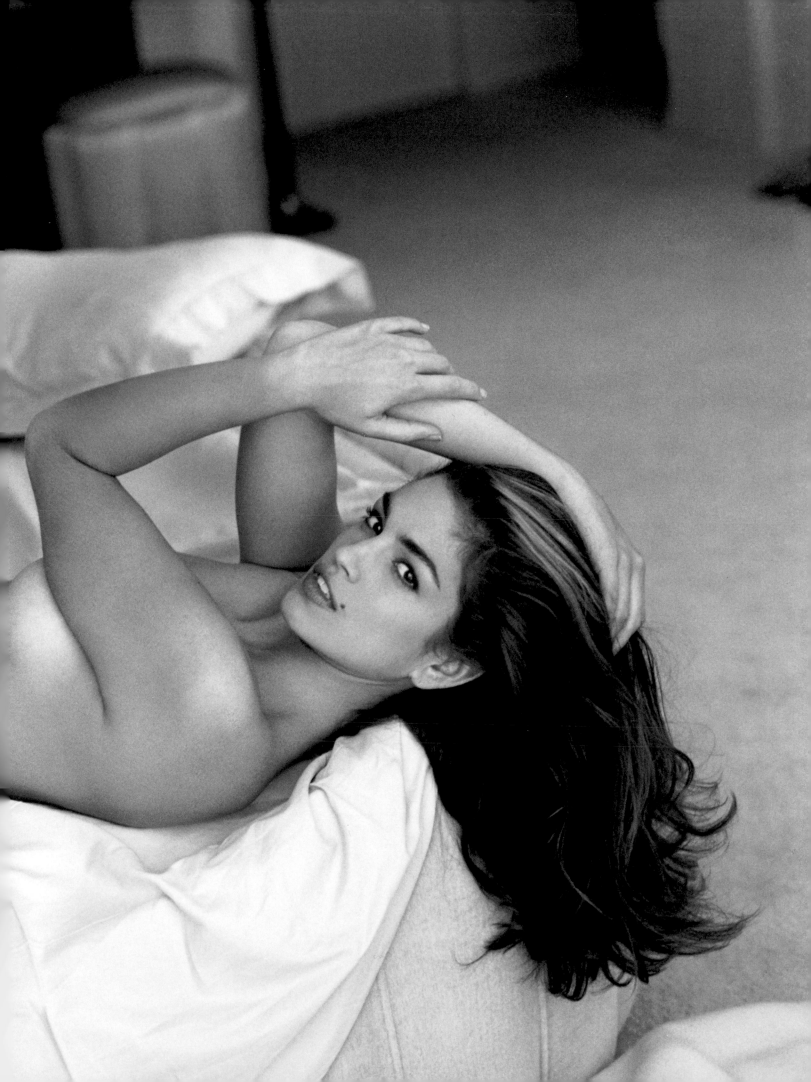

THE FANTASY MAKER

When it came time to choose a photographer to shoot my swimsuit calendars, my first and only choice was **Marco Glaviano**.

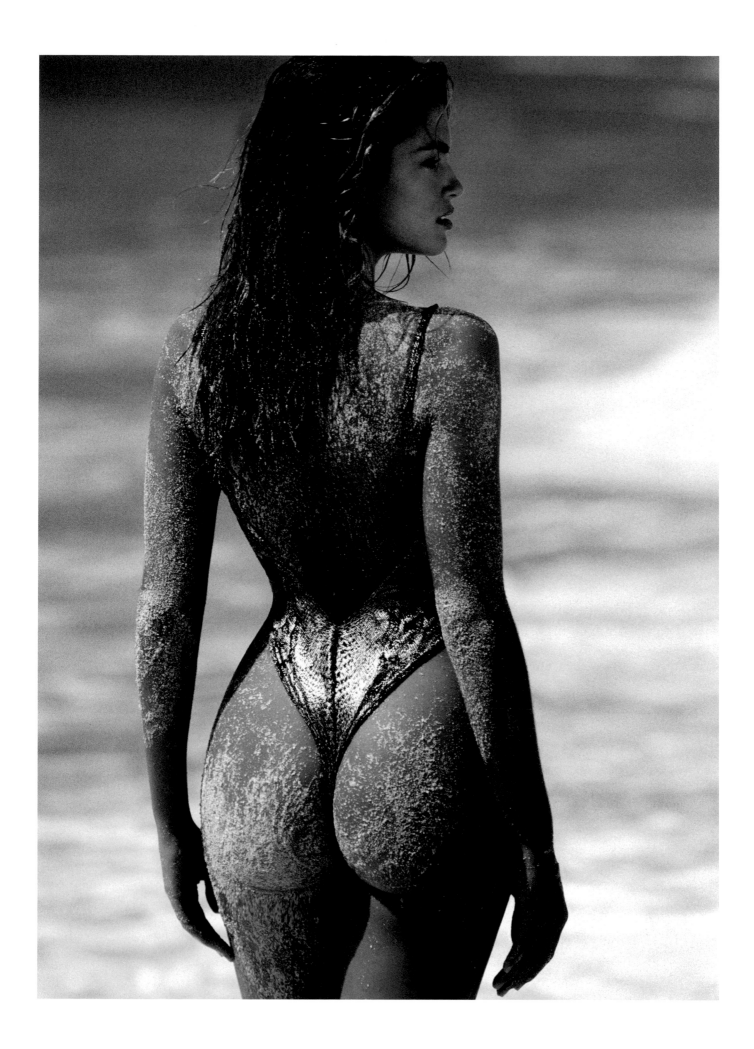

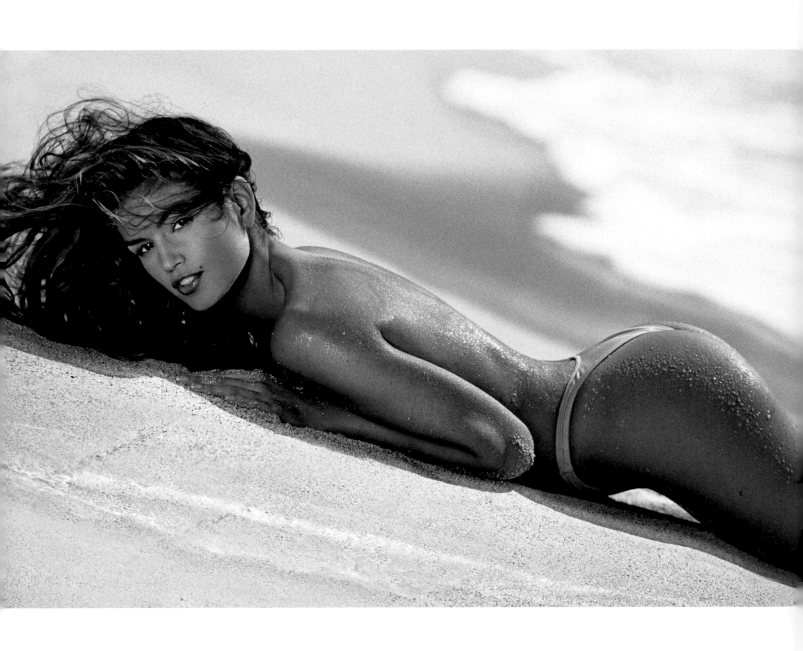

I knew my audience and wanted to deliver something young guys would want to hang on their walls.

When it came time to select a photographer to shoot my swimsuit calendars, my first and only choice was Marco Glaviano. I had worked with Marco several times and I believed that this Italian, with his macho appreciation of the female body, had the right sensibility for the project. I certainly wanted the photos to be beautiful, but I also knew my audience and wanted to deliver something young guys would want to hang on their walls. Marco, who had already shot a few posters of me and many other Elite models, was perfect!

For the first calendar, we headed to Cabo San Lucas in Mexico to shoot on the beach. Marco and I were both new to the challenges of coming up with a shared vision, and we both had strong ideas about how the calendar should look. Sometimes we bickered like siblings. Marco would say things that really offended me, like calling my breasts "titties." I would get furious, but he would just laugh, oblivious to the fact that I didn't take it as a compliment. Perhaps it was a language thing, but we managed to work through our differences and came up with fifteen images we both liked.

I had decided to donate 50% of the proceeds from the calendar sales to the hospital where my brother had been treated years before, so I was happy the project was successful. Being able to raise a meaningful amount of money for the American Family Children's Hospital in Madison, Wisconsin, felt like a great way to honor my brother and marked the beginning of my philanthropic efforts.

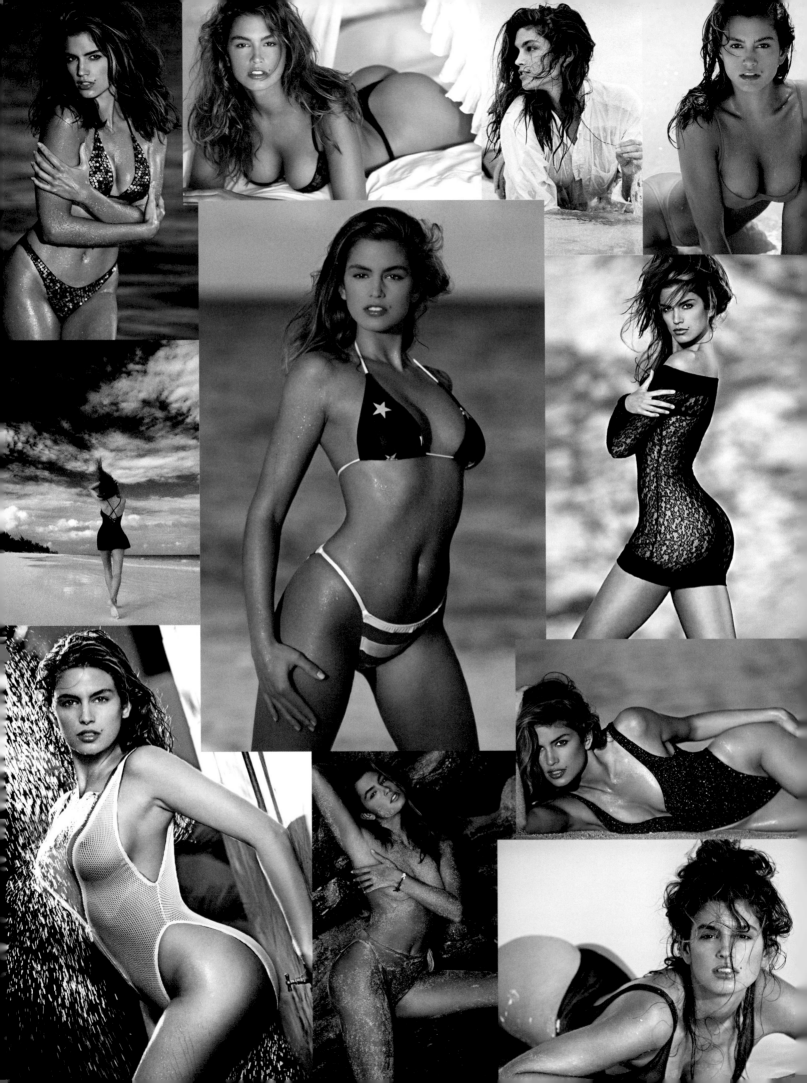

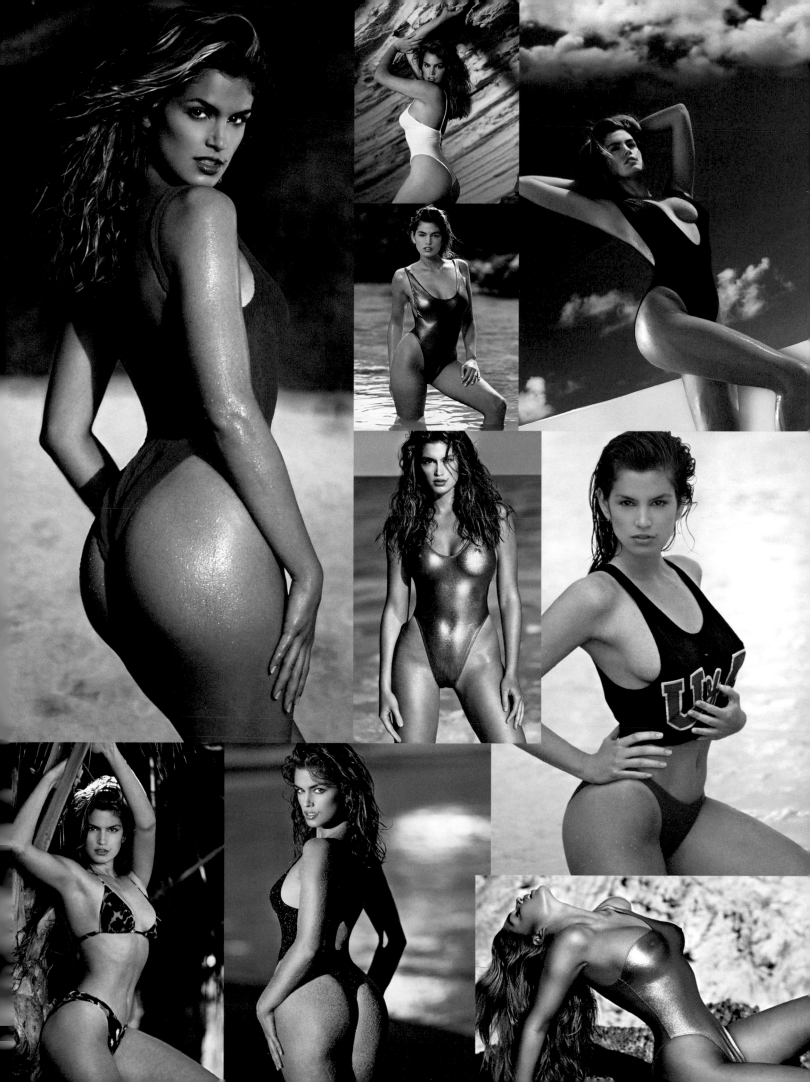

Marco and I went on to shoot three calendars together. Each year we would go to another gorgeous beach—the Bahamas and St. Barths. I will never forget the day we were shooting on Harbour Island in the Bahamas. Everything was going smoothly, and we decided to trek through some vegetation to do a shot of me hanging from a coral tree—very "Jane of the Jungle." After the shot, we were hiking back to the hotel, and Marco caught his foot under a root. He fell, and the next thing we knew, a bone was sticking out of his lower leg!

Harbour Island is idyllic, but it isn't a great place to get seriously injured. There was no hospital—only a little hut where we were able to get him some Tylenol. We called an ambulance plane to come from Miami, but the airport was still a boat ride away. Of course, the waves were choppy that day. Somehow we managed to lift Marco onto the boat, but he was in a lot of pain, and each wave elicited a scream. I decided to play sexy nurse: there I was, in my bikini, leaning over him, holding his hands, singing to him, with my "titties" in his face. If he hadn't been in so much agony, I'm sure he would have even enjoyed it!

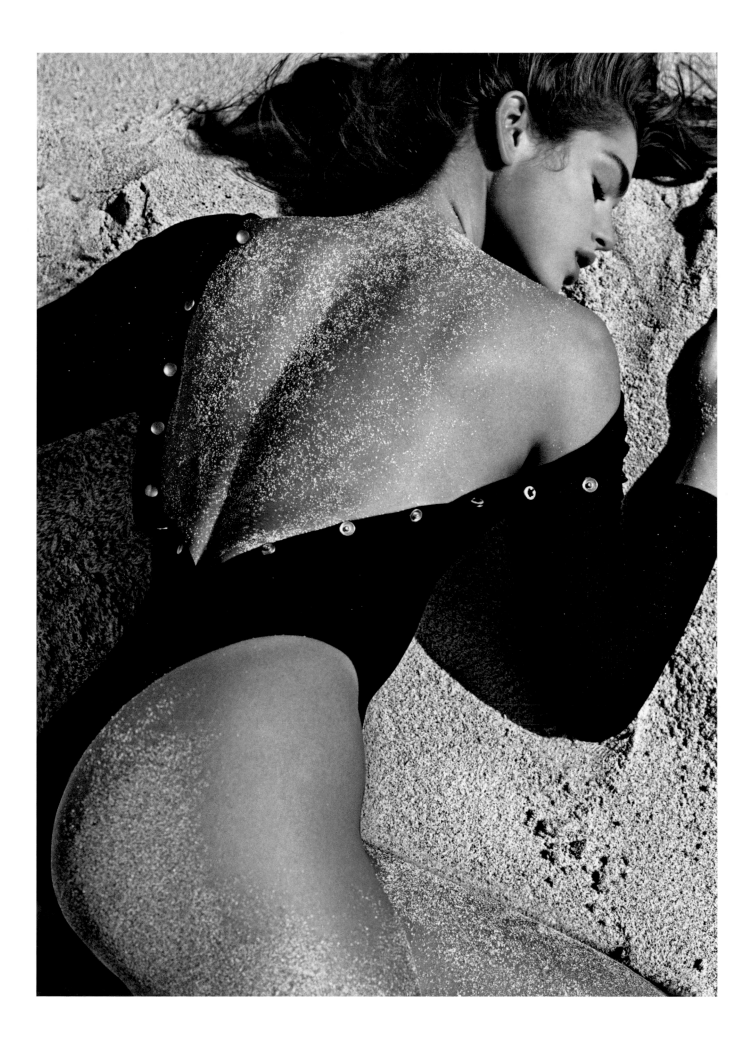

THE PERFECT-IONIST

Steven Meisel is the epitome of a fashion photographer and has the uncanny ability to spot the next big thing and help turn her into a pro.

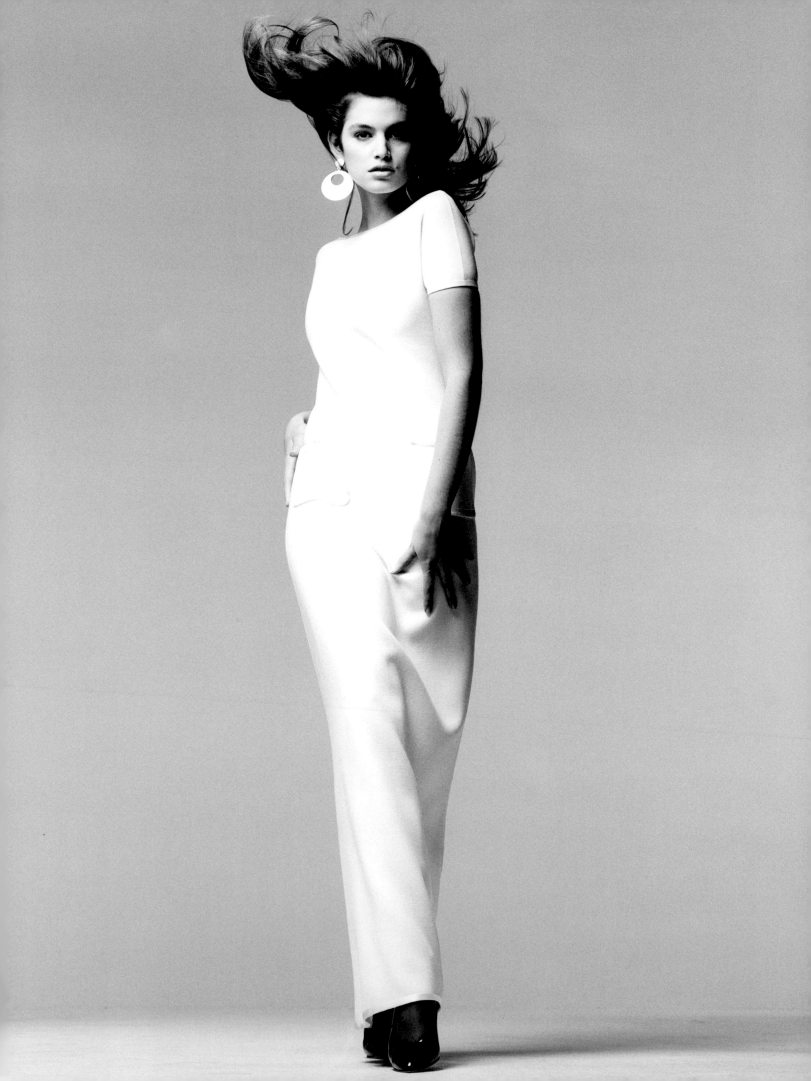

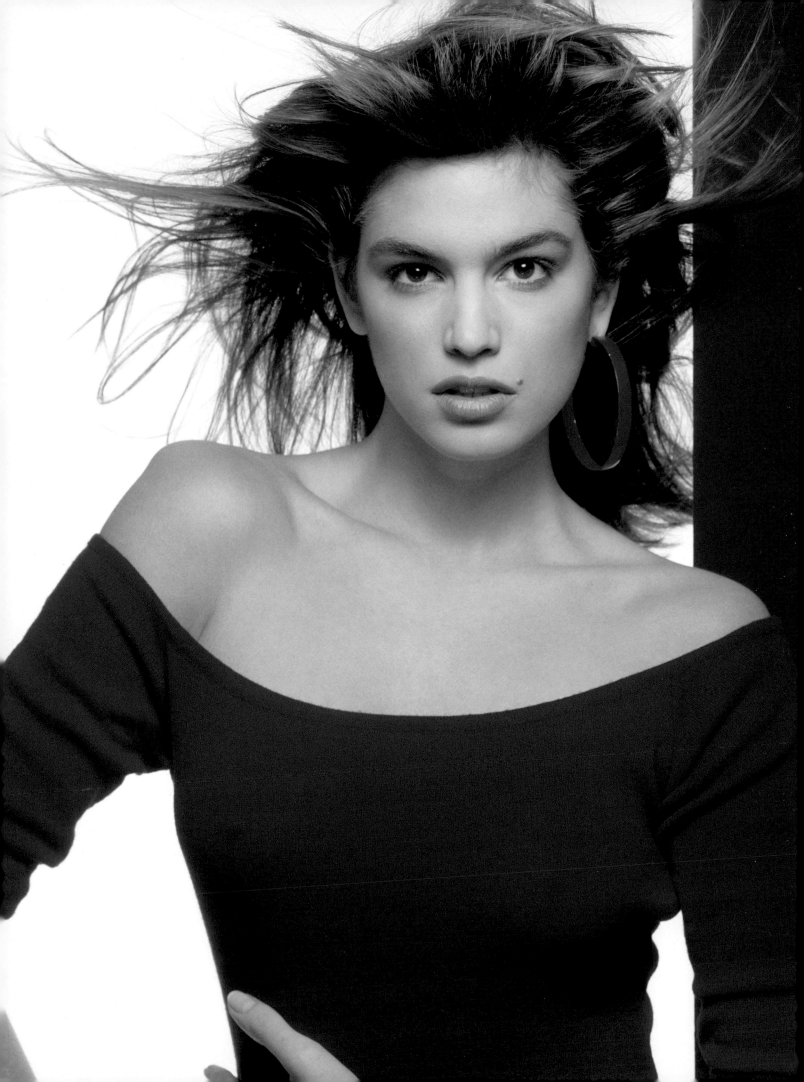

Having started out his career as a fashion illustrator, Steven knows and loves to tell a fashion story.

Underneath his signature hat, Steven Meisel is the epitome of a fashion photographer. Having started out as a fashion illustrator, Steven knows fashion and how to tell a story visually. Before you set foot in his studio, he has done his homework and has a clear vision of what he wants the shoot to look like. Everyone gathers in the makeup room to discuss the look for the day. The team works hard to execute Steven's vision and if you can't deliver what he wants, move over. Steven will take a makeup brush in hand and do it himself.

Before the advent of digital cameras, which enable models to get instant feedback on a monitor, a model would rely primarily on feedback from the photographer in terms of what did or didn't look good in a shot. But Steven would place a huge mirror behind himself and the camera. Even though this was new to me, I loved working this way. With a mirror in front you can instantly see how your movements look. It is a great tool to help sharpen a model's skills. Steven would explain to you exactly how he wanted you to move—how to elongate your neck or take a bigger stride—and you could practice right there in front of your reflection.

Once the shoot was underway, the studio was transformed into a rock concert. Steven would crank the stereo up full blast to the point where you were barely able to hear him shouting directions over the music. Somehow, one song became the soundtrack for that day's shoot and the music worked to amplify your performance. We would listen to that one song over and over again. I remember a shoot for American *Vogue* where the only song we listened to all day long was Janet Jackson's "When I Think of You." Whenever I happen to hear that song even now, more than twenty years later, I am instantly transported to the white seamless "stage" at Steven's studio.

Steven has the uncanny ability to spot the "next big thing" and help turn her into a pro. To this day, Steven is one of the most important photographers a model can work with. Not only does he elevate the quality of a model's work, but once she's been photographed by Steven Meisel, the fashion world takes note. His shoots are smart, original, and fierce, just like him!

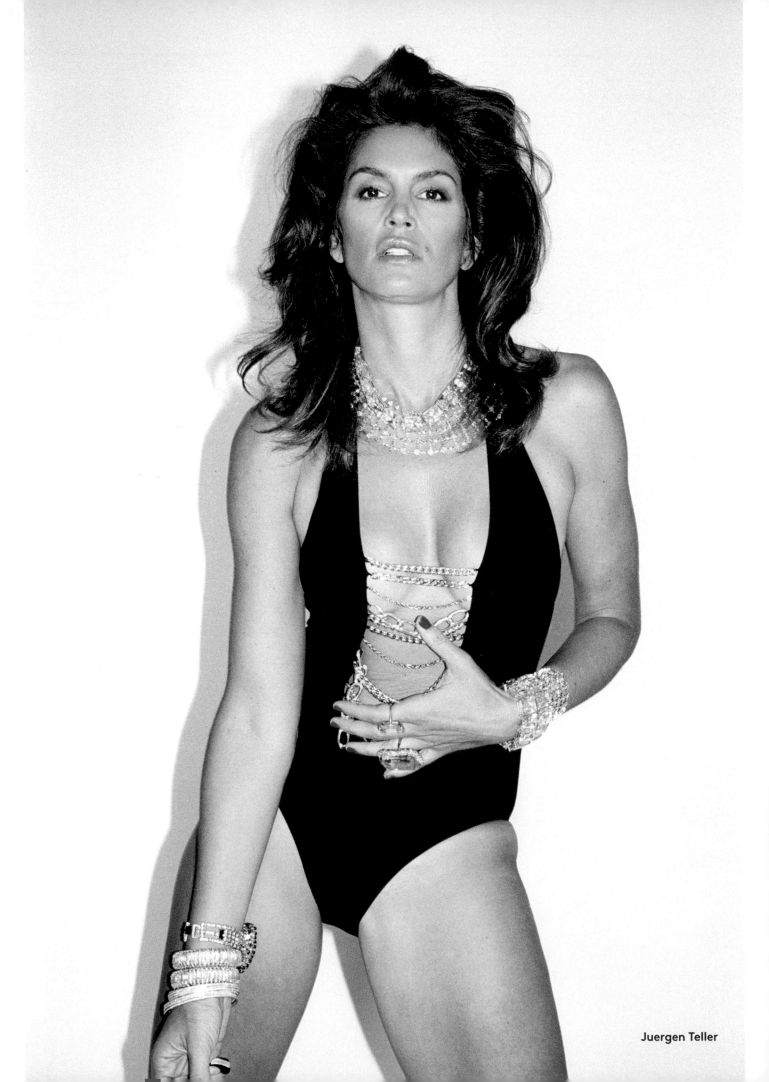

Juergen Teller

THE NEW ESTABLISH-MENT

I think one reason my career has continued for much longer than I ever imagined it would is that I love working with new talent.

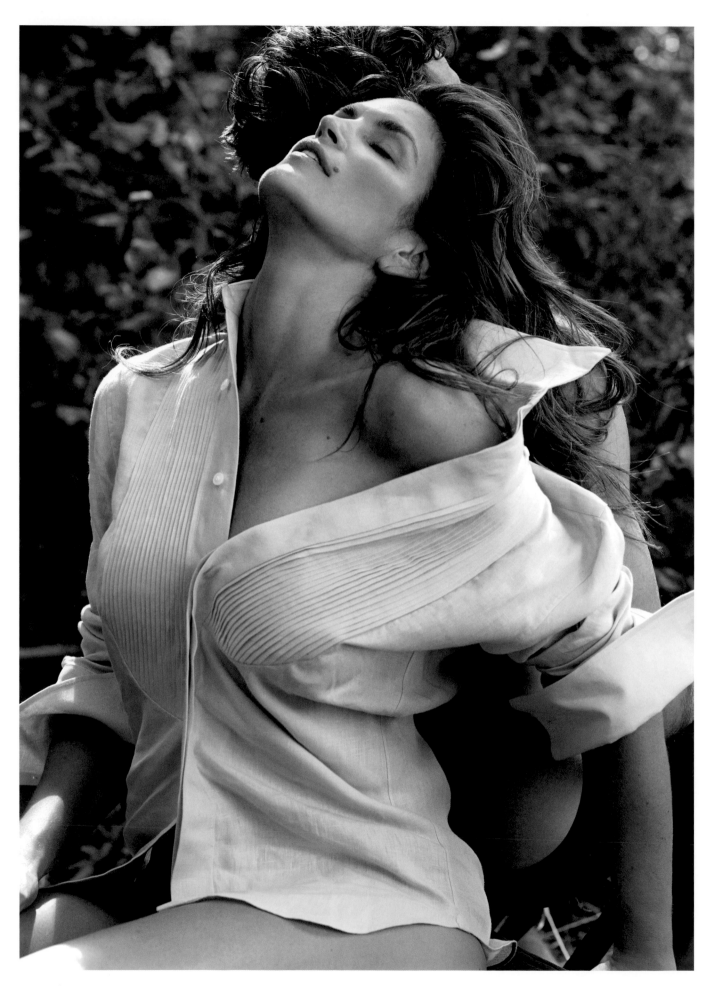

Sebastian Faena

Just when I think I've done
pretty much every type of shoot
imaginable, I will show up on
set and be surprised.

I feel incredibly lucky to have worked with so many legendary fashion photographers. In some ways, it's made me a bit jaded. I'll be on shoots now, and some young whippersnapper will make a reference to something being "so Helmut," and even though I go along with it, in my mind I'm thinking, "not really."

Although it can be tempting to stick with the known and always work with the same people, I think one reason my career has continued much longer than I ever imagined it would is that I also love working with new talent. It's still interesting for me to try to become someone else's vision of me. And just when I think I've done pretty much every type of shoot imaginable, I will show up on set and be surprised. On a recent shoot for *V Magazine* with Brazilian photographer Sebastian Faena, stylist Sarajane Hoare had the idea to shoot me as a kind of tramp in men's clothing. (Did I mention there was also a hot male model tramp?) Forget the push-up bras and five-inch heels. My face was smudged with dirt, and I was wearing baggy trousers and beat-up loafers. For me, it's always fun to try something new and totally original, and I ended up loving the whole story.

Occasionally I'll be working with a photographer for the first time, and they will only want to shoot "Cindy Crawford" with big hair and lots of cleavage. Other times, someone might try a little too hard to make me look nothing like myself. Either way, I'm always game to give it a try and see what comes out of it; I know that one bad shot isn't going to ruin my career.

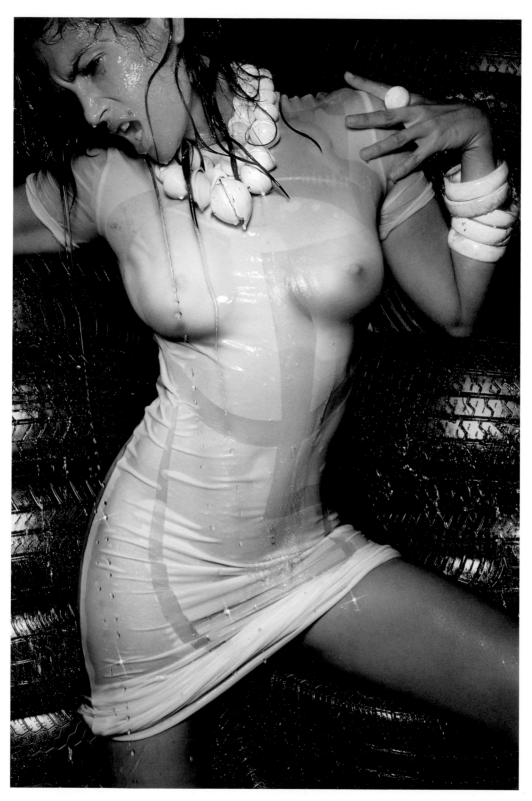

Nick Knight

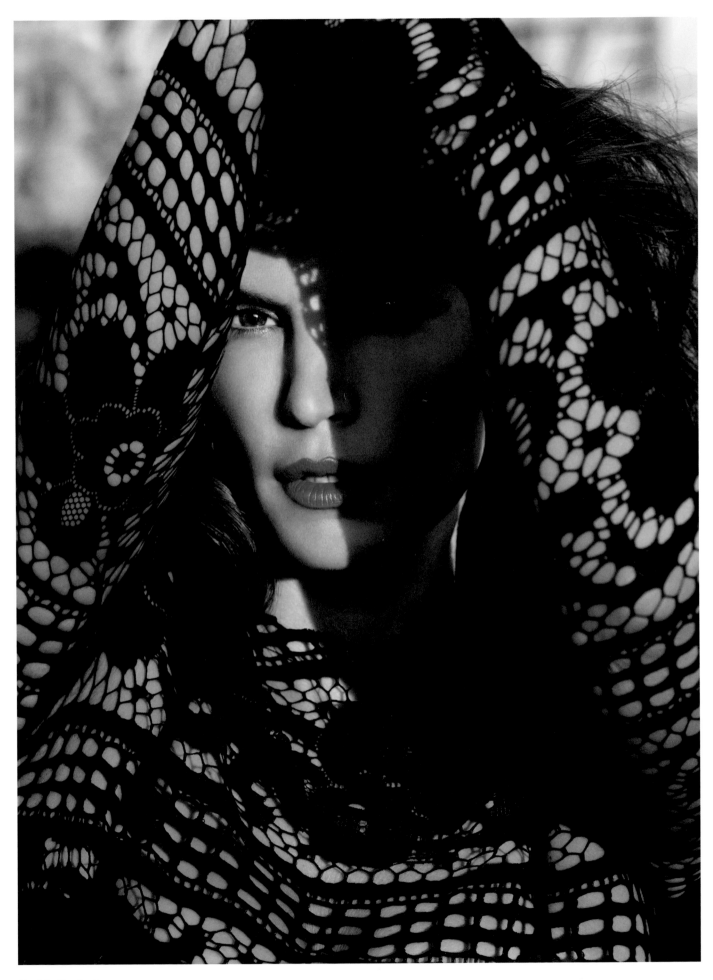

Cedric Buchet

Mikael Jansson

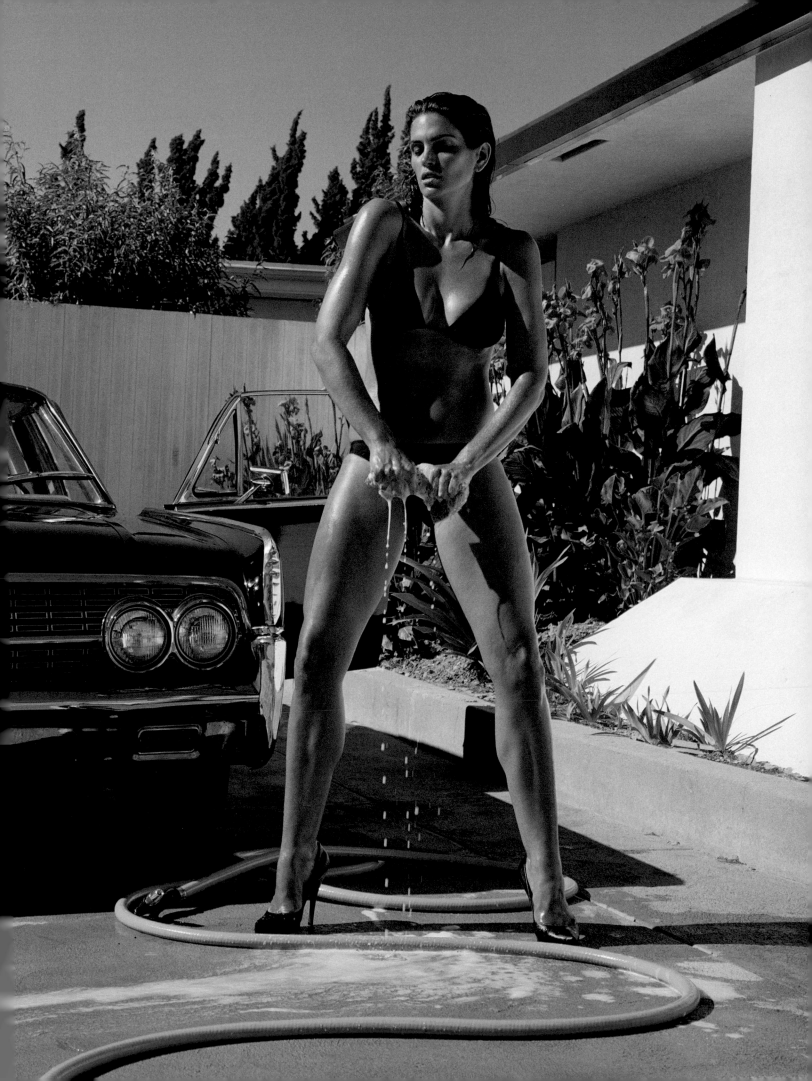

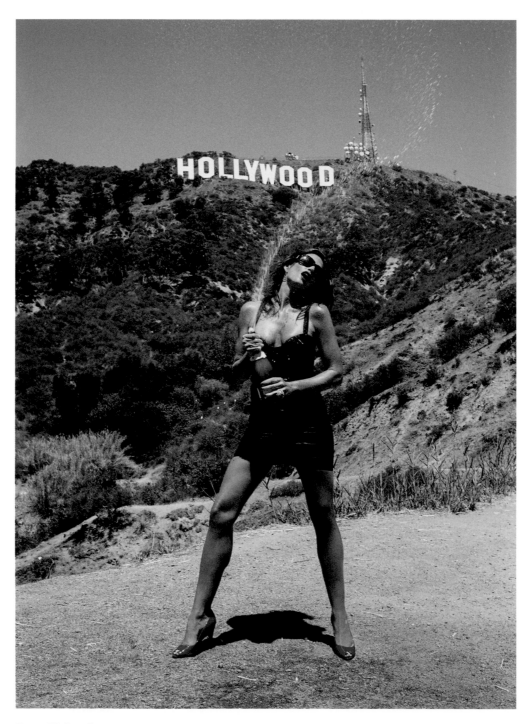

Terry Richardson

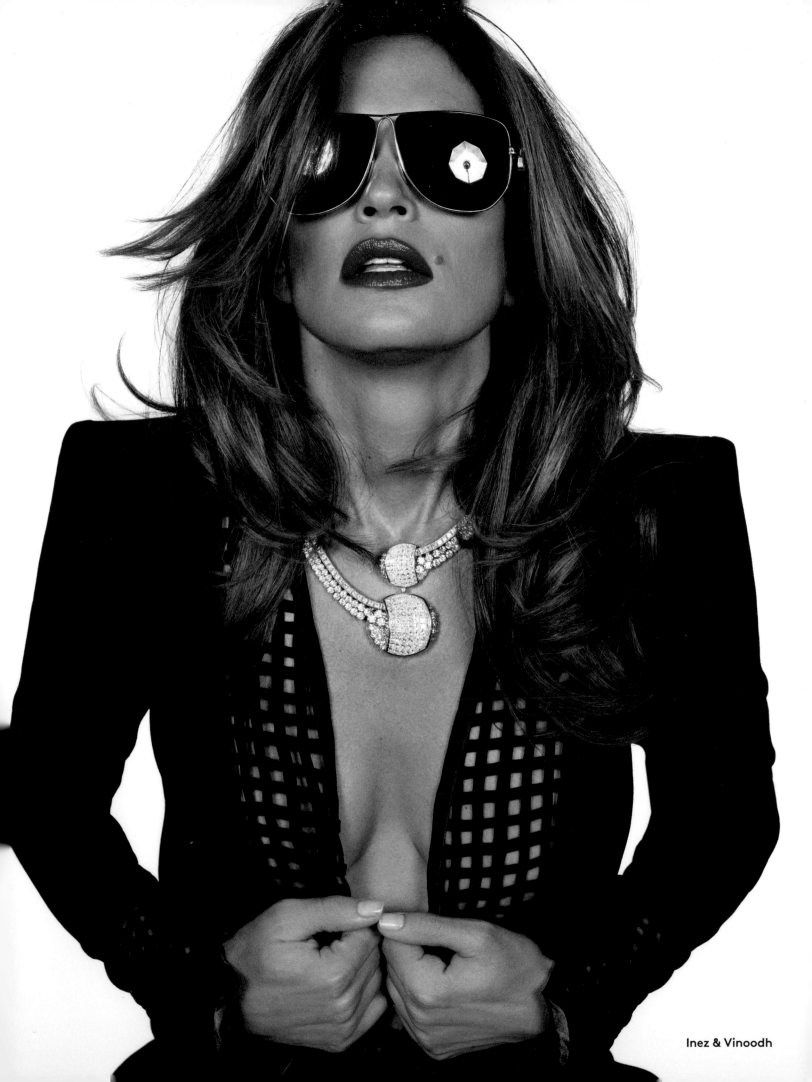

Inez & Vinoodh

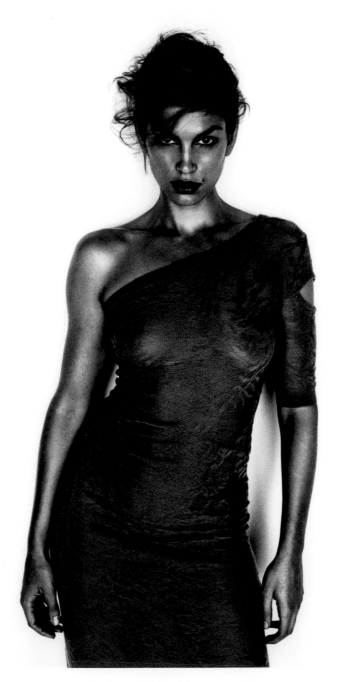

Michael Thompson

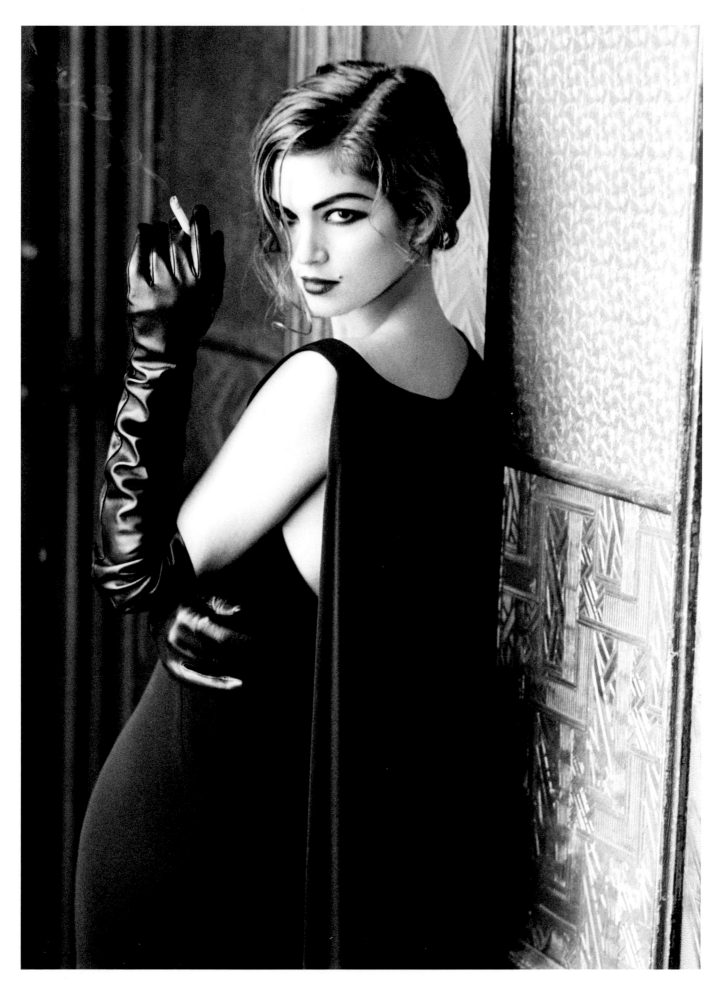

Ellen von Unwerth

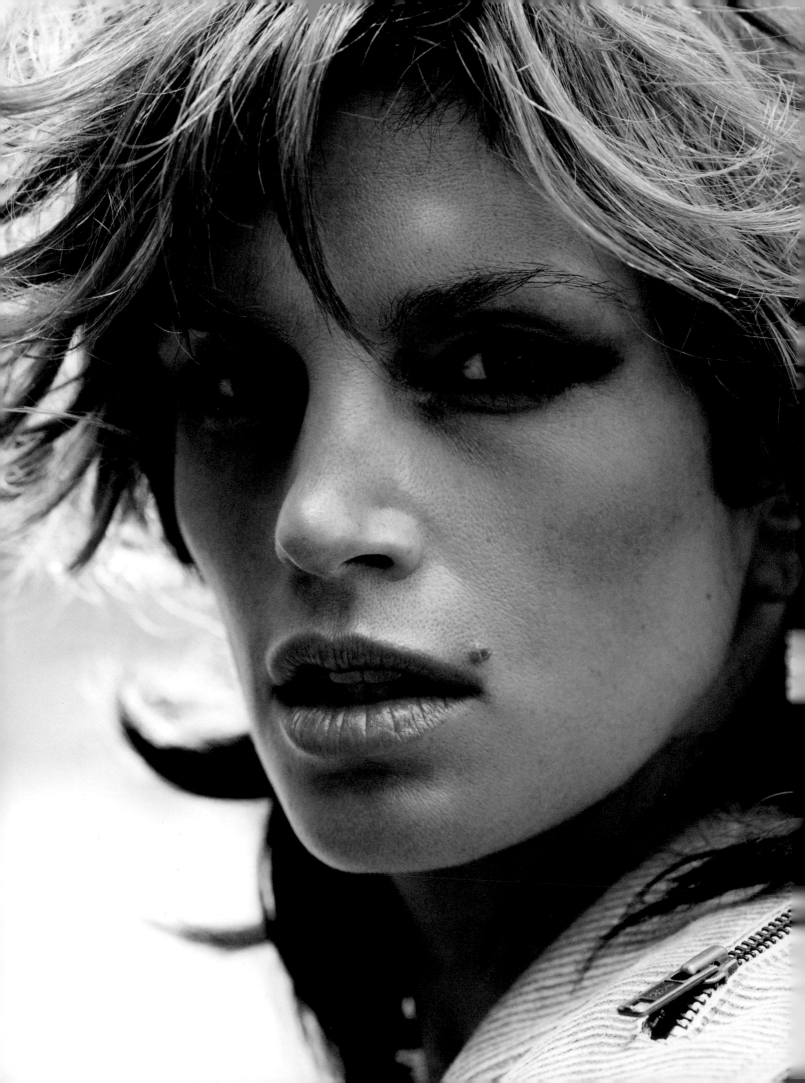

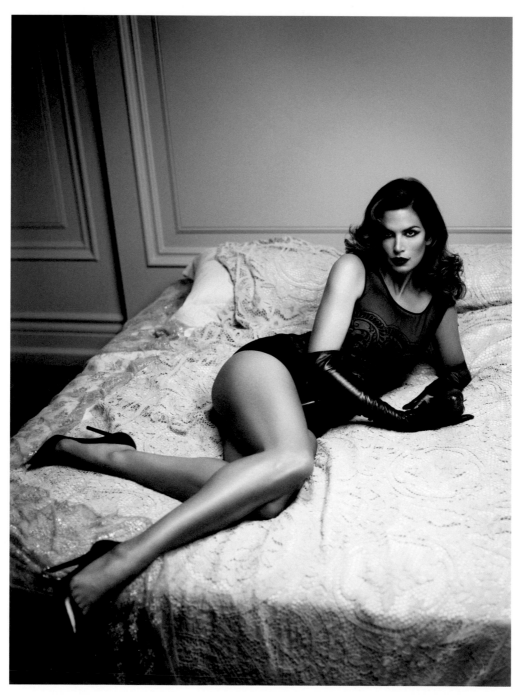

Mert & Marcus

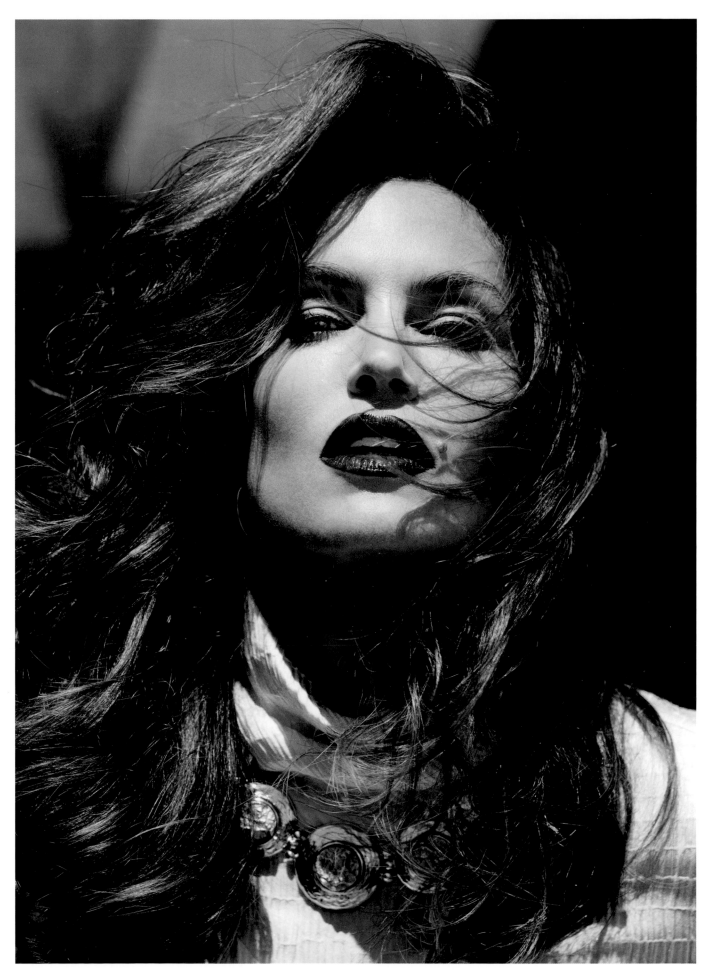

Andrew Macpherson

THE ART OF MODELING

Modeling has allowed me to tap into sides of myself that I never knew existed.

Some models think it's cool to claim that they hate modeling. They act blasé about the whole business, seemingly unimpressed by the rolling racks full of couture clothing and millions of dollars' worth of jewelry. But I love all that and so much more about modeling.

First of all, modeling has allowed me to tap into sides of myself that I never even knew existed. On any given shoot, depending on what the photographer and editor have in mind, I literally get to slip into someone else's shoes and assume another character. It's a place where I have permission to be haughty, coquettish, or demure. And while I always joke that supermodels don't wear capes, there is something Clark Kentish about being completely transformed into some kind of über woman by hair, makeup, and styling. You walk out of the dressing room with an attitude and a swagger.

There is also a lot more to modeling than a pretty face. In fact, some of the prettiest people don't necessarily make good models. Modeling is about being photogenic and also about what you do when you are in front of the camera. At first, it's about the basics—how to stand to make your hips look narrower and your shoulders broader, how to flip your hair just right (easier said than done), how to find the most flattering light, or being able to keep your eyes open while gazing into a setting sun. Good models can look at a Polaroid or the digital screen and figure out how they can make the picture better.

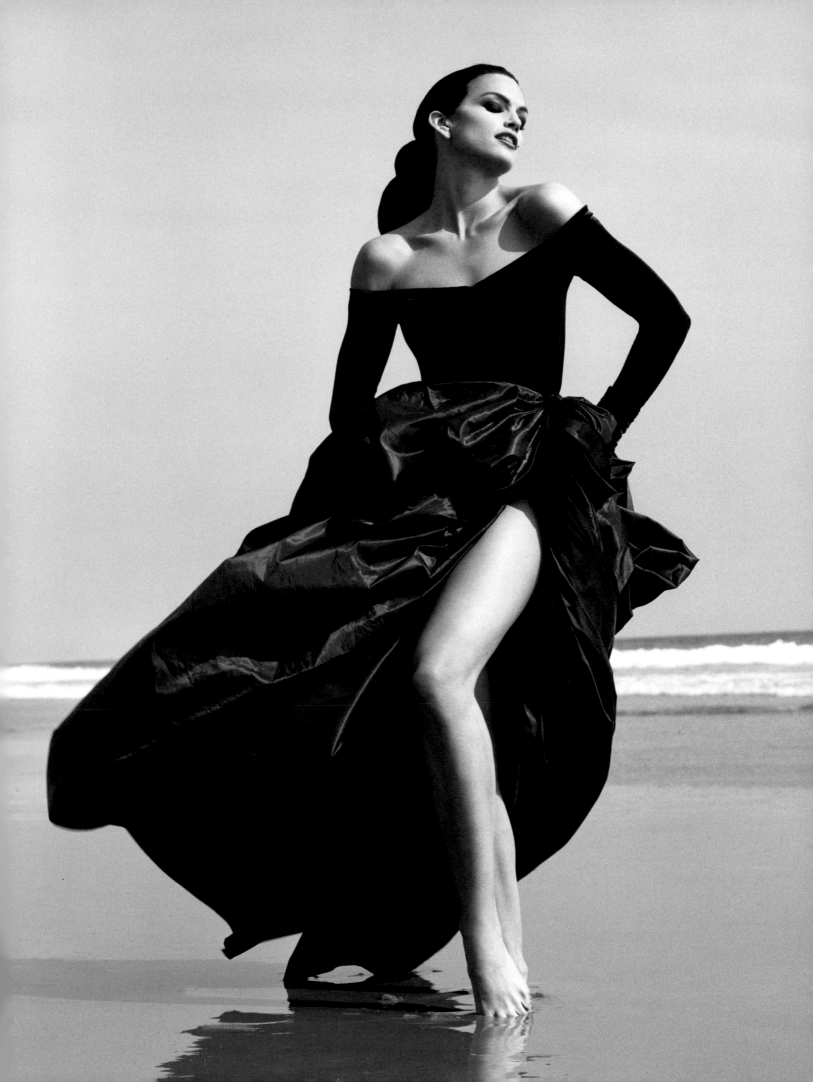

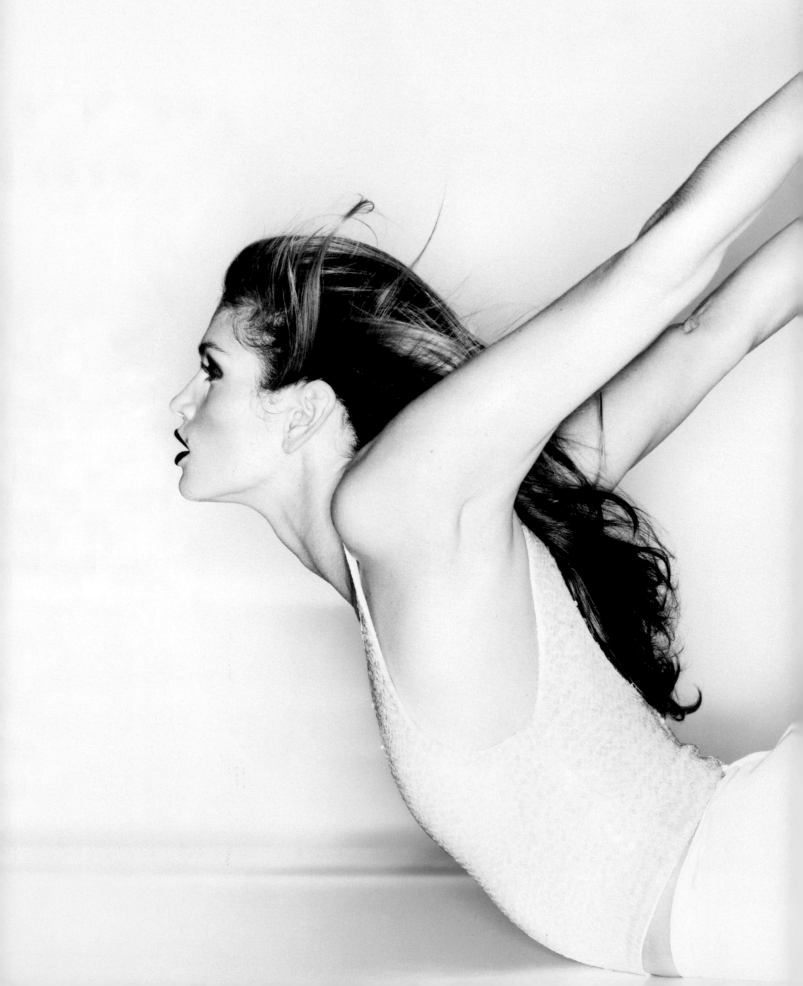

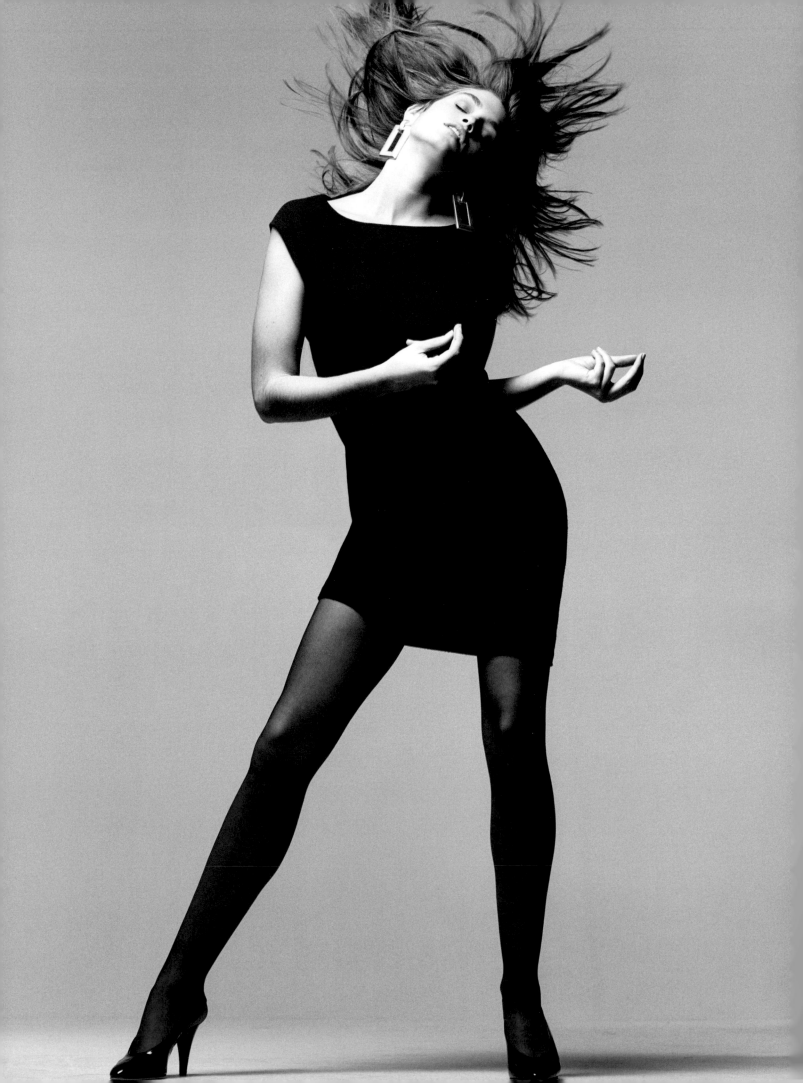

At first, it's about the basics—how to stand to make your hips look narrower and your shoulders broader, or how to flip your hair just right.

Being a good student, I applied myself to modeling the same way I had applied myself to school. As a young model I wouldn't have dreamed of showing up at Avedon or Penn's studios without familiarizing myself with their work and their style. I also paid attention and did my homework so that when the photographer or stylist referenced "film noir" or "Jean Shrimpton," I could speak the same language and know what they wanted from me.

And in modeling, as is the case with most jobs, your skill set improves with practice. You learn how to work your face to its best advantage, and finally how to smile naturally on demand (it took me at least ten years— I think that's why I didn't smile much in photos in the beginning of my career and, thus, perfected my look with my mouth slightly open and teeth showing a bit). With experience you also understand the clothes better and develop an awareness of the page as a two-dimensional medium. You understand that your job is to create a shape to fill the space architecturally. By bending an elbow or throwing your arm over your head, you can help make the eye focus on a certain detail—the tiny waist, the flared skirt, the shoulder pad.

I know that I bring a confidence and a fearlessness to set now that I didn't have when I was younger. However, the great irony of the modeling business is that, like professional athletes, models are considered to be in their prime when they are young and less experienced. I often wish I had known back then all that I know now, but I do feel fortunate that I am still able to put my skills to use. I love it when a photographer will say to me, "They sure don't make 'em like they used to."

AROUND THE WORLD

I've come to realize that the gift of travel is, without question, the best thing about my job.

I always used to say that the endless travel was the worst—and best—thing about being a model. While it is true that too much time away globe-trotting can be exhausting and isolating, I've come to realize that the gift of travel is, without question, the best thing about my job. Growing up in DeKalb, I had only been on an airplane once (to visit my grandma in Florida) before I started modeling. My parents had never been outside the United States. Our big family trip each year was usually to a lake in Minnesota, and while it was a great vacation, it didn't exactly broaden my horizons.

Right after I started modeling in Chicago, while I was still in high school, I got the opportunity to model in Japan for two months. The agency there paid for my flight and put me up in a model apartment. Then, at the end of the two-month gig, they would take their commission and reimbursement, and I would get to keep the rest. My parents took me to O'Hare International Airport, and I boarded the plane by myself. After a twelve-hour flight I landed at Narita International. From there I had to find my way onto a train for the hour-long trip into Tokyo, where I was to meet my agent. Somehow it all worked out—changing money, carrying my bags, and finding my agent, who walked me to a tiny three-bedroom apartment I was to share with two other models. There were futons on the floor and several cockroaches, as well. The mini fridge was filled with spoiled leftovers and not a lot else. What did I care? This taste of freedom felt like heaven.

It was the first time I had not lived under the care of my parents, and everything felt so new. I marveled at the taxi drivers with their white gloves, the bento-box lunches, and the iced-coffee vending machines (way before Starbucks). Just going to the grocery store was an adventure. Somehow, with the kindness of the Japanese people, I learned to get around using the color-coded subway, finding my way to go-sees and bookings. I explored Tokyo's diverse neighborhoods,

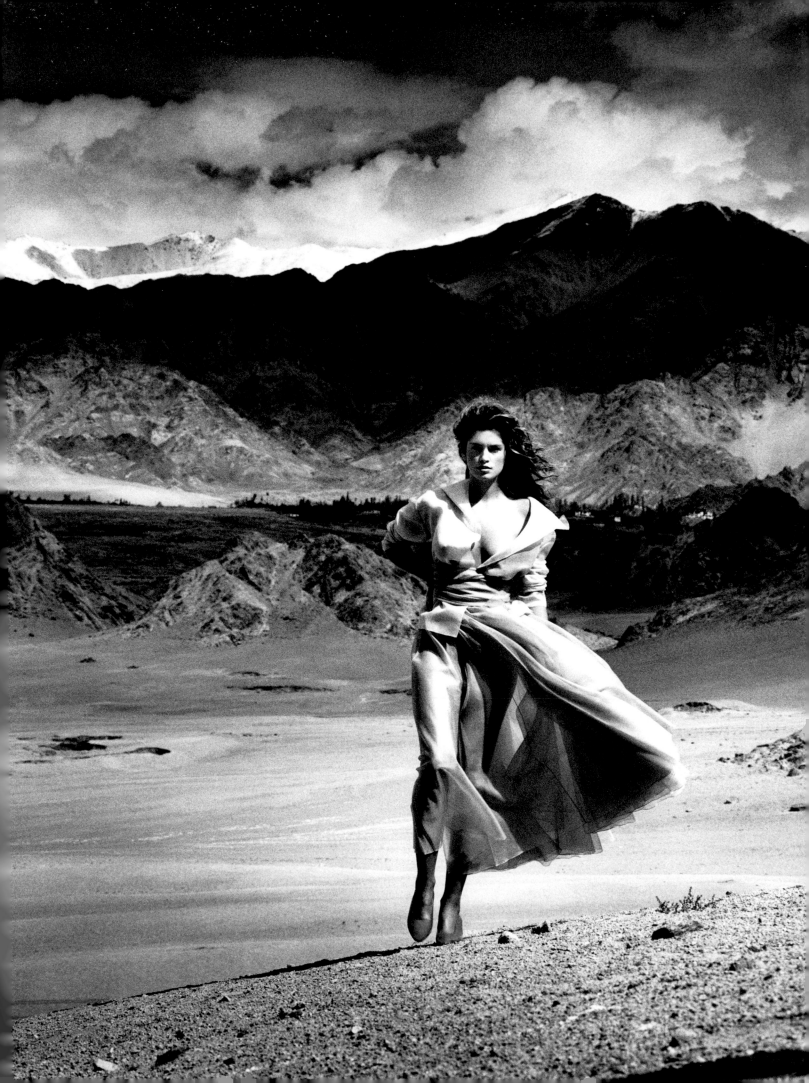

like Roppongi and Harajuku. I even visited Mount Fuji. After two months my curiosity was piqued; I had discovered a larger world beyond the confines of DeKalb and Chicago, and I was eager to see more.

Back then it was normal to shoot editorial stories and advertising campaigns in exotic locations like Mexico and the Caribbean and also places I never even imagined going to, like Bali, Senegal, China, and India. The agency would messenger over an itinerary and an airplane ticket. I'd throw a few bikinis and a black Alaïa dress into a duffel bag, and off I'd go. I saw a Hindu funeral procession in Bali and went to Kensington Palace to meet Princess Diana. With each trip, I saw a little more. I learned about art and architecture, food and fashion. I had a fling with an Italian, danced all night at a Parisian nightclub, and swam topless on countless beaches. When I started traveling, I was a young girl from a small town— until, all of a sudden, I wasn't. Traveling was the ultimate finishing school. And the greatest lesson for me was that, even though there are so many distinct cultures, in the end we as humans have more in common than we have differences.

On those first few trips I would try to capture every moment with my own camera; I didn't want to forget what I was seeing. Eventually, though, I put my camera down and learned to be fully present in each experience. Instead of a snapshot, I wanted to take a picture with my mind, to retain an imprint of all the colors and smells and tastes and feelings. Some places were so vast and beautiful that they seemed somehow diminished by the camera's lens. The foothills of the Himalayas in Ladakh was one of those places. In 1986 I was booked by British *Vogue* to do a trip to the very north of India with Patrick Demarchelier. Just getting

there was an adventure—planes, trains, and automobiles. We ended up at a small camp where we stayed in yurts—round tents with wooden floors and no running water; a Sherpa brought each of us a bowl of hot water every morning for our bath. Everywhere you looked were breathtaking views. The air was pure and thin and the mountains so huge, they seemed to loom over each vista with their snowcapped peaks. I had never been so surrounded and overwhelmed by natural beauty before. How would I ever describe this to my folks back home?

I am eternally grateful to have been given the opportunity to see the world through so many different photographers' lenses. The longer I've been in the business, the more conscientious I am about making time for some cultural experience on each trip. I've found if I don't make that a priority, far too many times I would never see much more than my hotel room and the set. By exploring other countries and cultures, I feel much richer as a person and, also, much humbler.

Just a few months before finishing this book, I had the opportunity to take one of those trips of a lifetime in my role as brand ambassador for Omega Watches. I have been a spokesperson for Omega for more than twenty years and been on many incredible trips with their team, but this one was special even by their standards. Not only did I get to visit Peru, I would also be participating in a documentary about Orbis International, a nonprofit organization committed to improving eye care around the world. I was able to share the experience with my thirteen-year-old daughter, Kaia. Together we visited the ancient site of Machu Picchu and saw the beauty and wisdom of that lost culture. Even more important, we spent time with local children before and after their sight-giving surgeries. Every moment with those Peruvian children reminded us how blessed we are. Being able to see your life in relationship to the much larger world is the true gift of travel.

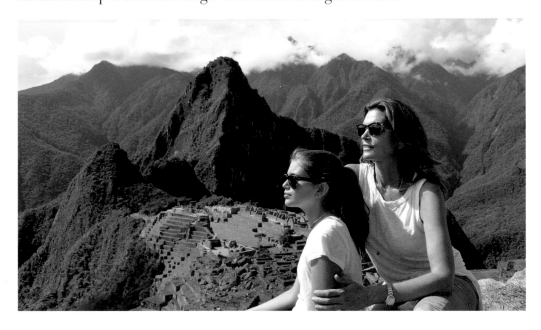

THE SUPERMODELS

The worlds of music and fashion collided in that single
moment to create a unique alchemy—and one plus one
all of a sudden seemed to equal a thousand.

T here's a lot of debate about when and where the term supermodel
was coined. For me, these two photo shoots were the catalyst; they
started a chain of events in the early 1990s that led to a group of models
transcending the world of fashion and becoming household names.

Several of us had been running around together doing the same shows,
going to the same parties, and hanging out at the same restaurants. Photographers
and designers started to pair us up more and more on the runway and in photo
shoots, but only in groups of two or three. In the spring of 1989 Herb Ritts gathered
Stephanie Seymour, Naomi Campbell, Tatjana Patitz, and me together for a
Rolling Stone shoot. He photographed us curled up naked together on the deck of
his house in the Hollywood Hills. He also asked Christy Turlington to come by to
join us for lunch, then convinced her to jump in at the last minute for his personal
portfolio. Christy was prohibited from being part of the shoot because of her
Calvin Klein contract, but Herb somehow had the foresight to include her, anyway.
The iconic image that includes all five of us, "the naked supermodel twister," wasn't
shown in public until 1996.

® **VOGUE**

JAN
£2·20

THE 1990s
WHAT NEXT?
COLLECTIONS
THE NEW DECADE'S NEW SHAPING
PRINCE IN PICTURES
ENTER THE VOGUE AWARDS

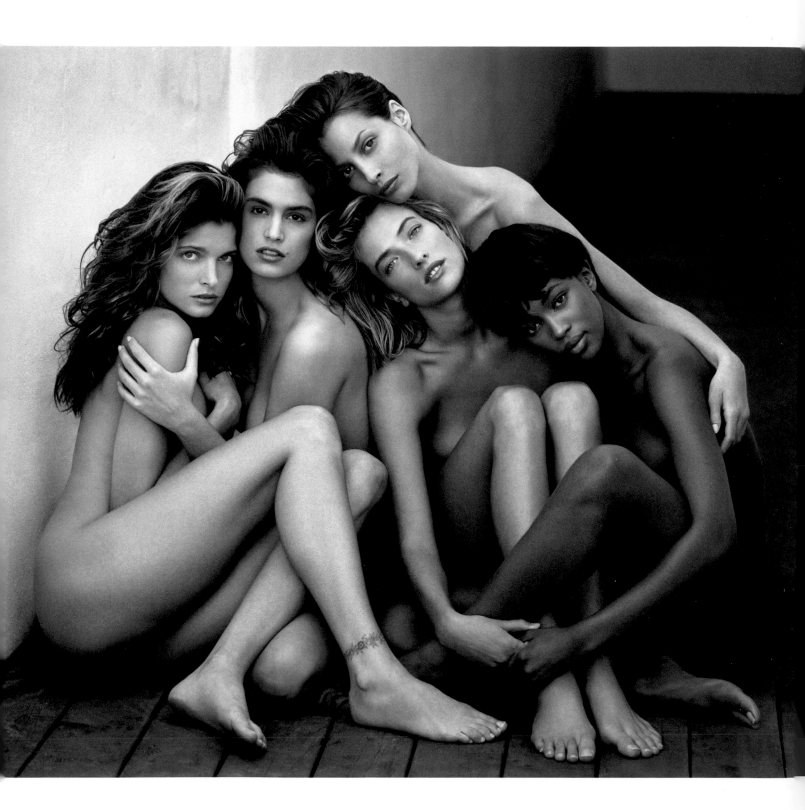

Herb photographed us all
curled up naked together
on the deck of his house in
the Hollywood Hills.

A few months after Herb's shoot, Liz Tilberis asked Peter Lindbergh to shoot the January 1990 cover of British *Vogue*. She wanted him to portray the image of a "new woman for the coming decade." Peter thought this would be impossible to accomplish with just one face. Instead, he proposed using a group of models. We shot outdoors in Tribeca on a terribly hot summer day in 1989. Peter's gentle nature and calm disposition was probably the only thing that made this shoot with so many personalities go smoothly. But, then again, we weren't divas yet!

When the issue hit the stands, there was a lot of excitement. Beside the fact that the cover was a group of girls, each with her unique look, Peter's choice to have very little makeup and natural hair gave it a fresh, modern feel. George Michael saw the cover and specifically requested the same girls for a new music video he was shooting. He insisted on all of us. David Fincher was on board as the director. I was already in Europe for work when they sent me a Walkman and a cassette tape to listen to the song, "Freedom! '90" so I could memorize the words by the time I got to the set. I flew to London with my headphones on. The way the days were scheduled, each model arrived at a different time so we all shot our scenes separately. They'd worked out each girl's part in advance so we never saw what everyone else was doing, or how it would all come together.

When I first saw the finished video, I remember being slightly disappointed, feeling like my part was the least glamorous. All the other women looked so gorgeous—Naomi strutting her stuff in a tight leopard dress, Tatjana looking so cool with a cigarette—while I was stuck in a bathtub and then with a towel on my head. At the time I wasn't able to see what everyone else saw. People loved it; the video became a huge hit and played nonstop on MTV.

Not long after the "Freedom!" video was released, Gianni Versace booked Naomi, Christy, Linda, and me for his runway show in Milan. The show closed with "Freedom!" blasting as the four of us came skipping down the runway holding hands and lip-syncing the lyrics. George Michael had recognized a moment in fashion and transformed it into a lasting pop-culture image. Versace reclaimed it for fashion by putting it on his runway. The worlds of music and fashion collided in that single moment to create a unique alchemy—and one plus one suddenly seemed to equal a thousand (or, as Linda Evangelista might have put it, 10,000).

I always think of these images as the day the supermodels were conceived and the Versace show as the day they were born!

All the other women looked so gorgeous— Naomi strutting her stuff in a tight leopard dress and Tatjana looking so cool with a cigarette— while I was stuck in a bathtub and then with a towel on my head.

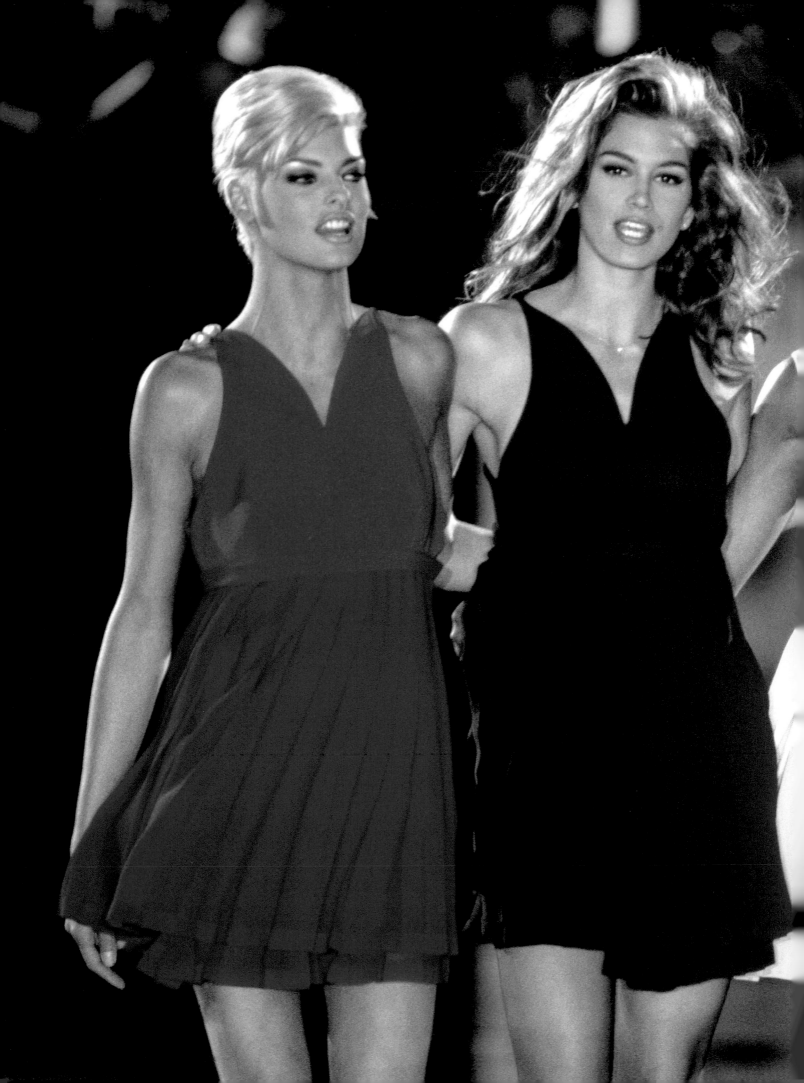

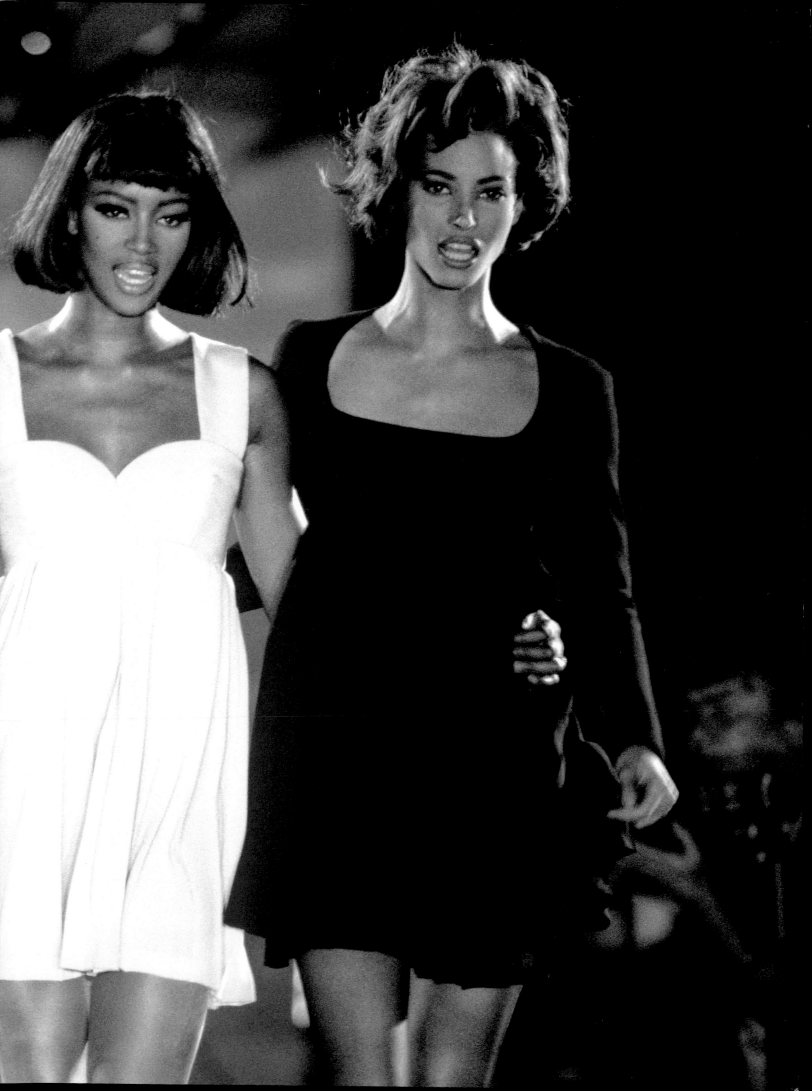

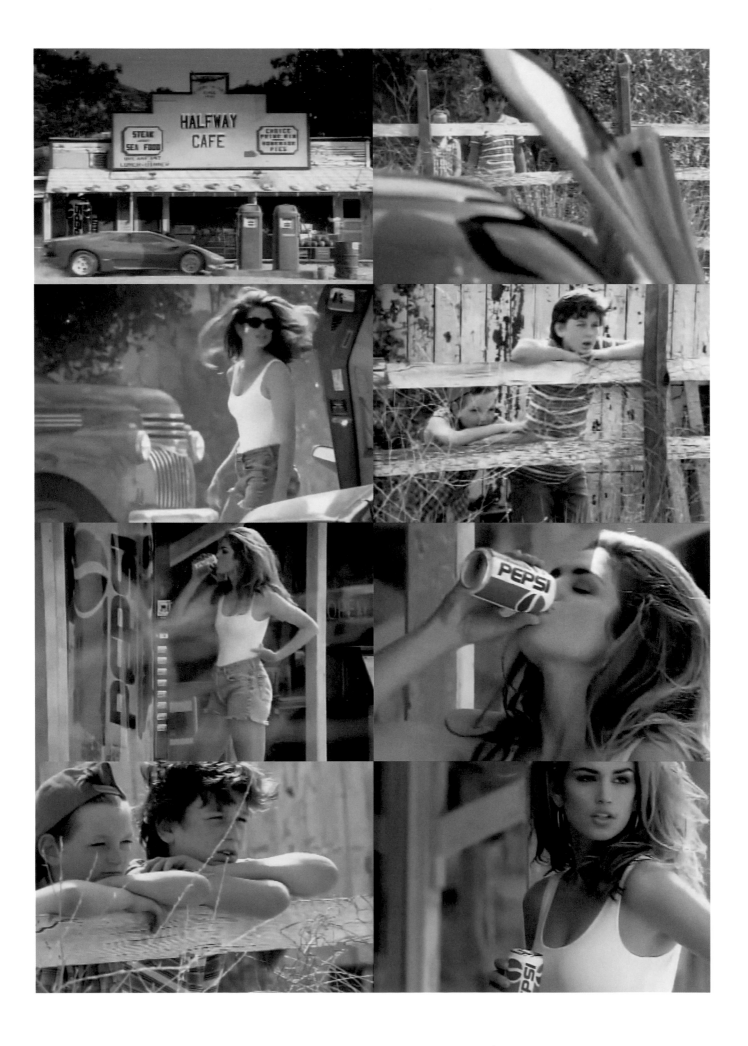

JUST ONE LOOK

The Pepsi commercial was all it took to cement my image
as the sexy all-American girl next door.

All I can say about my first Pepsi commercial in 1991 is that it was the perfect combination of the right concept, the right music, and the right pair of cut-offs. We shot at an old abandoned gas station in the desert outside of Los Angeles, with Joe Pytka directing. I'd never worked with Joe before, so I had no idea that even though it might take him forever to set up the shot, once they started shooting things moved quickly. If you hit your mark and didn't screw up your lines, you might only get one take!

It didn't feel so special at the time, but when I finally watched it during the Super Bowl, I realized we had an instant classic. That commercial was all it took to cement my image as the sexy all-American girl next door. I love the fact that it still gets airtime around the big game and is included in the best Super Bowl commercials of all time.

Fifteen years later, we recreated that spot for Diet Pepsi. The concept was how some things never change—I wore the same shorts and once again there were two adorable little boys hanging on a fence checking me out—but some things do. This time instead of a red Lamborghini I was driving an SUV with my two children in the back.

Over the years, I have enjoyed my long-term associations with several companies, Pepsi included. What makes these relationships last is the ability to acknowledge how I have evolved. The new Diet Pepsi commercial was a playful nod to the original spot, with a wink to the fact that I was now a mother. I still have those cutoffs tucked in the back of a drawer somewhere in my closet. Who knows? Maybe Kaia could wear them in her own Pepsi commercial someday!

BEING GEORGE

I've realized that often it's not the most beautiful pictures that stick in people's minds and become the most iconic.

I can't remember exactly how the *George* cover happened, but I'm pretty sure Herb Ritts gave me a heads-up that John F. Kennedy Jr. was going to call me to talk about being on the cover of a new magazine he was launching.

I had first met John at the twenty-first-birthday party my friend Mark Bozek hosted for me at B. Smith's in New York. At the time, John was on Page 6 every other day—riding his bike around Manhattan, dating so-and-so, or taking the bar exam. He was New York's most eligible bachelor, and I was excited to meet him.

Nothing much came of that first meeting, and when I ran into him at other parties and functions, he was always a perfect gentleman. Nonetheless, I was curious to hear what he had to say. I couldn't help but be flattered that he asked me to be on the cover of his debut issue. Herb was set to be the photographer. All the pieces were falling into place except one tiny thing—the concept. Since the magazine was called *George* and covered politics and pop culture, John and Herb wanted me to dress as George Washington—wig and all! How was I going to look sexy in that? Now, if anyone could pull this off, it would be Herb, but I still had my reservations.

On the day of the shoot, I drove to Smashbox Studios in Culver City, Los Angeles. Herb's talented team had definitely gotten the memo. Carol Shaw did beautiful, if slightly powdered makeup. Peter Savic had created an amazing wig that was a dead ringer for the George Washington I saw on one-dollar bills. Stylist Kate Harrington had gone to a costume house to find an authentic Revolutionary War outfit and then had it tailored. The pants fit like a glove, and she even stuffed the

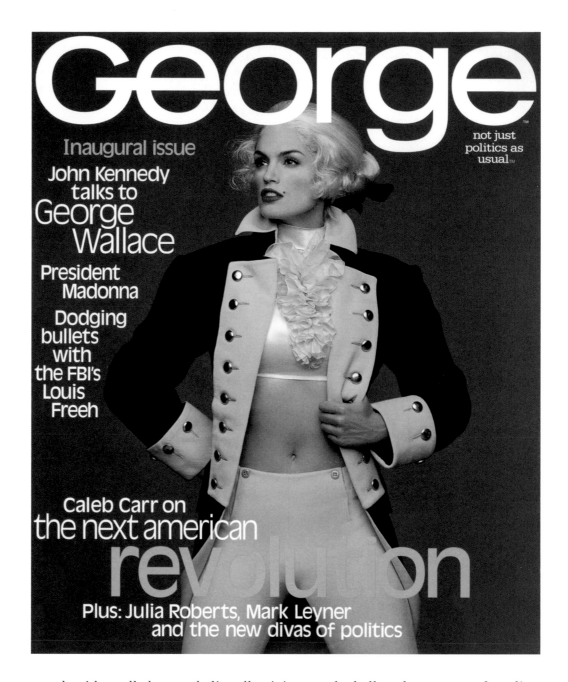

crotch with a rolled-up sock, literally giving me the balls to become our founding father. But her genius, and the thing that really makes this picture work, was her decision to crop the shirt to show my bare midriff. It introduced sexuality to what could have become a camp and predictable image.

I've realized that often it's not the most beautiful pictures that stick in people's minds and become the most iconic. Do I think this is the prettiest picture of me? No. But Herb's ability to turn me into a modern, sexy George Washington, one that helped create the prototype for John F. Kennedy Jr.'s magazine, caught the imagination of the country. I'll never forget how proud John looked that day as he spun around the cover of his passion project and said, "Ladies and gentlemen, meet George." I have to admit, I was pretty proud, too.

THE POWER OF AN IMAGE

As a model, I don't take pictures at face value, but this image was so provocative that people wanted to believe I was making a statement.

I love this image, and there's not one thing I would change about it. However, the experience of shooting it taught me an invaluable lesson.

In the summer of 1993, I received a phone call from Herb Ritts, who in addition to being a great photographer was also a very good friend. He asked if I was free the next day to come to the studio and "be an extra" for a *Vanity Fair* cover he was shooting of k.d. lang. I would do anything for Herb. I was also a fan of k.d.'s and thought it sounded like fun. I showed up the next morning without a publicist or any of the other planning that would normally go into a cover shoot for *Vanity Fair*. It was k.d.'s cover, not mine. I was basically a prop.

k.d. had recently come out, and Herb had come up with a clever idea to challenge gender stereotypes. I didn't think twice when the stylist handed me a black bathing suit and some high-heeled boots—Herb told me to straddle a barber's chair and pretend to shave k.d. That's when she blushed. We were shooting on the roof of Herb's Hollywood studio, and k.d. was singing along to her new CD between rolls, a private concert. It was playful and kitsch, and we were all in on the joke.

Three months later, when the issue hit the newsstand, I was surprised that some people didn't seem to get the joke. k.d. was very open about her sexuality, and somehow people thought that my being in the photo was saying something about my sexuality. For me, this shoot wasn't any different from one where I'd kiss some

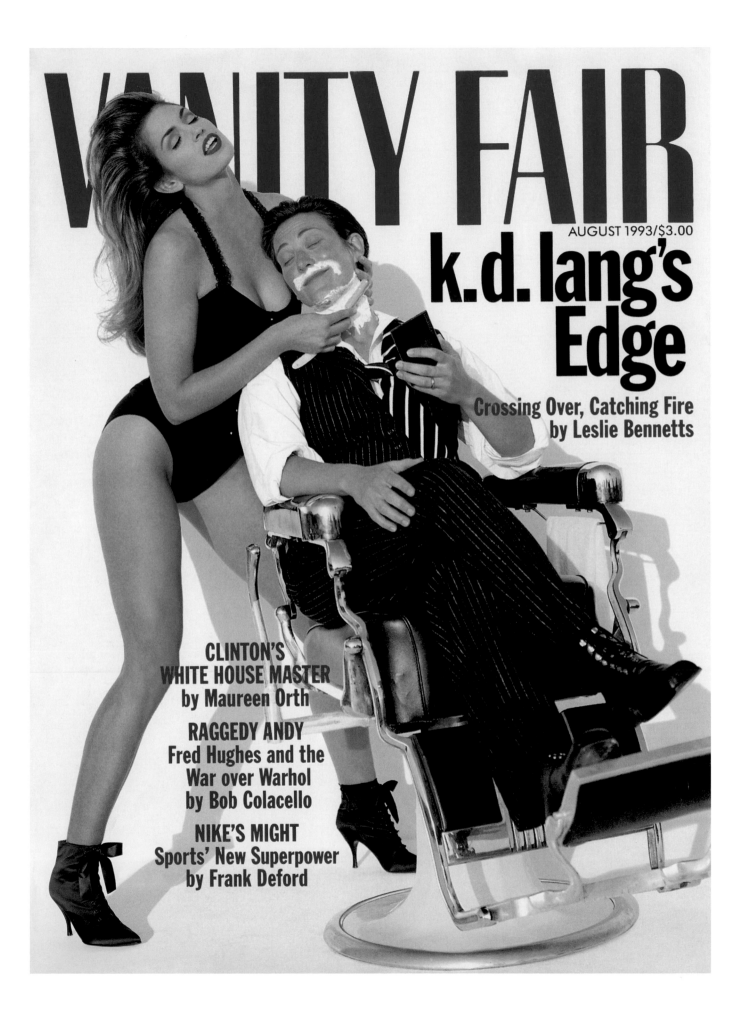

VANITY FAIR

AUGUST 1993/$3.00

k.d. lang's Edge

Crossing Over, Catching Fire
by Leslie Bennetts

**CLINTON'S
WHITE HOUSE MASTER
by Maureen Orth**

**RAGGEDY ANDY
Fred Hughes and the
War over Warhol
by Bob Colacello**

**NIKE'S MIGHT
Sports' New Superpower
by Frank Deford**

hot male model I'd just met on set, or sit in a Jacuzzi wearing a million dollars' worth of jewelry. If Herb had taken the exact same photo of me shaving Jack Nicholson, I doubt anyone would have read anything further into it. As a model, I don't take pictures at face value, but this image was so provocative that people wanted to believe I was making a statement.

I smile when I think about Herb and k.d. and the message they were sending, upending people's perceptions of sexuality. Right or wrong, people make assumptions based on what they see. Knowing what I know now, I absolutely still would have said yes to this shoot. However, I would be more aware that people won't always differentiate between Cindy Crawford the model and Cindy Crawford the woman.

THE DIGITAL REVOLUTION

Nothing has changed the experience for me as a model more than the shift to digital photography.

It might come as a surprise to learn that the experience of being a model in front of a camera is very different depending on what kind of camera the photographer is using. The slow and precise pace of an 8x10 is vastly different than the control of a Mamiya, which, in turn, has very little in common with the spontaneity of a handheld Leica. But nothing has changed the experience for me as a model more than the shift from film to digital photography.

I had seldom considered how much of modeling is a performance. After two hours of preparing hair and makeup, I would arrive on set, and the show would begin. The photographer's lens was focused on me, and so was everyone else. The assistant would be moving the lights and checking the exposure. The hair and makeup people would be standing by to rush in at a moment's notice. The stylist was jumping in and out of frame to smooth a wrinkle or adjust a sleeve. And, of course, the photographer himself would be giving directions and egging me on with praises such as "Beautiful!" and "Yes, that's perfect." The more love I would feel from my "audience," the more I was able to turn it on. It really felt like we were all part of the show.

Then in the late 1990s, everyone started shifting to digital cameras. Even the hardware involved in digital photography is different. Now, in addition to the camera, there is also a large monitor wired to it. Not only does this make the equipment less portable, it also requires more technicians. Back in the day, a

As a model I've learned to use these digital advances to my advantage. After the first few frames, I'll check the monitor to see how I can make the picture better.

normal-size crew was six to seven people—model, photographer, photographer's assistant, hairdresser, makeup artist, stylist, and stylist's assistant. Now, suddenly, the crew has grown by at least two or three people. Often, as a model, I have very little interaction with the digital team, and I miss the sense of intimacy we had as a smaller crew.

The biggest change, however, comes with where everyone's attention is focused. These days you are most likely to find the team hovering around the monitor. Sometimes I will be the only one on the set, and I get lonely! I miss the energy coming from the sidelines.

The other thing that's challenging about the digital process is that everyone is constantly critiquing the image on the screen. And while there are a lot of good things about being able to see and manipulate an image instantly, it can also interrupt the rhythm of the model and the photographer on the set. Once upon a time the photographer would shoot a couple of Polaroids to make sure everyone (the client) was happy. Then we all had to trust the photographer and what he was seeing and capturing with his camera. When he said, "OK, I think we got it," we stopped. Now the entire team—sometimes even the caterer or a random delivery person—is looking at the screen, commenting as we go. It can make me very self-conscious when I hear a lot of whispering by the monitor. Also, for a model, not every pose or angle is perfect. But sometimes, in order to get to that next great pose, you may make certain moves that don't look great. Those bad shots used to end up in the trash. But with digital photography, the team has less tolerance for even one bad frame. If something doesn't look good, the photographer will stop me, possibly missing out on something weirdly beautiful and unexpected that might have happened next.

I don't want to sound old-fashioned, because there are certainly many great advantages to digital photography. For one thing, it speeds up the whole process. And seeing the image clearly gives everyone the confidence to move on quickly once we do get it. I also find it amazing that you can zoom into anything you want to look at more closely. This is useful for checking makeup and other details. As a model, I've learned to use these digital advances to my advantage. After the first few frames, I'll check the monitor myself to see how I can make the picture better.

Digital technology has also brought retouching to a new level. In many ways, it has become its own art form. While retouching used to be expensive and time-consuming, now anyone with access to Photoshop can instantly wipe away a blemish, carve off a few pounds, and even stretch images to make people look taller. While the newfound ease of digital retouching invites abuse, and I agree that it is often overused, it serves an artistic function. Being able to tweak and enhance an image helps create the illusion and fantasy. In the end, that's what fashion is all about, right?

BODY IMAGE

I was never one of those girls who could eat
whatever I wanted and not gain weight.

I never had a typical model's figure. Even back when I was starting out, and models were allowed to be a healthy and athletic size six, I was still on the voluptuous side. It's a testament to so many of the photographers I worked with that, instead of making me feel self-conscious or telling me I should lose weight, they gave me confidence in my body by showing me how beautiful it was. Sadly, it often takes others to make us see the beauty in ourselves.

Growing up, I was super skinny. The kids at school nicknamed me Daddy Longlegs. Being skinny wasn't "in." I wanted to be like the girls who got their periods and boobs in seventh grade. They had hips, cleavage, and every boy's attention. I was a late bloomer, and it took me a while to catch up.

By the time I started modeling when I was still in high school, I was five-nine and a half and weighed about 125 pounds. Over the next few years I filled out, gaining another five pounds. But it wasn't until I got to New York and started modeling, wearing real designer clothes and samples, that I had a hard time fitting into some things. I could usually get into the runway samples, but often the leg was tight or the waist pinched.

I had never dieted and knew little about nutrition. I grew up on meat and potatoes with the occasional Twinkie thrown in for good measure. Before I moved to New York, I had never had a bagel, but bagels and cream cheese seemed to be on the breakfast buffet at every shoot. I discovered I liked bagels, and I thought pasta was a healthy choice for dinner. I believed I was being good not eating the bread that comes before dinner and having only a salad and a big bowl of pasta. I also had never really worked out, unless you count phys ed, and I'm not sure you could count the phys ed at DeKalb High School. One semester I had bowling! You gotta love the Midwest.

Pretty quickly I figured out that if I wanted to fit into the clothes to do my job, I was going to have to go about things differently. I started working out with Radu, a famous fitness trainer who at the time was working with fashion darlings such as Calvin Klein and Bianca Jagger. Every evening after work I would schlep up to his small studio on Fifty-Seventh Street, and he would unleash his Romanian training techniques on me. I have never been in such good shape in my life. To this day, the workouts I do are rooted in what I learned from Radu. I still work out with a trainer three times a week in addition to the occasional hike or bike ride on the weekend. Having a toned body is great, but the biggest gift Radu gave me was a sense of empowerment. He taught me that physical strength translated into feeling emotionally strong, as well.

I also started learning about food and about taking care of my body. Unfortunately, I was never one of those girls who could eat whatever I wanted and not gain weight (damn you, Kate Moss!). I experimented with different diets over the years—low-fat, low-carb, fruit only before lunch, vegetarian, and high-protein. Of course, as soon as I told myself I wasn't going to eat any sugar, bread, or whatever, all I could think about was sugar, bread, or whatever! I have finally settled somewhere around the idea of being 80% good, 80% of the time. For me, that's doable. Will I ever be rail thin? No. And sometimes I wish I were. Certain types of clothes do look better on that type of body.

Having a toned body is great, but the biggest gift Radu gave me was a sense of empowerment. He taught me that physical strength translated into feeling emotionally strong, as well.

On those days when I am feeling insecure, I remind myself of something Avedon once told me when I had lost a few pounds. He said he liked my face better when I wasn't too thin. At the time I was shooting a lot of covers and cosmetics ads, so he recommended that I not get too skinny. (OK, I guess I will have that bite of dessert—if you insist!) Later, after I started to work with Dr. Sebagh on Meaningful Beauty, he gave me similar advice. He told me to pick a weight—not my skinniest and not my heaviest—and stay there, not yo-yo, because it's better for skin not to expand and contract too much. And his message about dieting has also helped me learn to accept the body I have, and by that I mean accepting myself when I'm looking at my reflection in a dressing-room mirror—the real me as opposed to a posed, lit, and retouched photo.

I do think taking control of one's body by exercising goes a long way toward learning to love it for all the things it can do. After giving birth to my children, I had a whole new appreciation for what my body was capable of. When I'm eating healthy, nutritious food, I walk a little taller. I'm still five-nine and a half (unless I've started shrinking already), and I weigh between 135 and 140 pounds. I am blessed to be healthy, and I can pretty much still do all the things I love— chasing my kids, hiking, swimming in the ocean. And I'm lucky to have a husband who loves my curves. Rande finds me my most beautiful the way I look when I wake up in the morning.

But I'm also aware of what's going on in the fashion business. Young models are getting thinner, and sample sizes are getting smaller. There isn't a chance in hell that I would be able to squeeze into them. And no matter how great you can feel about yourself some days, when someone hands you a pair of pants that barely fit halfway up your thigh, it feels awful.

There is a lot of criticism of models being so thin these days, and here's what I have to say: First of all, fashion is about change. The pendulum always swings back and forth, from Marilyn Monroe to Twiggy, from supermodels to heroin chic. That's how designers, photographers, and editors get inspired. Second, consumers must realize that the power is in their hands (or, rather, their wallets). If they don't like the images they see, they have the power to stop buying the magazine or the designer's dresses. Above all else, fashion is a business, and sometimes change can only happen when the bottom line is affected. That said, it is exciting to see current fashion embracing a broader idea of beauty. To my mind, the most important message I can promote and exemplify is one that supports diversity and health.

TAKI

CHA

NG
NCES

In looking back at my career, even I am surprised by all the chances I have taken—especially for someone who doesn't see herself as much of a risk taker.

NUDITY

It usually starts with some version of "let's try the trench coat with nothing underneath." Before you know it, you're naked.

I grew up in a pretty conservative, churchgoing family, and I can't remember seeing my mother in anything skimpier than granny panties or a skirted swimsuit. If you had asked me at age sixteen if I would ever model nude, I'm sure I would have said no. So, considering the number of nude photographs I've done throughout my career, something must have changed.

I was eighteen the first time I was asked to pose nude. A few weeks after finishing high school I was in Paris shooting for French *Elle*—a spa story on health and fitness. My hair was short and slicked back, and I was wearing very little makeup. After doing a few shots in workout clothes and then another in a fluffy white robe, the photographer asked if I would be comfortable taking off my robe. He showed me how he wanted me to sit sideways in a chair with my hands covering my breasts. He assured me that nothing too private would show, and he was true to his word. Everyone was protective on set, holding the robe up to cover me as I got into position, and afterward I was surprised only by the thought that it really hadn't felt like that big of a deal. My main concern was what my parents would think, but I was pretty sure they would never see it—French *Elle* wasn't available in DeKalb!

When I came back to Chicago and was still working with Victor Skrebneski, he photographed me for the Chicago International Film Festival poster. I wasn't naked, but the male model standing next to me was. I worked hard to avert my eyes, and when Victor asked me to lay the back of my hand against the model's thigh, I remember blushing. But once the actual photography began, I was able to focus on what Victor was asking for and almost forgot that there was a naked man standing next to me. I somehow never got around to mentioning the details of the shoot to my boyfriend at the time. I'm not sure he would have understood.

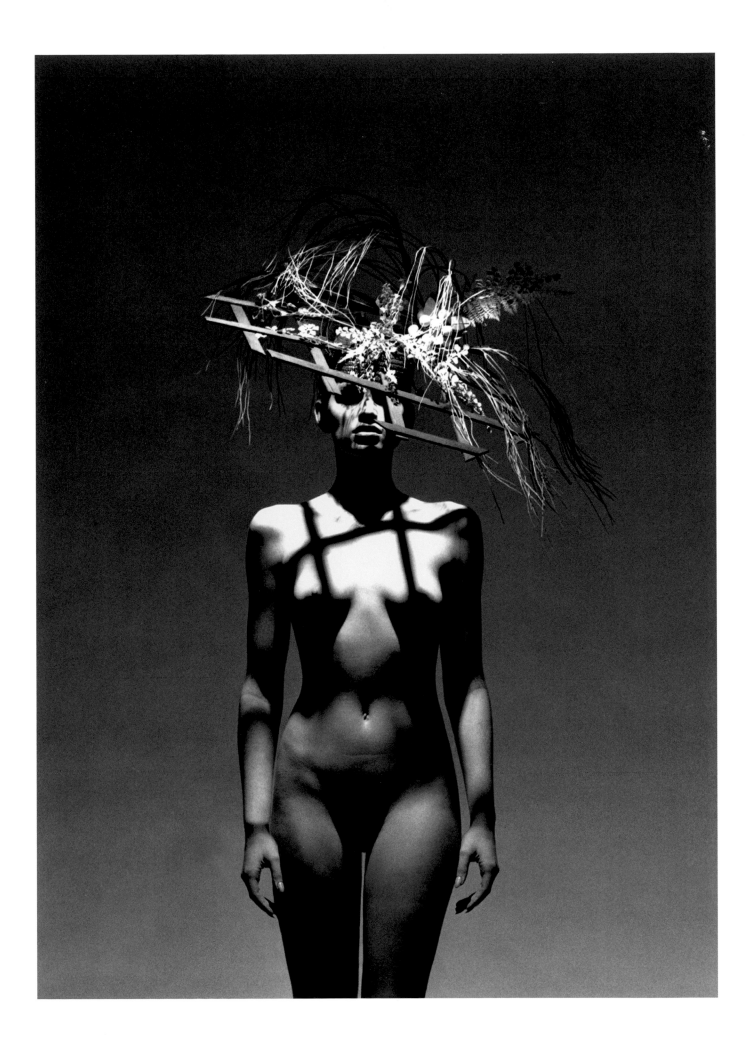

Not too long after that, Victor asked to shoot me naked for a personal project he was doing. The shoot wasn't about nudity but, rather, about hats. I was merely the mannequin wearing a hat, heels, and nothing else. Victor loved my figure and taught me how to make it look even better by thrusting out a hip or arching my back. The pictures weren't intended to be sexy, and as I started to connect to my body as a shape, I began to lose some of my Midwestern prudishness about nudity.

As a model, you can feel exploited and taken advantage of even with your clothes on. Being naked certainly heightens that feeling of vulnerability. Each and every time it is a personal decision, and, luckily, most of the time I have been happy with my choice. The only nude shots I've ever regretted were those taken when I felt pressured, having let a photographer talk me into undressing. But even in those cases I always had the option to say no and have no one else to blame for how I felt.

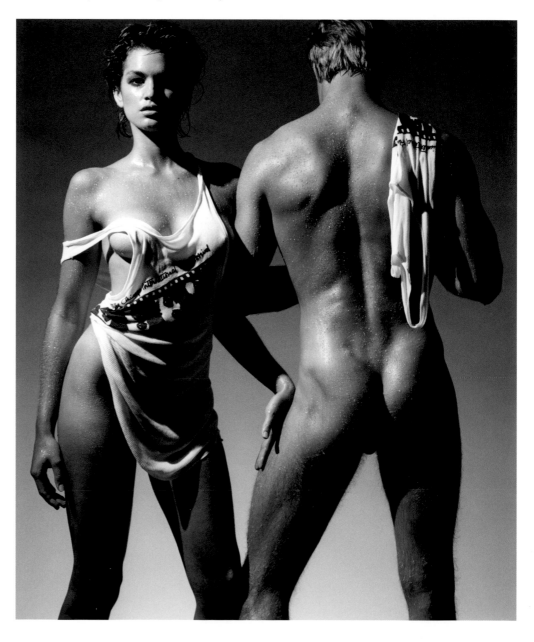

In many ways I think that at some points in my life I photographed better without clothes. I have curves and an athletic figure, and I understand how to show the lines of my body. In the right environment, I began to feel more comfortable and freer as a model when I didn't have to think about what I might be wearing—especially when the clothes were designed for a different body type. I had been trained to be aware at all times of what it was that I, as a model, was "selling," and I found a certain freedom in being naked. And, the more you pose nude in front of the camera, the more comfortable you become with it.

I do wonder when I'll be officially "done" with nudes. At thirty, I thought, no way would I still be posing nude at forty. But when forty rolled around, a few times it still felt right. Now that I'm almost fifty, my age (and the fact that I have teenage children) is always in the back of my mind.

I haven't yet come to the conclusion that a body stops being beautiful at a certain age. I was flattered when *W* magazine recently asked me to pose for fashion photography team Mert and Marcus wearing only a strategically placed bed sheet. Who knows if I will ever pose nude again? Maybe when people stop asking

Being naked certainly heightens that feeling of vulnerability. Each and every time it is a personal decision, and, luckily, most of the time I have been happy with my choice.

PLAYBOY

When I first discussed a potential *Playboy* shoot with
my agent, our immediate reaction was "no way."

Getting the call from *Playboy* in 1988 was totally unexpected. My modeling career was off to an amazing start. I was flying all over the world, working with all the important magazines, photographers, and designers.

When I first discussed a potential *Playboy* shoot with my agent, our immediate reaction was "No way." True, Paulina Porizkova had done *Playboy*, but she was already well established and had always been a bit of a rebel. For me, as a relative newcomer, it was a big risk. There was virtually no crossover from being a *Playboy* model to high fashion. If anything, the perception was that doing *Playboy* might get you a cameo on a TV show.

There were a million reasons to say no, but the biggest ones were about association and connotation. *Playboy* carried the stigma of "T&A," the sexual objectification of women, inviting a certain kind of attention. I worried I would never again be taken seriously by the fashion industry. Would doing *Playboy* disqualify me from the coveted cosmetic contract? And, most important, how would I break the news to my parents? My father already thought modeling was a nice word for prostitution.

And yet, there was something compelling and challenging about the idea. When I was growing up, a *Playboy* centerfold epitomized every American boy's fantasy. I couldn't help wondering if there was a way to redefine what it meant to be in *Playboy*, and make it something that I could be proud of. My agent and I decided to explore the possibility. Ultimately, what convinced me was the fact that Herb Ritts was to be the photographer. Even though I had only posed for Herb a few times, I loved his work and the way his pictures made women look.

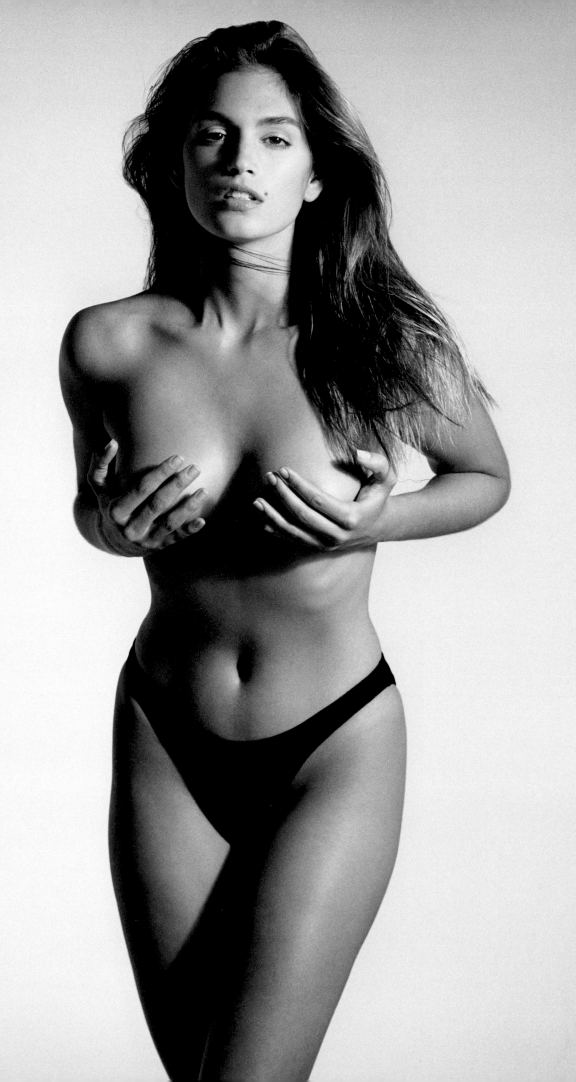

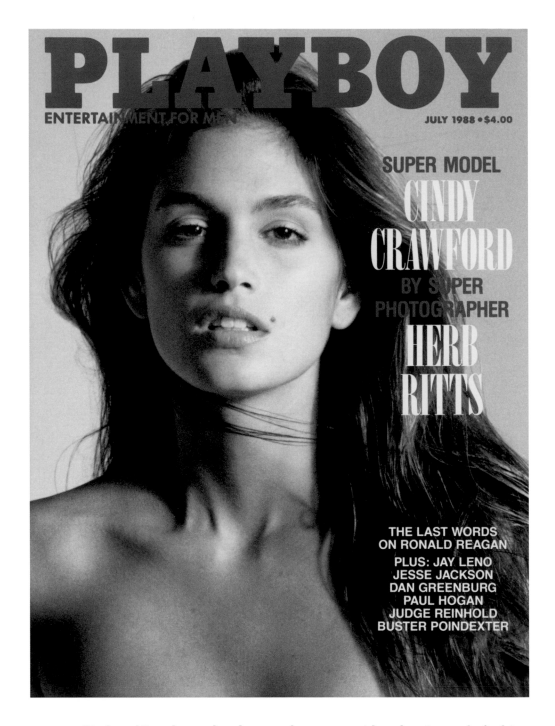

Herb and I spoke on the phone and came up with a plan. Instead of asking *Playboy* for an astronomical amount of money, I would do the shoot for a nominal fee. In exchange, the magazine would give us total creative license and the right to pull the whole layout if I wasn't happy with the result. That gave me the safety net I needed, and off we went to the black sand beaches of Kona, Hawaii.

Herb had decided to piggyback the *Playboy* shoot with another shoot we were doing for French *Vogue*. Tatjana Patitz was the other model for that shoot, and we started with those pictures. Somewhere in the middle of the trip we focused more on the *Playboy* shots, but the transition was seamless. We had decided in

advance that I wasn't comfortable with full frontal nudity, so, really, the images we did for *Playboy* weren't that different from those we had done for French *Vogue*. I never once felt objectified or uncomfortable.

A few weeks after we returned, Herb asked me to come to his house to see his edits. He had prints spread out on the floor of his home office, and his friend and frequent houseguest Richard Gere also happened to be there. It's one thing to look at naked pictures of yourself; it's quite another to do so in front of a total stranger who also happens to be one of the world's biggest movie stars. I was so flustered I could barely focus. It was the first time Richard and I had met, and I felt nervous and exposed. But even in the awkwardness of the moment, I loved the photos and was happy for the story to appear in *Playboy*. If those pictures had appeared in any other magazine, no one would have thought twice about them. As it was, the shoot opened up a whole new audience for me.

The images we did for *Playboy* weren't that different from those we had done for French *Vogue*. I never once felt objectified or uncomfortable.

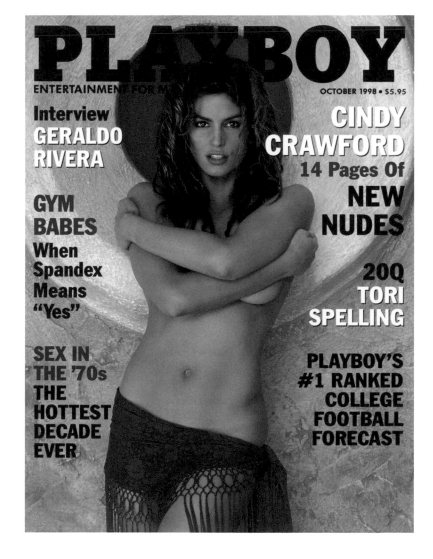

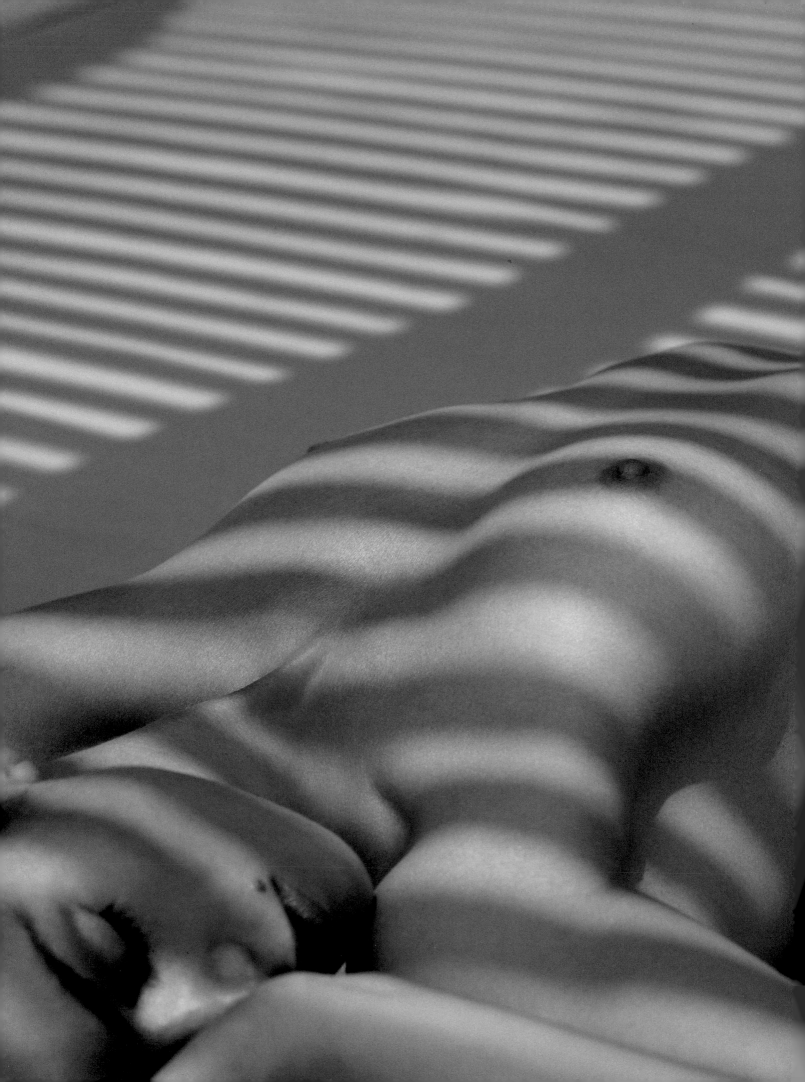

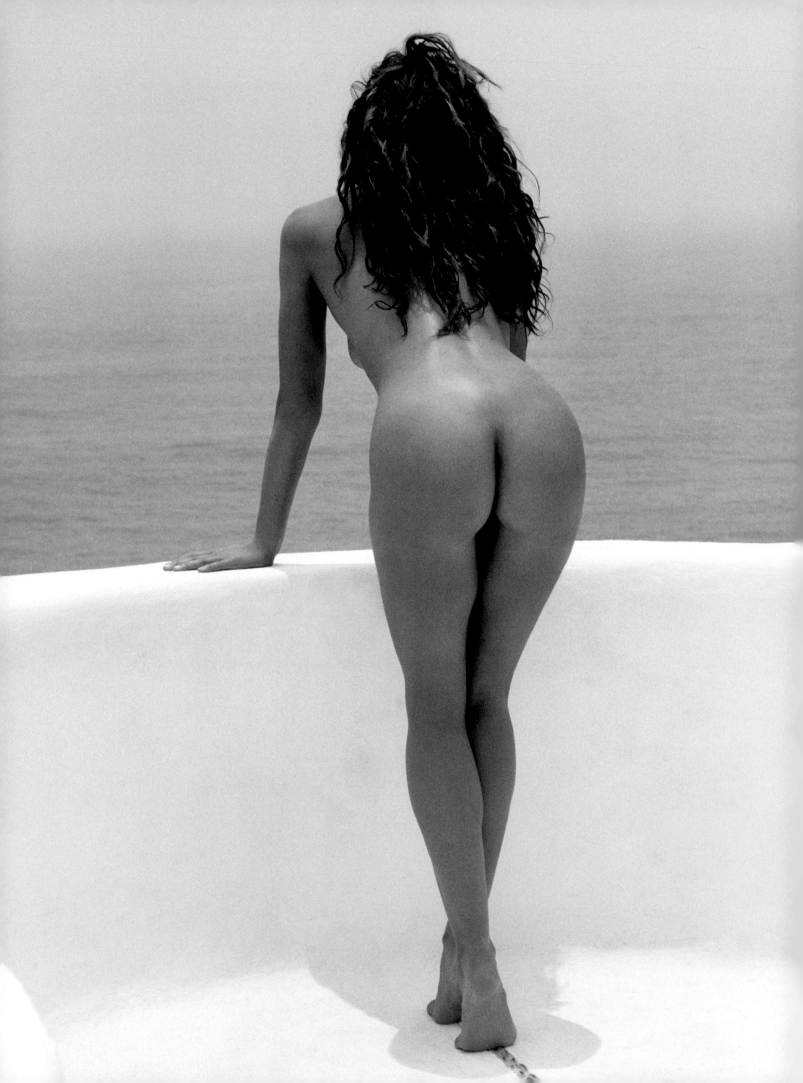

I would like to say it was all part of my plan, but since I was only twenty when I made this decision, there was definitely an element of luck involved, too. Fashion magazines cater to women. Being able to reach a male audience was a huge part of what helped propel my career forward. After *Playboy*, MTV came calling, and that led to many other opportunities beyond the fashion world. It's funny; to this day, when I show up for an autograph signing anywhere, the first three guys in line are always clutching a twenty-year-old copy of *Playboy*.

When *Playboy* approached me again ten years after that first shoot, I said yes for a second time, with the caveat that I would have even more control this time. Of course, I only wanted to do it with Herb Ritts, and I would still have final approval of the photos and layout. But now I wanted the big paycheck, too!

Herb and I collaborated before the shoot. We didn't want to repeat what we had already done. We both agreed that since the first shoot had been black-and-white, this one would be primarily in color. We chose the pastel walls of Costa Carayes in Mexico as our location. We also agreed that we needed to push the envelope a bit further this time. Because I had worked so much with Herb by this point and had such a comfort level with him, I was able to be very free with my body in front of his camera; I knew he would always protect me. Also, the fact that Herb was gay removed the possibility of any sexual tension on set. For Herb, photography was always about form.

At thirty-two, my body was different than it had been at twenty-two. I was definitely stronger and leaner. I owned my body in a new way. I felt less shy and more like a woman. There is a strength and power to these photos that I don't see when I look back at my first *Playboy* story. This time the pictures were—much to Rande's chagrin—more revealing. Still, I love these pictures as much as I loved the first story.

Playboy approached me again when I was around age forty. After careful consideration, I declined. In some ways I was tempted. Who doesn't want beautiful pictures of their body? Especially at an age when you are all too aware that you won't have that body forever. But in the end, I declined out of respect to Rande and also my son, Presley. I didn't ever want to embarrass him. Having your fourth-grade friends possibly see naked pictures of your mother might fall into that category. I couldn't (and wouldn't want to) take back the past, but I was ready to acknowledge that my life had evolved to include my family and that posing for *Playboy* was not part of my present.

HOUSE OF STYLE

In 1989, I got a call from MTV asking me about hosting a new show they were doing on fashion.

At that time, MTV was playing mostly music videos (imagine that!) and just starting to branch out with original programming. One of the producers there, Alisa Bellettini, had an idea about covering fashion in a new way. Up until that time, the only fashion personality on TV was CNN's Elsa Klensch.

My agent was not thrilled by the idea of my hosting a little show on a small network for virtually no money. I was working almost every day, either making a big day rate for advertising campaigns or doing great editorial shoots for magazines. But Alisa Bellettini convinced me to take a chance, so I agreed to do the pilot.

Alisa had her own reasons for wanting me so badly for *House of Style*. Because MTV's audience was predominantly male, she needed a host who was a fashion insider but who also appealed to guys. Since I had appeared on the covers of *Vogue* and *Playboy* in the same year, she felt I covered both bases perfectly.

Our first shoot was on the roof of a skyscraper in Manhattan overlooking Central Park. It was a steamy summer day, and I had to provide my own wardrobe; I wore a black dress and vintage motorcycle jacket. There was no teleprompter, so I had to memorize all the wraparounds. I had never hosted a show before, so I was nervous and insecure.

When the first episode aired, I thought I was awful—stiff and robotic. One reviewer even said my voice had all the interest of a telephone operator's. But because we didn't launch the show in a big way, there wasn't a lot of pressure. And because we offered a totally fresh look at fashion, we slowly found our audience. By then, Alisa and I had both a friendship and a working relationship, and we were both eager to do more work together. What a luxury it was to be able to develop the show and my on-air skills without all the criticism that comes with a big premiere. I definitely got better with each episode and eventually started writing my own scripts. It was so much easier to memorize and perform when the words were my own.

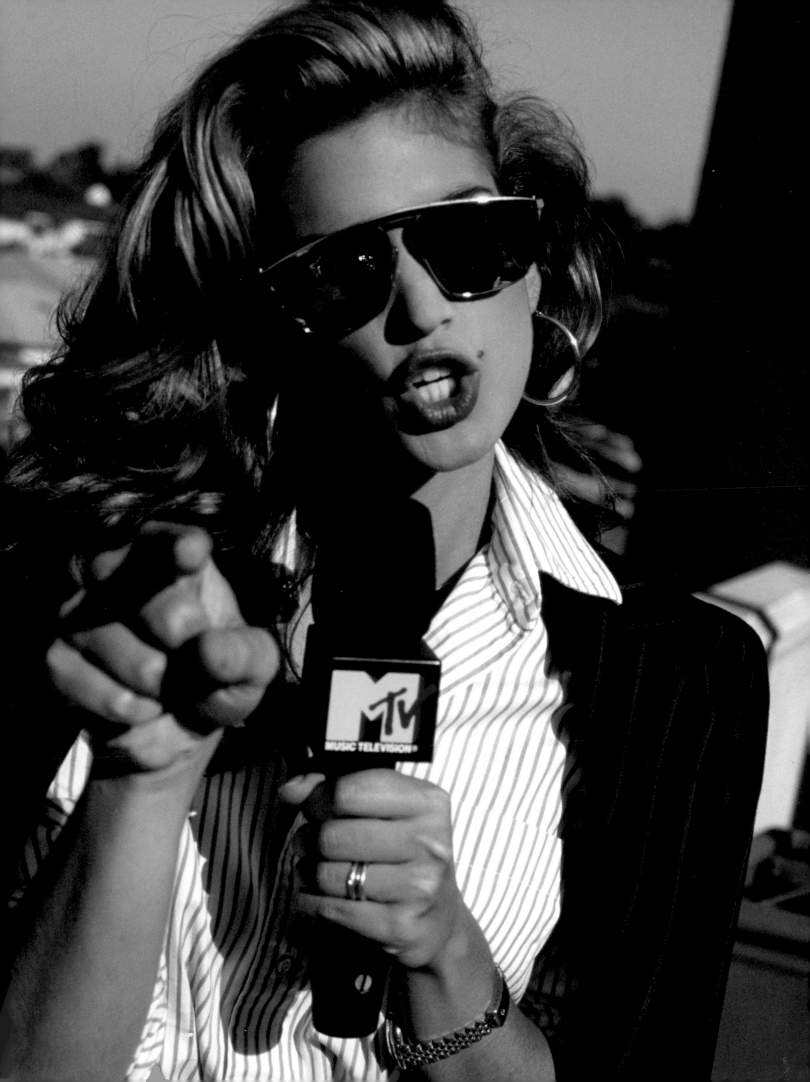

Alisa was obsessed with fashion, and *House of Style* was about celebrating all of it—from street style to couture, with a little rock-n-roll thrown in. We set out to demystify beauty by showing Naomi Campbell putting on zit cream or me sucking in my stomach on a swimsuit shoot. We would film Jean Paul Gaultier in his atelier in Paris and on the same episode have fellow designer Todd Oldham creating something with a glue gun. The show helped me establish a new identity within the world of fashion. People began to see me as more than just a model; I became someone with a voice, ideas, and opinions.

I hosted *House of Style* for seven years and had many great experiences. The irony is not lost on me that I was on MTV, the "coolest" network at the time, but I wasn't a "cool" girl. (I still don't think I fall into that category, but being married to Rande Gerber—the coolest nightlife guy—gives me some undeserved street cred!). My naïveté made me relatable and brought a certain authenticity to the show. Backstage at the VMAs one year I innocently asked Chris Robinson from the Black Crowes what type of leaf was embroidered onto his suede pants. I also thought Led Zeppelin was a person.

One of our favorite setups was to put celebrities into unexpected situations. I got to watch Duran Duran's Simon Le Bon try on dresses at Sears and see Dennis Rodman in a thong (I'm still recovering from that!). Another memorable moment was standing onstage with Guns N' Roses at the Freddie Mercury tribute concert at

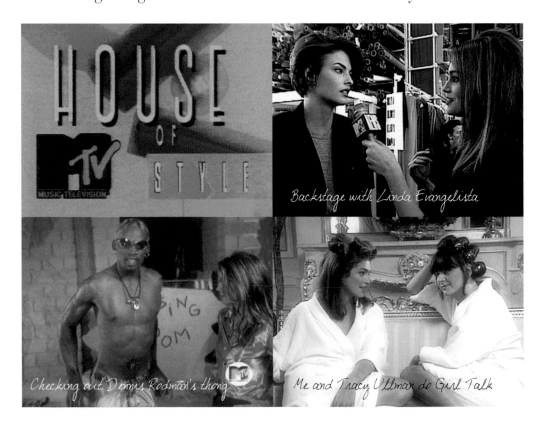

Backstage with Linda Evangelista

Checking out Dennis Rodman's thong

Me and Tracy Ullman do Girl Talk

The *New York Times* called *House of Style* "silly, superficial and wonderful." I couldn't have been more pleased.

With Lenny Kravitz at the VMAs

Wembley Stadium in London. Getting a little glimpse of what it's like to be onstage in front of 90,000 adoring, screaming fans is something I will never forget.

The *New York Times* called *House of Style* "silly, superficial and wonderful." I couldn't have been more pleased. Fashion is many things, but to me, that is fashion at its best. And even though I eventually said good-bye to *House of Style* (I joked with Alisa that I simply couldn't go shopping with one more rock star), my years on the show taught me so much about being in front of the camera and also gave me an outlet to share some of the people and ideas that make fashion fabulous.

TRUST YOUR INSTINCTS

Seeing this image always reminds me that it's ok to say no
to something that goes against your conscience.

I love this photograph, but probably not for any reason that you could ever guess. First of all, I was working with some of my favorite people in the fashion business: photographer Patrick Demarchelier, fashion editor Paul Cavaco, makeup artist Kevyn Aucoin, and hairdresser Orlando Pita. If I'm not mistaken, the idea for this shoot came from Kevyn. Working with some older actresses, he had discovered a special kind of theatrical tape that could be used to create a temporary face-lift. Two sticky pads are connected with a type of stretchy band. You stick one end to one temple, stretch the band over the top of the head (hidden under the hair), and stick the other end to the other temple. Instant lift. Kevyn became obsessed!

He had the idea to photograph some of the biggest models at the time, utilizing the tape to change our faces, but no one had thought it necessary to mention it to the models beforehand. So when I sat down in the makeup chair, Paul, the editor, and Kevyn explained what they wanted to do. I had an immediate reaction to the idea—something about it didn't feel right—but I let the experiment continue.

When Kevyn was done, I looked in the mirror and didn't like what I saw. First of all, the tape really hurt. It was like having a ponytail that's way too tight. It wasn't so much that my face looked completely different; what really bothered me was the message we were sending to women. Even the best hair and makeup wasn't good enough? Now we had to go to extreme measures to enhance our faces? What would that say to the reader? And what possible takeaway could there be for them? It would be ridiculous if women walked around with taped faces in real life.

I told Paul I wasn't comfortable and didn't want to do it. He would have none of it. He started saying things like, "How dare you have an opinion? You're only the model, for crying out loud. Don't you understand that fashion is about being extreme?" It took every ounce of strength I had to hold my ground—and I did my shot without the tape.

After the shoot was over, Paul and I made up. Probably the coolest thing he did that day was to admit that, even though as an editor he had been annoyed with me for not consenting to the concept, as a father to a young daughter he was proud of me for wanting to set a good example.

Seeing this image always reminds me that it's OK to say no to something that goes against your conscience.

OVERCOMING FEAR

Modeling is not a truly scary job, even though some of the people involved in the business can seem scary or intimidating.

Most of the time, the scariest part of my job is trying to squeeze into five-inch heels that are a size too small. But at times I have been asked to do things that were scary to me. The first time was when I was still eighteen years old. I had been in Paris modeling for a few weeks and was booked to do a shoot in Bermuda for British *Vogue*. I was excited to take the job, because I was ready to come back home to the good ol' USA. A trip to Bermuda would get me that much closer. We were shooting a spa story and for one of the first shots, the photographer asked me to balance on a stone wall. I found out at that moment that I was afraid of heights, and even though it didn't feel safe, I kept my mouth shut and held on for dear life.

The next day, they wanted to shoot me inside a steam shower—with the door closed. In I went, and, after several minutes, I started to feel that I was overheating. I tapped on the door to ask the crew to let me out. I don't know if it was just the fact that I was feeling dizzy, but I seem to remember the photographer laughing and no one opening the door. I passed out! The door opened and they dragged me out.

Talk about a wake-up call. I know it is a model's job to try to bring the photographer's vision to life, but I also believe it is the photographer's job to keep the model safe. When I realized that wasn't always the case, I understood that I had to protect myself and have a more forceful voice about what was acceptable to me. Slowly, I found ways to say no.

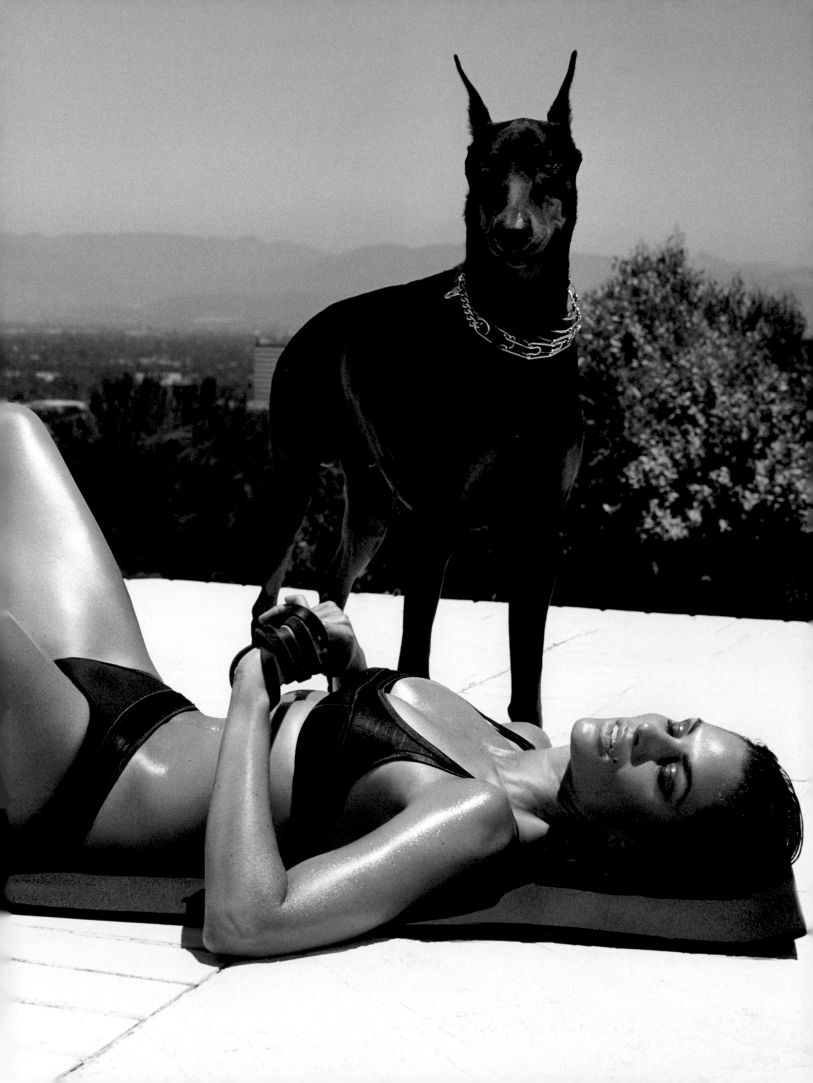

When the snake wrangler wrapped the 40-lb. python around my shoulders I nearly passed out. It was heavy and it smelled disgusting. I didn't move a muscle.

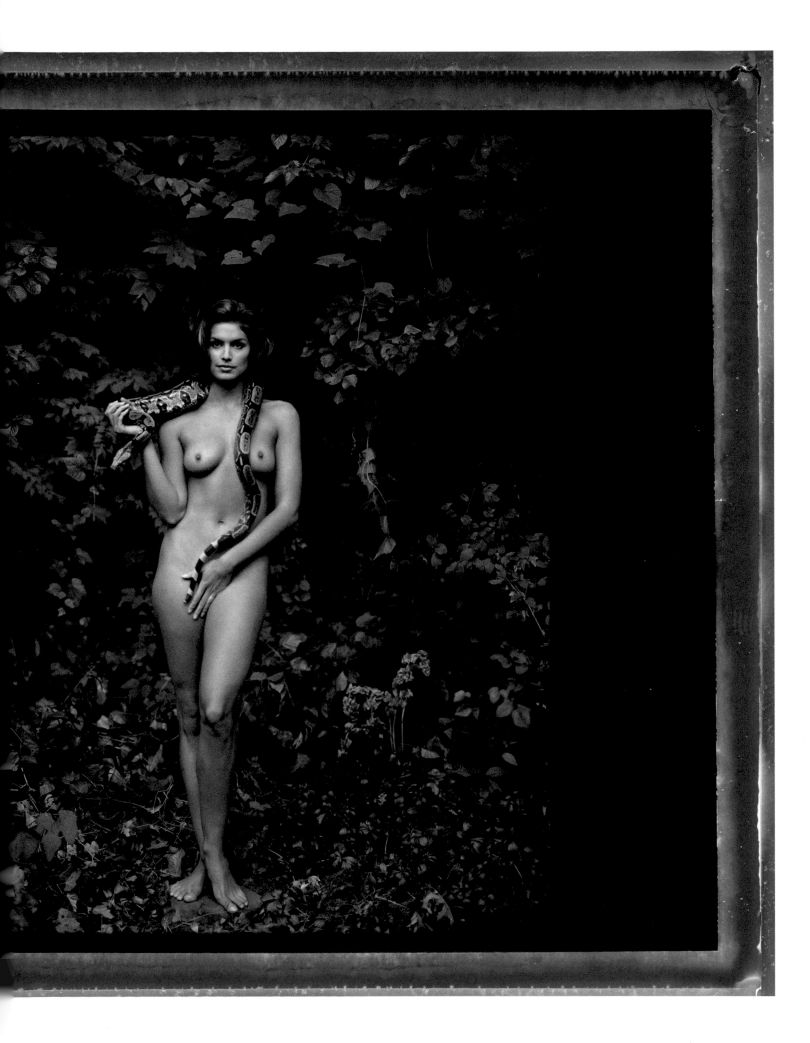

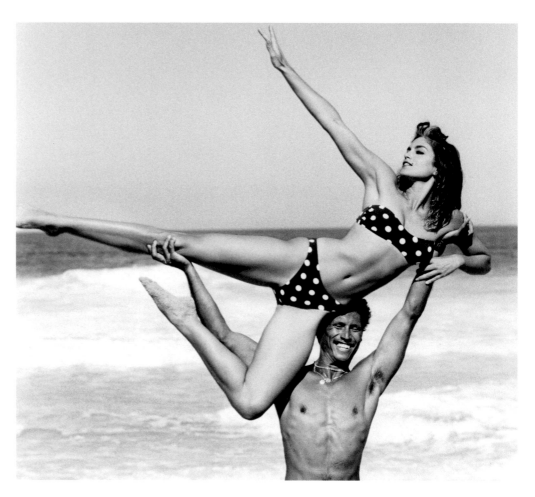

A few years later I was in Hawaii with Patrick Demarchelier for American *Vogue*. We were shooting a surf story on the North Shore. Patrick proposed that we do one shot of me on a surfer's shoulders. OK, I could do that. Then he went on to explain that I was to paddle out into the ocean with the surfer and climb onto his shoulders as he surfed a wave in! What? Oh, and then the editor, Grace Coddington, told me not to get my hair wet. C'est impossible!

That's when I had a stroke of genius! In my best dumb-model voice, I told Patrick I didn't understand what he was talking about but that I was sure if he could just show me how to do it, I could figure it out. Needless to say, we did the shot standing on the sand.

While that maneuver has gotten me out of many precarious situations, I've also had to find ways to confront my fears. Even though I have two adorable dogs now, I was never really an animal person—probably because I didn't grow up with pets and had been bitten by dogs once as a young child and once as a teenager. I've been afraid of dogs ever since.

Over the years I've been asked to do many shots with dogs, and for the most part they have been very well trained and behaved. But on a recent shoot, the photographer, Mikael Jansson, requested the biggest, meanest-looking Doberman

he could find. In fact, he sent the first one away because it didn't look fierce enough. For one picture Mikael asked me to lie by the side of a pool in a bikini and spike heels while the dog loomed over me, sniffing my chest. That's when I discovered how useful deep breathing and meditation could be. The next shot involved standing nearly naked next to a barbecue grill holding a Flintstones-size steak as the trainer got the Doberman to bark at me. Somehow I was able to muster up the courage to do the shot. Chalk one up to professionalism; I do things in the call of duty that in real life would leave me running for the hills.

Probably the scariest thing I was ever asked to do was for a *Vanity Fair* shoot with Annie Leibovitz. She wanted to photograph me as Eve in the Garden of Eden—complete with a giant snake. Let's not forget that Eve was naked! When the snake wrangler wrapped the forty-pound python around my shoulders, I nearly passed out. It was heavy, and it smelled disgusting. I didn't move a muscle as the snake slithered around my body. I tried to look serene and seductive as Annie clicked away. Just as the snake was getting a little too friendly with his tail and started squeezing my bare shoulders together, the trainer jumped in and unwound it from me. I have never been happier to hear a photographer say, "I think we got it."

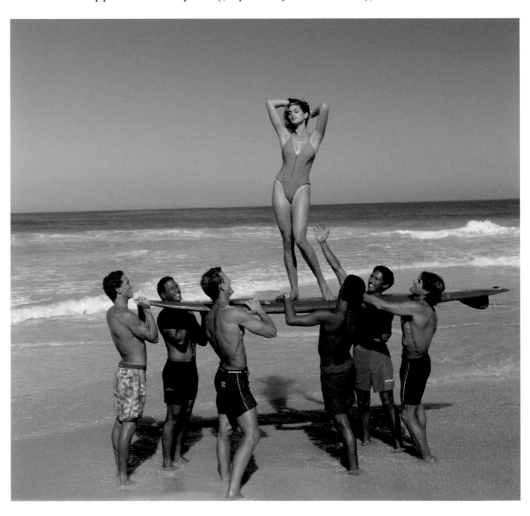

ACTING VS. MODELING

While it's true that a lot of would-be actresses use modeling as a springboard for their acting careers, I never thought of modeling as a stepping-stone.

I'm not sure what it's like now, but when I was a young model, there was a perception that models might naturally transition into acting. Hey, she's pretty; maybe she can act, too. Models such as Lauren Hutton and Kelly LeBrock had become successful actresses. While it's true that a lot of would-be actresses use modeling as a springboard for their acting careers, I never thought of modeling as a stepping-stone. I had never dreamed of becoming an actress. I guess I had never dreamed of becoming a model, either, but when modeling became a viable career for me, I was content being the best model I could be.

One day, not too long after my first couple of covers had hit the newsstands, I was shooting with Richard Avedon. He mentioned that a friend of his, director Mike Nichols, wanted to meet me about a new movie he was getting ready to make. Knowing nothing about the project (*Biloxi Blues*) and without an acting agent, I agreed to the meeting. Avedon set up the appointment for right after the shoot.

Normally, one might expect a young girl to be nervous or intimidated to meet such a famous director—I had been extremely anxious the first time I worked with Avedon, knowing that he was one of the biggest photographers a model could hope to work with, and I wanted to make a good impression—but because I wasn't trying to become an actress, I had no butterflies when I showed up to meet Mike Nichols.

He greeted me at the door of his office, and the two of us sat down. He slid some "sides" (the pages of script an actor might be shooting that day) across the table and asked me to read. I had never read lines or even seen a script before. In any event, when Mr. Nichols asked me to "read" the sides, I did exactly that. I read them aloud with no feeling whatsoever. When I got to the end, he said, "Well, you can read." I don't think he meant it as a compliment.

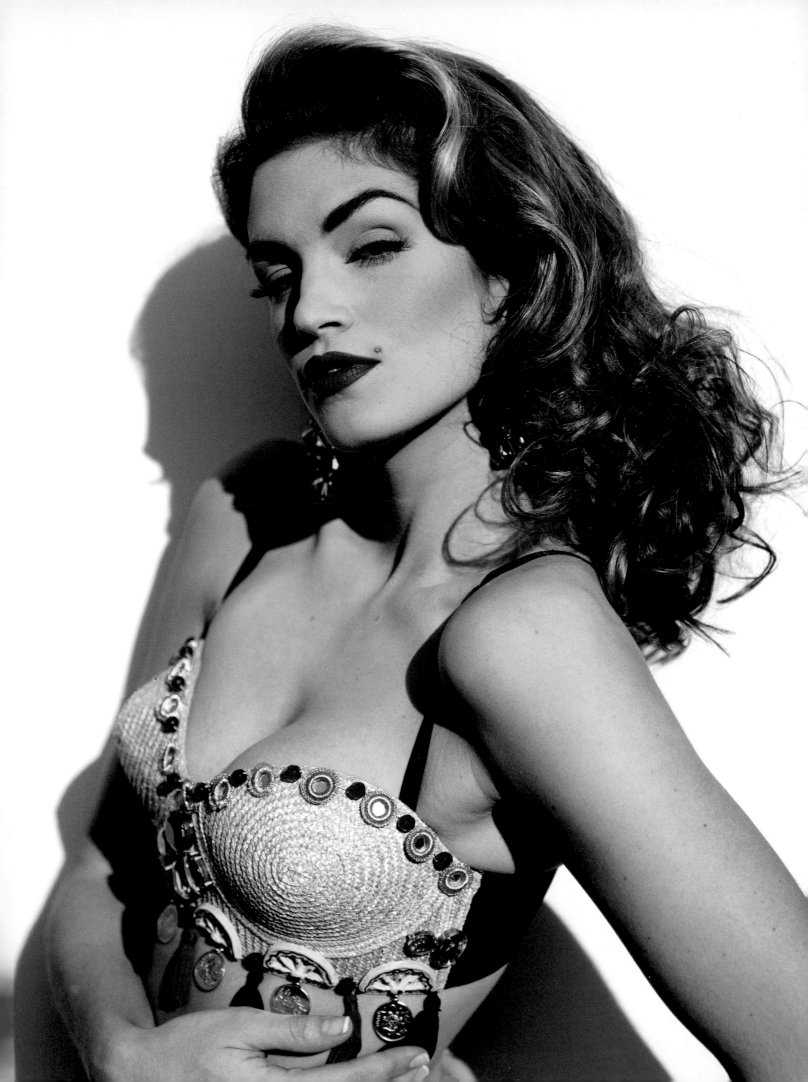

I was completely embarrassed when I realized my mistake. He hadn't meant "read" the lines; he'd meant "act" the lines. If only I hadn't taken him so literally, I would have known what he wanted and at least tried to act it out. He thanked me for coming and showed me to the door.

After that experience, I was even less interested in acting. Sure, if I got a call to be an extra as a "model walking down the street," as I did in the opening credits of *The Secret of My Success* with Michael J. Fox, I'd say yes. I knew I could do that. But acting wasn't something I was passionate about, so I didn't think much about it.

A few years later, I got another call to come in for an audition. Cameron Crowe was casting for his new film, *Jerry Maguire*. I was a big fan of Cameron after seeing his film *Say Anything*. Even though I had never taken an acting class, I decided to go to the audition. That audition was a great experience. Cameron knew I was a novice and took the time to work with me on the scene, reading lines and giving me direction. I didn't get the part, but I walked away with an appreciation for what a good director brings to the table.

Still, I wasn't bitten by the acting bug. I'm not sure if the fact that I was with my ex-husband, Richard Gere, at the time had any effect on my position. Yes, being around filmmakers and filmmaking was interesting and glamorous, but it also felt good to keep our worlds separate and for me to have success that wasn't in any way connected to who he was as an actor.

Running in that circle, however, did expose me to a lot of directors and producers. One of them was producer Joel Silver, whom I had first met in Paris when I was twenty years old. I was there shooting for *Vogue* with Wayne Maser, and for some reason Joel stopped by the shoot, and we became friends. At that time, Joel was producing big-budget hits like *Lethal Weapon, Predator,* and *Die Hard*.

People might think that modeling and acting are similar, but for me they require two completely different skill sets.

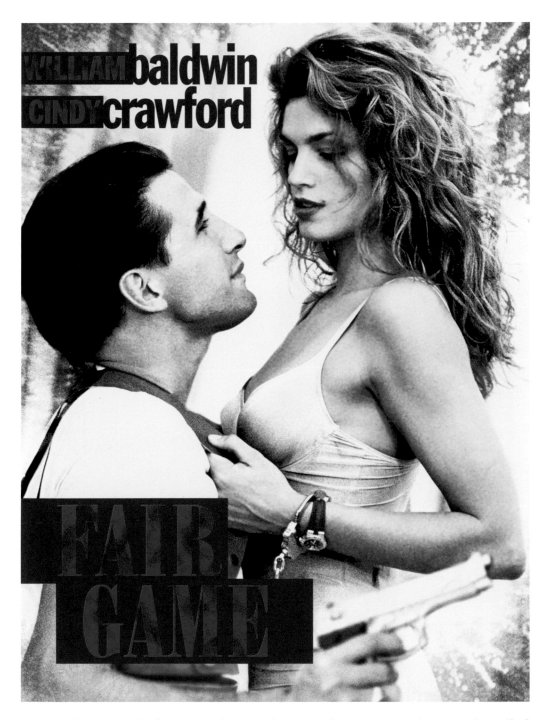

In 1994, Joel was getting ready to make a new action movie called *Fair Game*. He asked if I wanted to be in it. Originally, I said no. Why would I try acting again? I had a great thing going. But Joel has a reputation for getting what he wants, and he kept asking. Being married to a movie star at the time, I knew all the crazy demands to make that might discourage a producer, but Joel said yes to every one. I still kept saying no, because deep down I was afraid of failing. Actually, more like terrified. Ultimately, I also realized that if at age twenty-eight I turned down opportunities out of fear of failure, I would be limiting my choices for the rest of my life. In the end, I said yes.

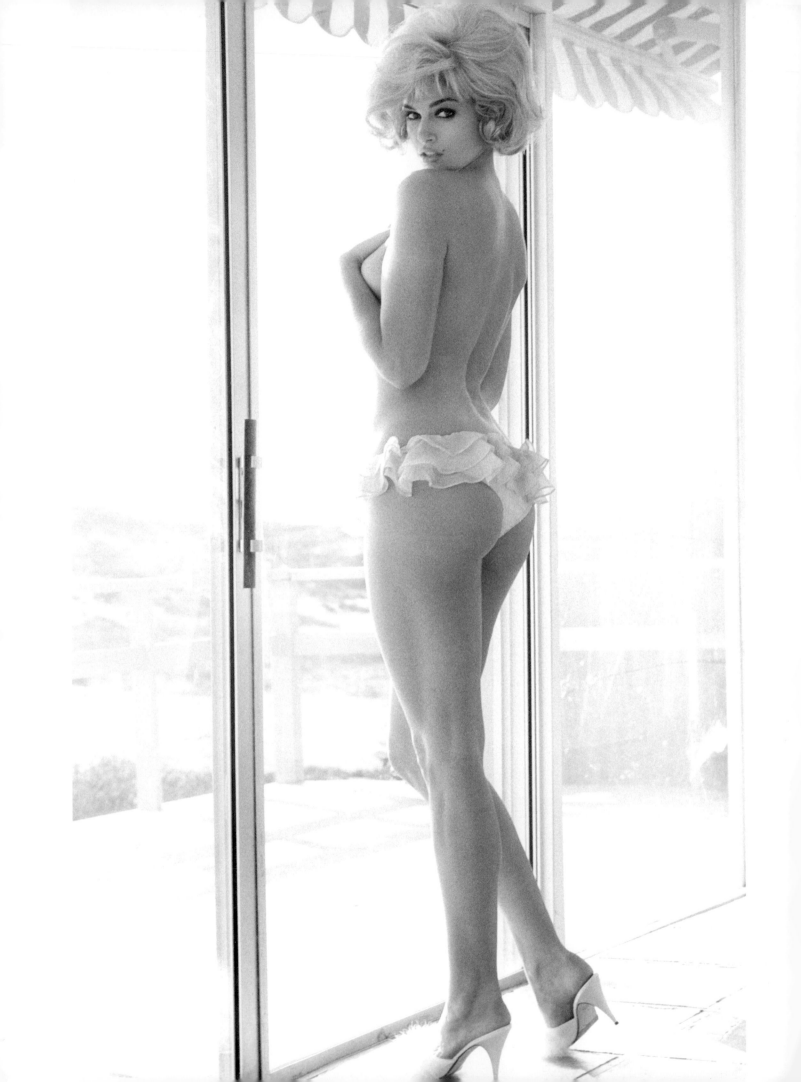

Once I committed to the film, I committed. I worked with an acting coach to get ready to shoot. On the first day, my knees were trembling. My first scene was one with Billy Baldwin in a car. I got to learn about the magic of filmmaking as the car was loaded onto a trailer so that it would look as if we were driving. I had been on many commercial sets before, but a movie set is a photo shoot on speed. And this was a particularly complicated shot, with cranes and trailers. The assistant director was telling me that the first time he said "Action!" it would be for the trailer to start moving and that the second time would be my cue. Unbeknownst to me, the camera was already rolling when I asked, "So when you say 'Action,' do I start talking?" The whole crew burst out laughing, and I'm sure Joel was wondering what he had gotten himself into.

Making *Fair Game* was definitely outside my comfort zone. People might think that modeling and acting are similar, but for me they require two completely different skill sets. Most of the time, when a photographer wants you to smile, he simply says, "Smile," and you smile. With acting, it's more about getting to the smile by connecting to emotions within.

Models are also trained to be 100% conscious of the camera at all times. Once I'm on set, even if I drop an earring or need to adjust the strap of a shoe, I do it in a way that I know will look good to the photographer. It could even end up being the shot. Models make direct eye contact with the lens, almost always flirting with it. It seems to me that actors are trained to forget the camera and simply let it capture on film the honesty of a moment. Actors rarely make eye contact with the camera; rather, the camera is an unobtrusive observer.

Some models do go on to become great actresses. They can retrain themselves and lose themselves in a role. I could never fully forget that the camera was there and that the lines were not my own. By doing *Fair Game,* I learned that I am very comfortable in front of the camera as long as I am being some version of myself. As soon as I try to become another person, I just feel silly. I don't even believe it myself.

When the movie finally came out, I got slaughtered in the reviews. Even though I thought I was prepared, it still hurt. It's never fun to read negative things about yourself. One reviewer, though, a woman, got under my skin. I didn't care that she panned my acting abilities, but what really bothered me was that she didn't even allow for the possibility of my being a lawyer. She said something to the effect of, "as if someone who looks like Cindy Crawford could ever be a lawyer." Part of me wanted to call her up and shout, "Hey, I could have been a lawyer if I wanted to!"

Even though *Fair Game* was considered a flop, for me, it was a personal success. I had allowed myself to take a chance doing something totally new. More important, after that experience, I was able to put the idea of acting to rest once and for all. Knowing it was not part of my future cleared the path for possibilities that were more in line with who I was.

I am very comfortable in front of the camera as long as I am being some version of myself.

CINDY, INC.

I wish I could say that it was all part of a master plan, but I don't think I could ever have dreamed up the career that I have had.

I get a lot of credit for being one of the first models to successfully "brand" myself. I wish I could say that it was all part of my master plan. But I don't think I ever could have dreamed up the career that I have had.

When you start out as a young model, your job is to show up and do exactly what you are told to do and put on whatever the stylist hands you. If you are curious and keep your eyes and ears open, however, you can learn a lot about lighting, art direction, styling, design, and marketing. I paid attention and tried to take it all in.

At a certain point I started having my own opinions about how I wanted to be photographed and portrayed. On many occasions I was able to contribute my thoughts and be part of the creative process, and that felt great. Having an opportunity to write and be an executive producer on *House of Style*, as well as producing my swimsuit calendars, gave me the desire and confidence to start developing my own projects.

After working out with Radu for several years, he and I decided to do an exercise video together. I had become famous in part for my body; people constantly asked about my fitness regimen. My answer was always: Radu. The video was to be our way of sharing with other women the type of routines he put me through during our one-on-one sessions in his New York studio. Certainly Jane Fonda had paved the way for exercise tapes with her hugely successful aerobics videos, but they didn't speak to me or, I felt, to my generation. Radu's workouts were grittier than pink leotards, and I wanted the music and the look of our video to reflect that.

My agent introduced me to several different distribution partners, and I chose Good Times Home Video, not because it was the most prestigious partner, but because I felt they would let me have the most creative control. Having control felt great, but it also was scary. All of a sudden I was responsible for choosing the director and the art director. What if I made a mistake? I couldn't blame anyone but myself.

Throughout the process of making *Shape Your Body*, I had to learn to trust my creative vision and then be able articulate it to others. I found that I am much better at editing than I am at coming up with ideas from scratch. But it wasn't enough to just say what I didn't like. I had to develop my opinions enough to help come up with solutions and alternatives.

Even though at times I felt I was in over my head, I enjoyed the creative process. For every decision I made regarding look, music, and graphics, I considered what I would want to see myself. You can get into trouble when you

LIPS

LIPSTICK IS THE ONE THING I SOMETIMES GET TRENDY ABOUT. NOT ONLY IS
IT QUICK AND EASY TO CHANGE, BUT TRYING ON DIFFERENT COLORS IS FUN.
(ONE OF THE PERKS OF MODELING IS BEING INTRODUCED TO A NEW SHADE
JUST ABOUT EVERY TIME I'M ON A SHOOT.) I'M A FIRM BELIEVER THAT
LIPSTICK SHOULD MATCH YOUR MOOD AND NOT YOUR CLOTHES. LIKE ALL
MAKEUP, IF A COLOR LOOKS GOOD ON YOUR FACE, IT WILL PROBABLY GO
WITH ANYTHING YOU WEAR. SOMETIMES I ONLY WEAR LIP PENCIL WITH
GLOSS. OTHER TIMES, I WANT A PALE, NEUTRAL MOUTH. THEN THERE ARE
MOMENTS WHEN I WANT THE ALL OUT DRAMA THAT ONLY A TRUE RED CAN
BRING. LIPSTICK IS EMOTIONAL AND EXPRESSIVE. EVERYTHING ELSE COULD
REMAIN UNCHANGED -- YOUR DRESS, YOUR HAIR, YOUR OTHER MAKEUP --
BUT ADD A NEW LIPSTICK AND NOTHING FEELS QUITE THE SAME. A CHANGE
OF LIPSTICK CAN TRANSFORM THE BASIC FACE -- AND, IN THE PROCESS,
YOUR WHOLE ATTITUDE.

worry more about what your "audience" wants than about following your own vision. If you are clear about what you want, if you know what you like, then you don't have to second-guess all the time.

Fortunately, that first exercise video was hugely successful. It was even reviewed in the *New York Times*! I'm not sure if everyone who bought it was actually working out to it—I did hear of a fraternity who had it on a loop at their frat house—but all the great feedback went a long way toward boosting my confidence in my ability to branch out and do more of my own projects. It also reinforced for me how important it was to make sure any new endeavors had the same organic authenticity as my workout video; I wasn't making anything up or trying to sell something I didn't believe in. I've carried that philosophy into every project I've done since.

Radu and I did a second video as a follow-up, partly because of demand and to capitalize on the success of the first, but also because we felt that we still had more to say. *The Next Challenge* took my Radu workouts to a whole new level, and to this day, those workouts still kick my butt!

My next project was an instructional book with my friend and makeup artist Sonia Kashuk called *Basic Face*. When I first started modeling, I had never worn much makeup and found the whole process very intimidating. Sonia and I shared the same philosophy about makeup's purpose—to enhance a woman's natural beauty rather than cover it up—and we wanted to help women learn how to put on a "basic face" of makeup with confidence. I loved working with my dear friend, but I also loved sharing my access to the best. I felt so fortunate to work out with Radu and learn makeup tips from Sonia. And in the same way I am happy to share a good recipe, I loved spreading around the wealth of tips and tricks that worked for me.

Basic Face is as useful today as it was then, more than twenty years ago. In fact, my daughter just found an old copy and asked if she could have it. But as much as I love what Sonia and I created, I also learned an important business lesson doing that book. Coming off the huge success of the workout videos, our publishers had very high expectations for how this book would perform. The book did well, but certainly not what the publisher was hoping for and predicting. Because they were all hoping for a big hit, anything less felt like a failure. I have since learned to ask a better question before getting into a new business. "What does a single look like?" Of course, every time anyone gets up to bat they hope for a home run, but now I make decisions based on getting a single. Getting on first base should be celebrated, not leave you feeling like you've let anyone down. And if you are lucky enough to get a double, triple, or even home run, well, that's just icing on the cake.

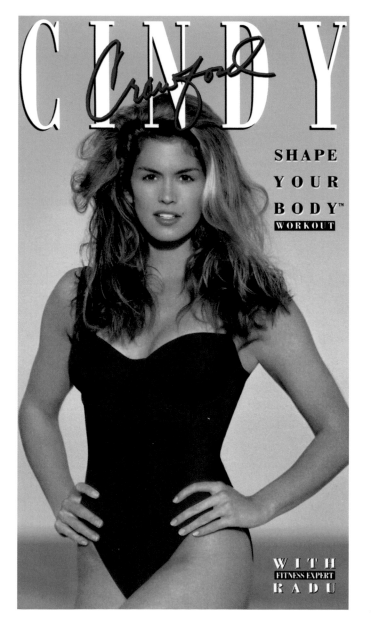

"To get ready to shoot this exercise video, Radu and I worked out twice a day, an hour before work and an hour after. It was grueling but I have never been in better shape in my life. All that preparation paid off and gave me the stamina I needed to do those same workouts over and over again during long 12-hour shoot days!"

At age thirty-five I had been under contract with Revlon for more than ten years. When my contract came up for renewal, I made my biggest and scariest career choice ever. I had met Dr. Jean-Louis Sebagh in Paris seven years prior on the advice of a friend. He was a plastic surgeon, but his main focus was on anti-aging skin care. I had gone to him for a vitamin treatment, and ever since then he was the person I turned to for the care of my skin. He and I had talked about doing a skin-care line together, but my Revlon contract had prohibited it. Negotiations for a new contract with Revlon weren't going smoothly, and I felt it was time to end our professional relationship. At that point in my career I had made and saved enough money so that even if nothing else came around, I knew I could take care of myself.

Several different companies approached me about doing my own line of makeup, but I'm not a makeup artist and had never had any trouble finding the basic brown eye shadow or under-eye concealer I needed for my personal use. I did, however, see taking care of my skin as part of my job—showing up with healthy hair, trimmed nails, and good skin—providing a clean canvas so the makeup and hair people could do their jobs. Dr. Sebagh and I came up with the idea of doing an anti-aging skin-care line based on the vitamin treatments I received in his office. We wanted each product to be meaningful and give results, and so Meaningful Beauty was born. I met with every potential kind of business partner—high-end retail, mass market, and finally Guthy-Renker—a direct-response marketing company that sold to customers via infomercials. In the end, I decided to work with Guthy-Renker, because I felt that the thirty-minute format would give us an opportunity to tell our story. Dr. Sebagh agreed.

Doing an infomercial at what could have been the end of my very long and successful career as a model was a gamble. Of course, in success, all would be forgiven. But if we failed, the stain of being in an unsuccessful infomercial might prove hard to remove. Because I believed in Dr. Sebagh, our story, and our products, I was willing to take the chance. I even welcomed the challenge of making an infomercial I could be proud of.

Today, Meaningful Beauty is a business that grosses more than $200 million a year. I've also gone on to partner in a line of furniture, Cindy Crawford Home, and even sit on the board of some of the companies I work with. I feel as if I've gotten a business education by immersion, and I love that part of my job now, as well. Certainly, when I started out modeling, a career for most models didn't last thirty years. I thought I would be lucky to get five good years, and then I would figure out what I was going to do for the rest of my life. I thought, "OK, when I'm twenty-five, it will all be over, and I will go back to school." At twenty-five, I said, "At thirty this will all be over, and then I will do something else." I never dreamed that I would still be getting in front of the camera at age forty-nine.

Perhaps I owe the longevity of my career to the fact that I've continued to grow and evolve within that career, always trying to find synergy with where I am in my life. At almost fifty, I'm not trying to sell swimsuit calendars anymore. Sharing my workout and makeup tips in my twenties made sense. When my kids were little, I got involved with a baby-products company. In my thirties and forties I got more serious about taking care of my skin and educating myself about what I needed to do to look my best as I aged (gracefully, I hope!), and so I helped develop a skin-care line. Being a wife and mother who wanted to create a warm home for my family led to my own furniture line. I think people saw that I wasn't trying to be anything that I'm not and have been willing to follow me because they trust my integrity.

SHIF
THE
FOCU

TING

JS

Even though my modeling career has lasted way longer than anyone ever could have predicted, at a certain point my life started to take on new dimensions. I found that I wanted to have more influence in my career and shift how I approached my business to create my own opportunities. I also wanted to expand my life to include a family. There is that constant yearning to have it all, and while I'm not sure you can have it all at the same time, it has never stopped me from trying.

DOWN THE AISLE

Rande is so easy going and he made me feel safe, I believed
him when he said he wanted to make me happy.

Ever since sixth grade, when I had my very first boyfriend, I've liked being
in a relationship. It seems that all through middle school and high school
I was always paired up with a boy, until senior year, when I had my first
real boyfriend. Our relationship lasted for four years, which was pretty
impressive, considering all the changes it survived—both of us going off to college
and then me moving to New York and becoming "Cindy Crawford."

When we finally did split up, I was only single for a few months before
I met Richard Gere, and we were together for six years. I learned a lot from those
two relationships and, luckily, was able to apply all those lessons to my current
relationship with Rande Gerber.

Rande and I met at a wedding. We were both involved with other people,
but our mutual friends had arranged for him to escort me to the wedding. Because
it wasn't a date, neither of us was trying to impress the other. He was late picking me
up but looked cute in his tux. I was annoyed and anxiously waiting down in my lobby
so I could jump into the car and rush to the wedding. During the drive, he apologized
for being late, explaining that when he went to get dressed, he realized he didn't have
a tuxedo shirt. He had to run to Bloomingdale's at the last minute to buy one, and
his shirt still had the creases in it from the packaging. We laughed and danced and
might have had one or two tequila shots. We had an instant connection, but it wasn't
until years later that we actually started dating.

I think it significant in my relationship with Rande that we started out as
friends. Yes, we were attracted to each other, but because of our circumstances, we
cultivated our friendship before we fell in love.

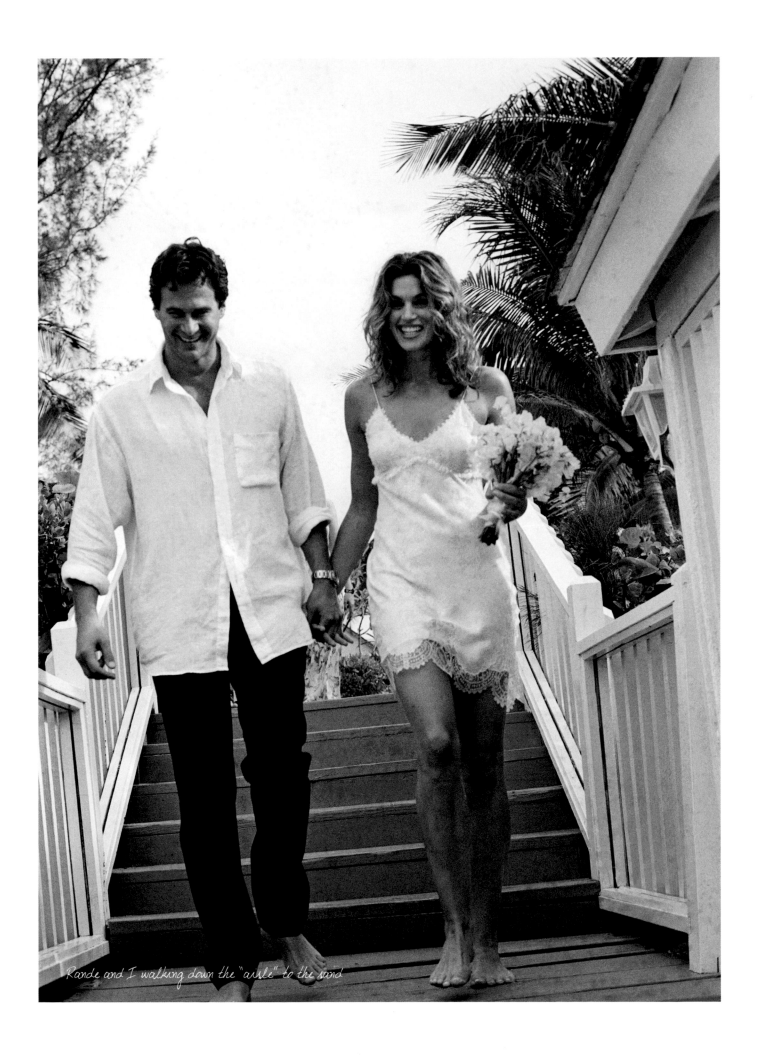

Rande and I walking down the "aisle" to the sand

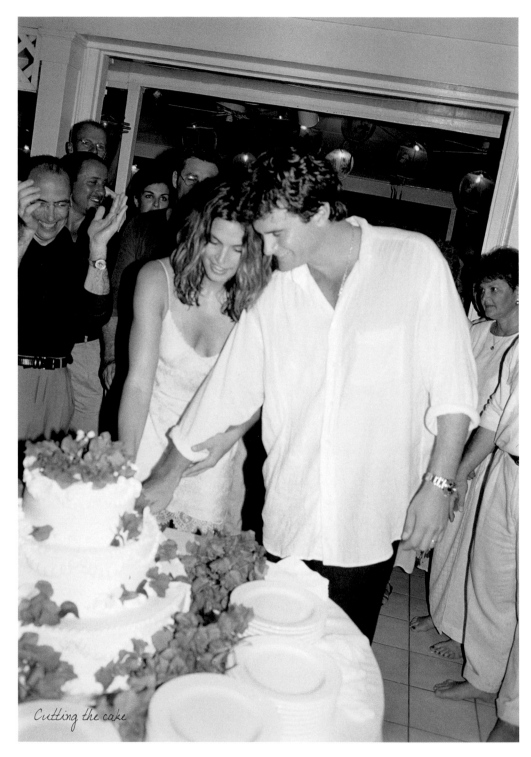

Cutting the cake

Rande is so easy going, and he made me feel safe. I believed him when he said he wanted to make me happy. When I first started staying overnight at his place, Rande would either drive me home or make sure I had enough money for a cab. It felt good to be taken care of. Of course, I had my own money by then, but he treated me in a way that made me feel like a princess. I loved the simple things—the gentlemanly way he opened doors for me or always made sure to walk between me and the curb when we strolled around Manhattan. Our time together felt fun and uncomplicated.

After a few years of dating and then essentially living together, Rande surprised me with a beautiful ring and a proposal on a sunny Sunday afternoon on the beach in Malibu. We planned to get married as soon as possible. Why wait? Especially since we wanted to start a family.

I had definite ideas about what kind of wedding I wanted this time around. I had been married before, to Richard, and wanted this time to be different. After work one day Richard had proposed marriage, and we flew to Vegas that night for a quickie wedding with a few friends. While there is some charm to getting married at The Little Chapel of the West and then going to Denny's afterward for some celebratory pancakes, I never quite felt that I was really married. I remember the next day being at a car wash in L.A. and hearing the radio DJ announcing my wedding and congratulating us—it was surreal.

With Rande, it was important to me to stand up in front of our friends and family and take our vows in front of people who loved us. The minister who married us asked each of us what we needed to hear to feel married. For me, it was "I now pronounce you husband and wife." It was also important to us to try to keep our wedding as private as possible. So in addition to planning the whole thing in six weeks, we kept it a secret until just a few days before. This made dress shopping a bit tricky. I told my stylist from *House of Style* that I was going to a Black and White party and wanted him to purchase both black and white dresses for me. I knew the minute I saw the short John Galliano slip dress he had bought off the rack at Barneys that it was perfect.

Rande and I headed off to Paradise Island in the Bahamas for the wedding weekend. We had told our guests that the dress code was no shoes, no jackets, and no ties. We wanted our wedding to reflect who we were as a couple: authentic and down-to-earth. I wore very little makeup and my hair in beachy waves. I wanted to look like the best version of the girl Rande loves waking up to every morning. Rather than have my dad walk me down the aisle and "give me away," Rande and I chose to walk each other down the stairs that led to the beach and the ceremony.

For so many women, their wedding day is the one day they get to have all the attention—special hair, makeup, a gorgeous dress, and stunning pictures. Even though as I model I get to experience those things a lot, there was still something magical about my wedding day. I'm so happy that my friend Arthur Elgort agreed to be our wedding photographer. Arthur is fun to have around and can talk to anyone, including the three grandmas who were there. But, more important, Arthur captured the spirit of the day. I look back at my wedding pictures and wouldn't change a thing—especially the man standing next to me.

MATERNAL INSTINCTS

It is the hardest, most challenging thing I have ever done.
Also, the most rewarding.

There was never any doubt in my mind that I wanted to have children. I'm sure a lot of that had to do with the fact that my mother was and still is a source of unconditional love in my life. She was a young mother yet handled her four children, the house, the grocery shopping, the cleaning, the PTA meetings, the Girl Scout troop leadership, and endless other responsibilities without ever picking up a parenting book. She was a natural.

I thought I would become a young mother, too. Maybe not in high school (my mom always joked that she would measure her success as a mother if she could get all three of her daughters through high school without any of us getting arrested or pregnant), but certainly once I found Mr. Right. I had a few detours along that road, but when Rande and I decided to get married, I was ready for children.

It didn't happen right away, though. Both my sisters had gotten pregnant the first time they tried, so at thirty-two I started to worry that I had waited too long. Finally, after several months, I got the smiley face on the stick. We were overjoyed.

Then reality set in. First it was the nausea: I was so sick those first few months that I'd throw up the minute I got out of bed each morning. No food appealed to me, so I subsisted on corn flakes and baked potatoes. The only benefit of morning sickness was that I actually lost ten pounds in my first trimester, which made it easier to keep my pregnancy quiet. We had decided not to tell anyone until we absolutely had to—partly for privacy, but also because I wanted to keep working as long as I could. Other than my breasts getting a bit fuller, my belly didn't pop until I was twenty weeks along.

Then everything changed. All of a sudden my body felt like some weird science experiment. I would like to say I was one of those women who loved being pregnant, but, honestly, I saw it as a means to a beautiful and much-anticipated end. Maybe it's just me, or maybe it's all models, but the idea of my body changing in so

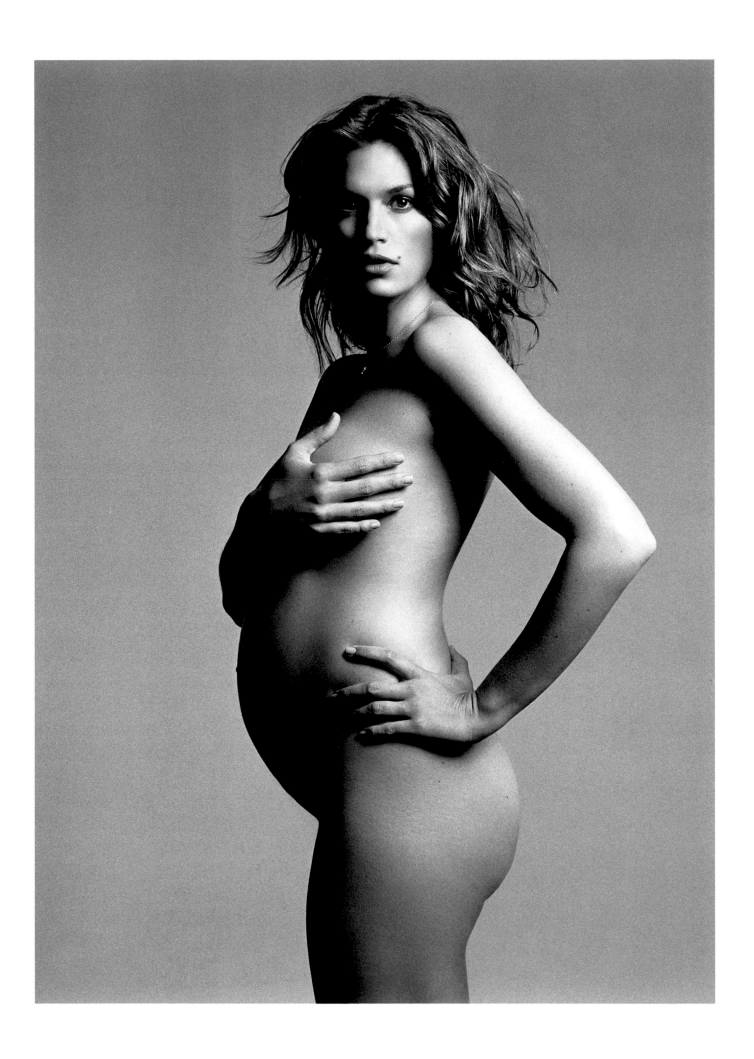

many ways, not knowing if it would ever go back, was terrifying. My perception had always been that being pregnant was another way of saying good-bye to your youthful figure. I had never known my mother to be thin, and it's possible that with each baby (four in six years) she never quite lost all the baby weight. Those extra pounds can add up over time. Throw in the stretch marks and saggy boobs, and I was scared. Don't get me wrong—I wanted a baby so much, I was willing to sacrifice my body, but I didn't have to like it.

A makeup artist friend of mine insisted that I check out a prenatal yoga class. She came with me, and she wasn't even pregnant. Now, that is a true friend! The class changed my whole approach to my pregnancy. For one thing, Gurmuhk, the teacher, reminded all of us that pregnancy was not a medical condition. Through yoga, she showed us how strong and flexible our pregnant bodies were—a far cry from treating women who are expecting like invalids. Gurmuhk gave me confidence in my body's ability to give birth to my child. She also introduced me to the idea of having a home birth attended by a midwife.

At first, Rande wasn't into that idea. "Why would we have our baby at home when we can afford the best care possible?" It took some convincing, but eventually he agreed that "the best care possible," for me, was to try to give birth in the familiar comfort of my own home.

I woke up at 2:00 a.m. on the morning of July 2, and seventeen hours later I was in my bed with my husband and my new baby boy. Pure bliss. Presley Walker Gerber entered our world that day, and I became a mother. It was the hardest, most challenging thing I have ever done. It was also the most rewarding.

I had only gained twenty-eight pounds during my pregnancy, but I remember the first time I got a glimpse of my stomach a few hours after Presley was born. Besides being swollen, it looked like a Shar-Pei puppy—too many wrinkles but not nearly as cute! And if I thought my breasts had filled out before I gave birth, I was totally unprepared for what they looked like once my milk came in—huge, hard melons. I took back every wish I had ever made for bigger boobs.

Wisely or unwisely, I had agreed to film an exercise video three months after giving birth to help new mothers get back into shape. This motivated me to start moving but also reminded me to honor that vulnerable state new mothers are often in. With a newborn, everything seems so overwhelming. Washing my hair felt like a big accomplishment. I needed to continue to eat enough so I could nurse, which meant I had to forget about counting calories. No matter how difficult it was as a new mom, I had to slowly take back my body. Even a twenty-minute walk was a way of taking care of myself (and, of course, baby Presley, snuggled close in a sling).

It took a full year before I lost all my baby weight. And even though I eventually got back down to my pre-pregnancy weight, my body will never be the same again (but, then again, neither will I). My waist is thicker, my boobs lost some of their perkiness, and I often have dark circles under my eyes from sleep deprivation. But, without question, it's all worth it. (It must be, because I did it all again two years later, welcoming Kaia Jordan Gerber into our lives. And, believe me, everything falls apart even faster with the second child, and I wasn't even rewarded with a shorter labor!) Becoming a parent and learning to love a child are probably the most selfless things a person can do. I hope that I can forever be a source of unconditional love to my children—just like my mom was for me.

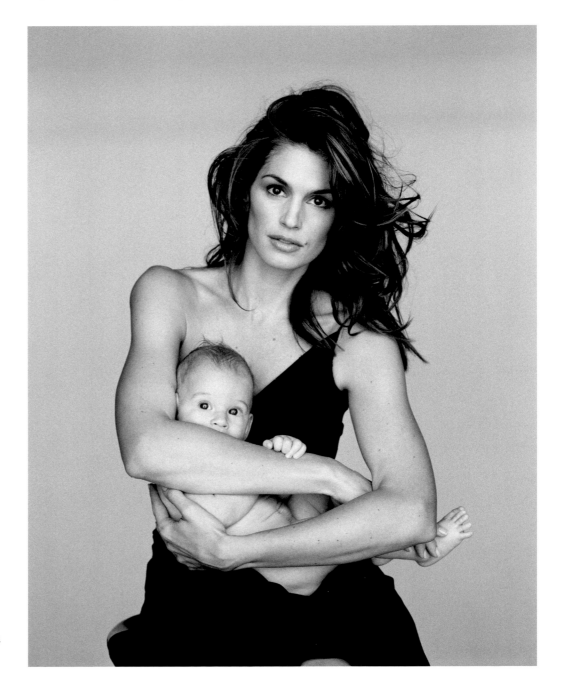

"I cherish this picture, shot by Gilles Bensimon for American Elle, because it represents my life finally becoming whole. I am reclaiming my pre-baby model self, while paying homage to the mother in me."

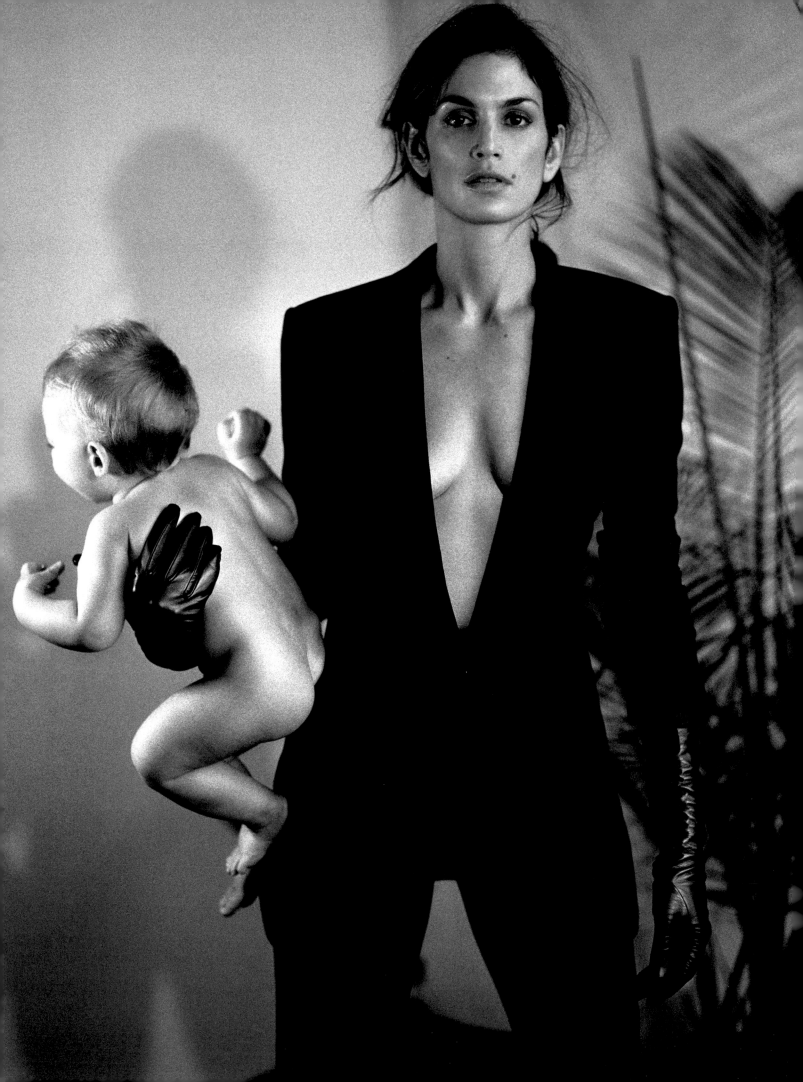

THE BALANCING ACT

My sister once told me that one of the greatest things about having kids is that you don't have to figure out your priorities anymore; you're looking right at them.

Like most women I know, I struggle with finding a balance in all the craziness of daily life. Family, work, relationships, fitness, philanthropy—I get tired just thinking about it all! I thought I was busy before I had kids, but then, once I had my children, I wondered what on earth I used to do with all my time. Being a mom is a full-time job with no time off for good behavior. Even when I'm away from my kids, they're still at the forefront of my mind. My sister Chris once told me that one of the greatest things about having kids is that you don't have to figure out your priorities anymore; you're looking right at them.

I feel fortunate that my career has evolved in such a way that I've been able to continue doing work I love. My professional schedule is more flexible than most, allowing for occasional stretches of time at home, which is nice for me but sometimes confusing for the kids, especially when they were younger. They always knew something was up when they saw me packing my rolling bag. When Presley was little he used to cry when people came over to do my hair and makeup, because he knew it meant that Mommy was leaving for work.

For most of us, trying to constantly keep all the plates in the air is a big challenge. Is it cheating if I buy the cookies for the bake sale or don't sign up to volunteer for the school fair? There are times when, no matter how hard you try, you just can't be in two places at once, and so you miss the school play or the show-and-tell session. Those are the times when I've felt most like a failure as a mom. Despite the hundreds of events I do attend, why is it that my kids only seem to remember the ones I've missed?

When Kaia was in third grade, her holiday music concert was scheduled on the same day I was booked to shoot a big hair-product commercial. You know those holiday shows: Your kid stands on risers in the middle of fifty other kids on a badly lit stage singing carols. His or her part is over in ten minutes, but you still have to sit through the performances of five other grades. Since I had missed Kaia's first day of school that year, I went to extreme measures to make sure I could be at her concert. The only way I could juggle it was to ask the hairdresser to come to my house at 5:00 a.m. that day. She worked on my hair for three hours and then set it all on soda-can-size rollers. I had asked the production team if I could have thirty minutes to be at my daughter's school before arriving on set. Of course it was one of the rare days of rain in Los Angeles, so I threw a big scarf over my hair to protect it from the humidity. I headed out the door feeling silly but determined. It didn't help one bit that Rande laughed and called me Babushka as we walked out the door.

We showed up at school and slid into our seats just in time. The other parents gave me strange looks as they tried to peer around my rollers, but I sat tall, feeling proud of myself. One of those "I can bring home the bacon, fry it up in a pan" kind of moms! As soon as Kaia's grade was finished with its song, I slipped out and hurried off to the shoot. Supermom!

When I got home that night, Kaia was mortified. "How could you show up at my school looking like that?" she asked.

I had run myself in circles to be there, only to embarrass her. On that day I realized that while I do believe you can "have it all," I'm not sure you can have it all at the same time.

I've certainly had days when I question whether I should quit working. After all, I've had a great career already, and I know in a lot of ways my kids (and my husband) would love having me home full-time. But the part that my kids might not understand yet is how much I get out of working. I love my job and the self-esteem that comes from working hard and being good at what I do. With luck, the example I am setting will make up for the field trips I've missed, and someday my kids will have the confidence to pursue their own dreams and careers they love. In the meantime, some days I have to battle "mom-guilt" just like everybody else.

Having a family and striving for a healthy balance is what finally makes me feel that my life is complete. In addition to surrounding me with love, my husband and kids keep me grounded and give me perspective. I will come home from some fabulous shoot and walk in the door, and they'll look at what I thought was very glamorous hair and makeup and laugh. They can hardly even talk to me until I wash my face. And while I love playing dress-up for work, I'm glad they prefer the real me.

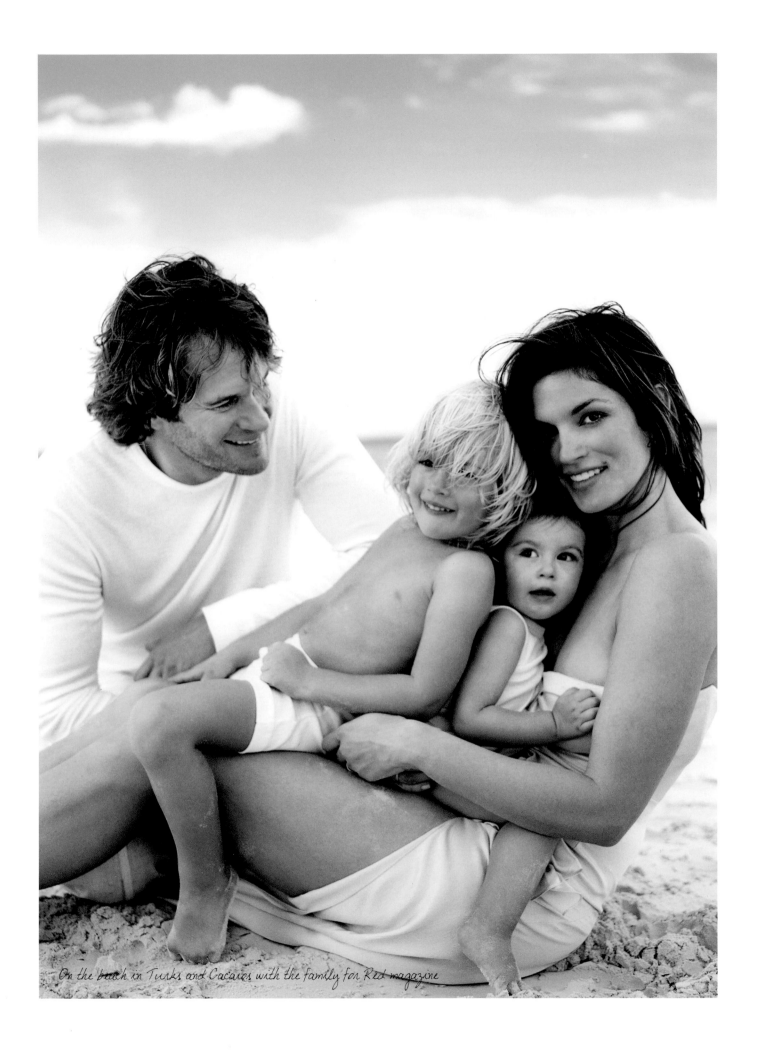

On the beach in Turks and Cacaros with the family for Red magazine

AGING

I wish I could say it is easy for me to be getting older.
After all, I have had a lot of fun in this body.

S ometimes I forget that the images I am used to seeing of myself aren't real, that they are all part of the illusion of being Cindy Crawford. And then I will catch a glimpse of the real, un-retouched Cindy or see an unflattering paparazzi shot, and it's a shocker.

I wish I could say it is easy for me to be getting older. After all, I have had a lot of fun in this body. I always tease my daughter—who, everyone agrees, is a mini-me—and say, "You have my old hair—I want it back!" Or, "You have my old legs—I want them back!" She just giggles and says, "It's my turn now." And she's right.

Like most young women, I didn't think about aging until I was well into my thirties. My twenties were filled with work, and most of my thirties were consumed with work and becoming a mom. While motherhood definitely brought changes to my body, I pretty much skated through my thirties, oblivious to aging, until it dawned on me at age thirty-eight that I wasn't immune to the process. Journalists would ask me how I felt about turning forty. And I would think, Whoa! Let's wait until I'm at least thirty-nine to start talking about it!

Now, as I approach fifty, the questions have begun again: How do I feel about that big benchmark? What I really want to know is, how the heck did this happen so quickly? Just yesterday I was finishing high school!

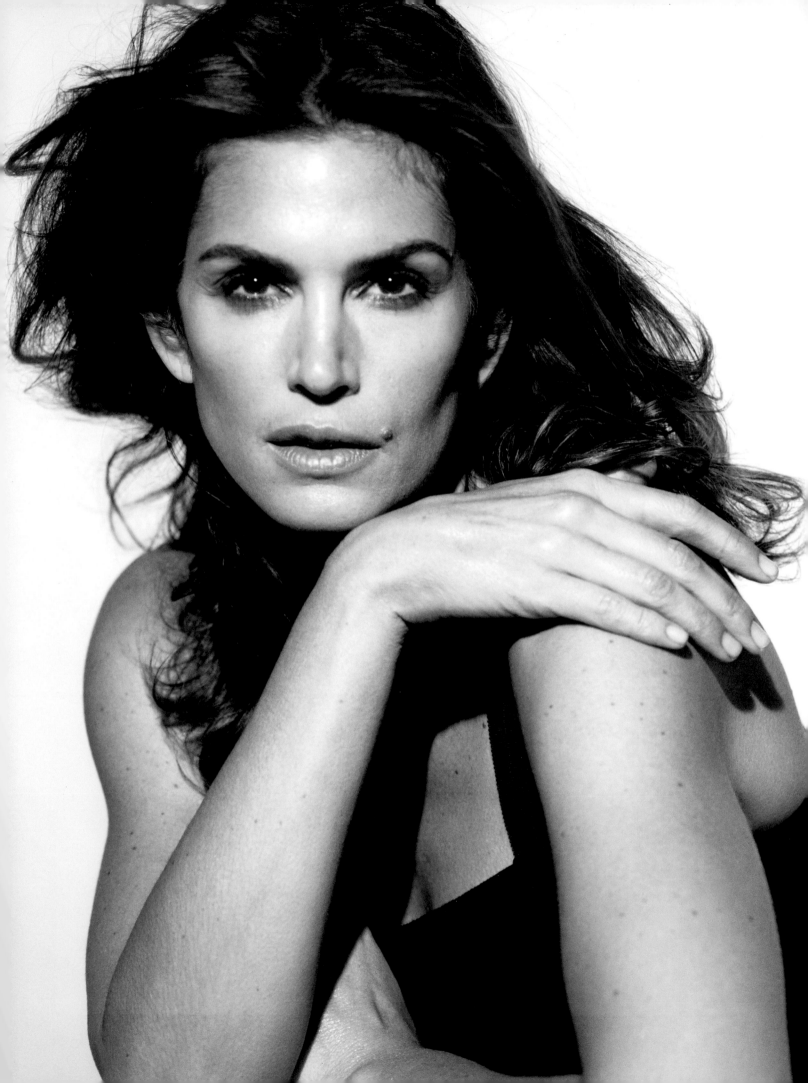

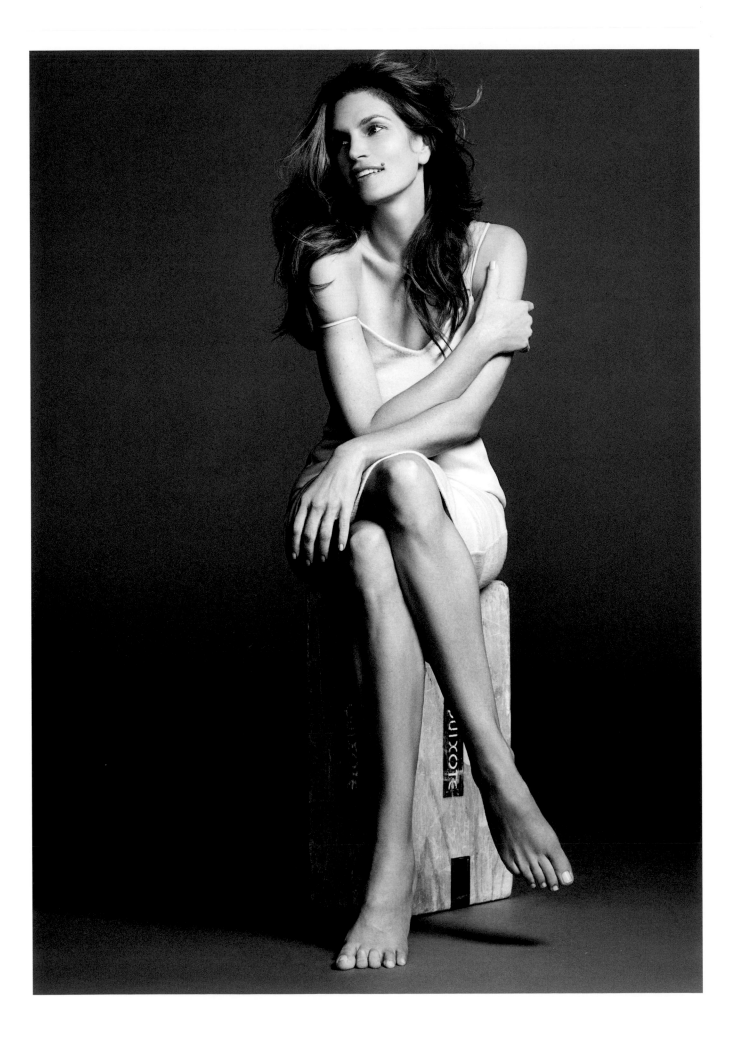

Men and women seem to have different struggles when it comes to getting older. Men might mourn the loss of strength and stamina—they just can't keep up with the twenty-year-olds on the basketball court anymore—while women often tend to be more concerned about what they see in the mirror. Gray hair, fine lines, and the realization that none of us can defy those pesky laws of gravity. Having been a model now for over thirty years and dependent on my looks for my work, seeing those changes might even be a little harder for me. At times the pressure to live up to the fashion industry's expectations feels overwhelming. I can still pull off a miniskirt and five-inch heels on set—but probably not in real life. And, truthfully, even if I could, I'm not sure I'd want to. I'm finding that I'm drawn to a more sophisticated style naturally, though I admit to a sense of loss of my old self, as well. The most meaningful way I've found to cope with these inevitable changes is to live in the present moment, continue to evolve, and to feel enormous gratitude for all that I do have: a happy marriage, a relationship with my kids that fills me with pride, and work that continues to inspire me.

I've never liked making a big deal of my birthday, preferring to celebrate with my family over a quiet dinner at home. More and more I find I just want to skip the day altogether. But writing this book for my fiftieth birthday is perhaps the best gift I could have given myself. It has forced me to really look at all the facets of my life and career and try to learn from them. Otherwise, I might never have taken the time to acknowledge my own personal journey—where I came from, some of the tough decisions I faced, and where I am now—to honor the achievements and the more difficult moments. In many ways getting older is its own gift.

At times the pressure to live up to the industry's expectation feels overwhelming. I can still pull off a miniskirt and five-inch heels on set, but probably not in real life.

WHAT I WOULD TELL MY YOUNGER SELF

I developed great confidence in Cindy Crawford the model, who she was and wasn't, and what she could deliver. But it took much longer for that confidence to translate into my personal life.

I had been living in New York for a year and had already appeared on dozens of magazine covers, when a friend of mine set me up on a blind date. Well, for me it was a blind date, but the guy knew that he was going out with "Cindy Crawford" the model. I'll never forget opening the door to my apartment to greet him. In that split second I could feel him sizing me up and realizing he wasn't actually going on a date with a walking Cosmo cover. I felt that the real me—Cindy without all the makeup and hair and styling—somehow wasn't good enough.

Models generally go to work with wet hair and clean faces. Then we spend two or three or more hours in the hair and makeup chair before we are "presentable." For an eighteen-year-old girl, this process of transformation can really do a number on your self-esteem. I remember arriving on the set all quiet and shy, and then slowly, as "Cindy Crawford" came to life in front of the mirror, I would become more extroverted. At a relatively young age, I developed great confidence in Cindy Crawford the model, who she was and wasn't, and what she could deliver. But it took much longer for that confidence to filter into my personal life.

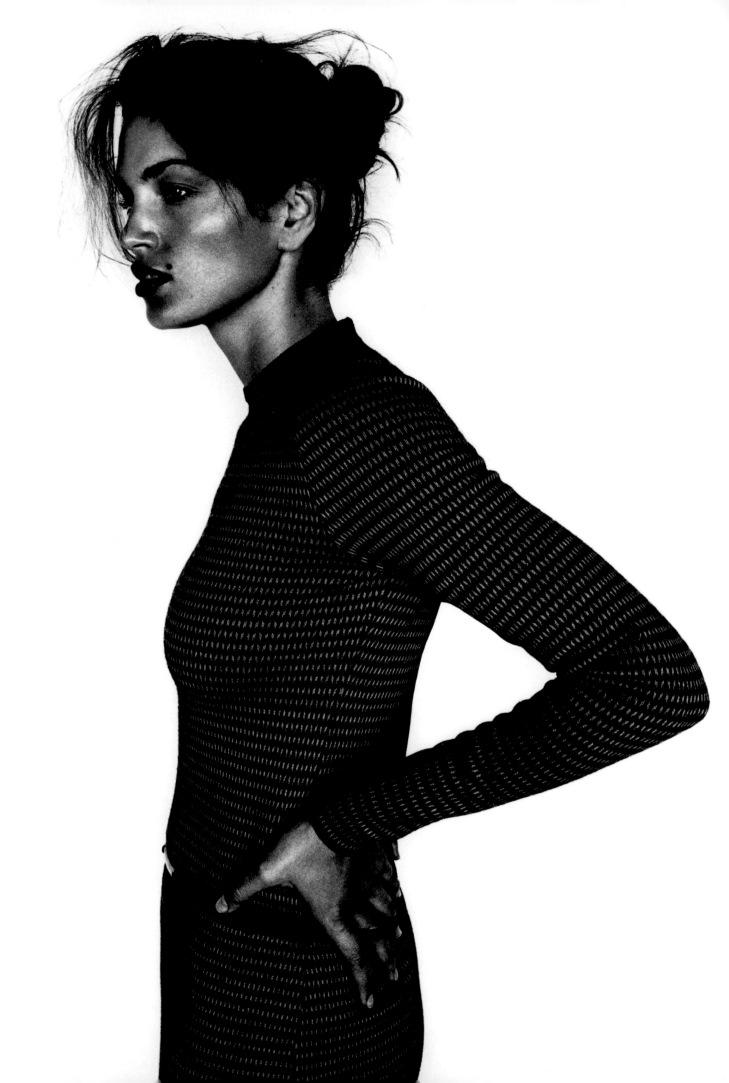

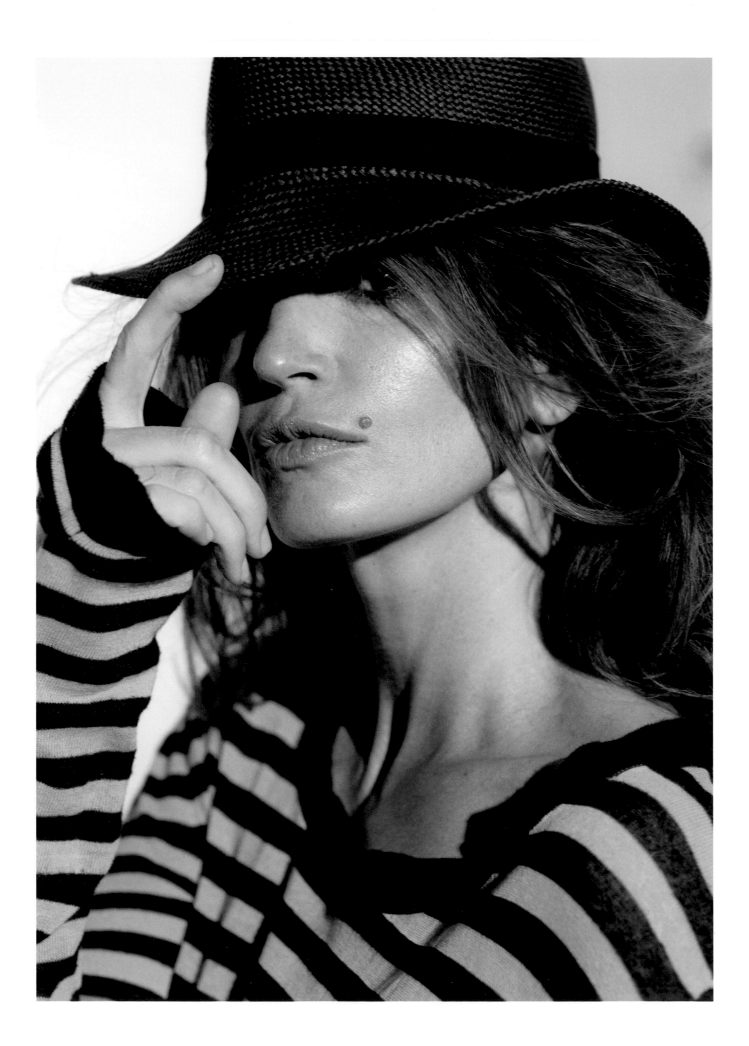

I don't have a lot of regrets about the way I've lived my life. Not because I haven't made mistakes—I've made plenty. But what's the point of regret? You can't undo the past. Sometimes when I look back at opportunities I might have missed out on, I do, however, wish that I had lived more fearlessly. Yes, I eventually became adept at taking risks with my career, but in other parts of my life I wasn't always as brave.

To a young girl from the Midwest, landing in the middle of the New York fashion scene was overwhelming. I often felt like the naked king in "The Emperor's New Clothes"—when would people figure out that I didn't belong? I often held myself back, too tentative and unsure to really immerse myself in my surroundings. Did I want to go on Armani's yacht for a few days? "No." I knew I could be "Cindy Crawford" for eight hours on a shoot, but I was scared that I couldn't deliver her 24/7. And what would I wear? I was pretty sure that I'd need something other than old sweatpants and my Northwestern T-shirt to lounge around in.

It was easier to say no.

I said no too often. I didn't want to risk making awkward mistakes. I found it safer to sit backstage at a show with my nose in a book. Part of that was me protecting myself—or simply hiding. I was never good at the "kiss-kiss" that appeared to come so easily to others in the fashion business. Naturally, people began to have expectations about Cindy Crawford the supermodel, and I didn't want to disappoint them. Now I'm more worried about disappointing myself.

I'd love to tell that hardworking girl with her nose buried in a book that it is OK to live it up a *little* bit. I know for sure I never would have been the girl at the nightclub dancing on a table without any underwear (that story is for a different book), but I could have let myself experience more. Life goes by quickly, and I've learned that decisions made from a place of confidence—rather than from one of fear—are the ones that get me to the place I want to be.

I'd love to tell that hardworking girl with her nose buried in a book that it is OK to live it up a *little* bit.

COMING FULL CIRCLE

While the folks inside didn't exactly roll out the red carpet, for the first time I felt like a peer.

About fifteen years after my exile from Skrebneski Studio, I got a message that Victor wanted to speak to me. I was surprised and had no idea what it could be about. My first thought was that maybe he was reaching out to make amends. But when I finally spoke to him, he didn't mention one word about how we had parted ways. Rather, he acted as if no time had passed and asked if I would come to Chicago to shoot a new poster for the Chicago International Film Festival.

After my initial shock, I did a lot of soul-searching. The first thing I realized was that while I had carried around so much angst and emotion for fifteen years over our manner of parting, he probably hadn't thought much about it. If he had, he likely wouldn't have asked me to work with him again without first apologizing.

Part of me liked that I was now in a position where he wanted something from me. I had succeeded as a model beyond my wildest dreams. Victor wasn't the only photographer who could make me look good, after all. I knew if I went back to work with him, I would be returning as a New York model with all the respect that entailed. Perhaps I would even get a seat at the big table.

I said yes and a few weeks later found myself once again pulling up to Skrebneski Studio—this time with a car and driver. While the folks inside didn't exactly roll out the red carpet, for the first time I felt like a peer. Of course, I would always respect Victor and his amazing body of work, but I had carved out my own success, as well.

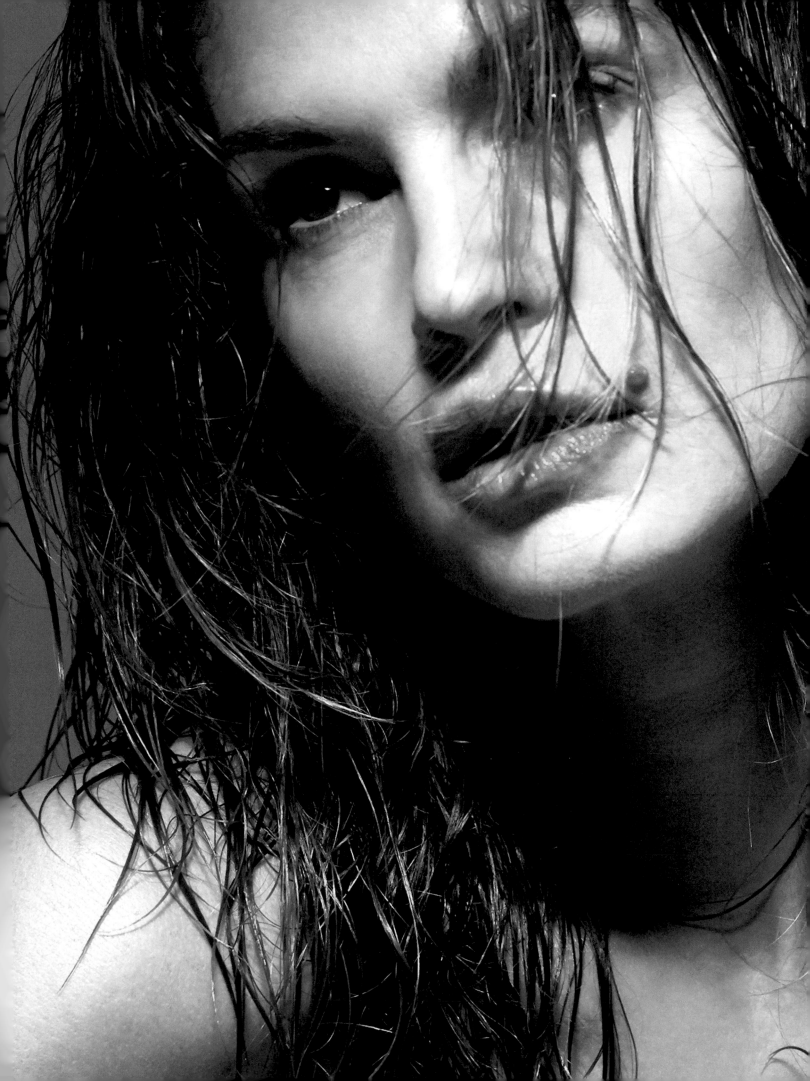

A beautiful moment with my mentor Victor Skrebneski.

Victor and I fell right back into our old way of working together, which had always been easy. And when it was time for lunch, I found myself, for the first time, sitting with Victor. It was pleasant to reminisce about the past and old friends, and I left feeling happy that I had come back. I was able to let go of most of the hurt I had felt when I'd left the studio so many years before.

Victor and I kept in touch over the years through Dennis, his office manager. We exchanged Christmas cards and even had lunch on a few occasions when I found myself in Chicago.

In the spring of 2014, I was asked to participate in a documentary about Victor. The filmmakers came to my house to interview me about my Skrebneski years. Once the interview started, it became apparent that the interviewer was unaware of any past strife between Victor and me. At one point, I asked if Victor had mentioned what had happened when I first left for New York. The filmmakers had no idea but, of course, were eager to get the story on film.

I was happy that the documentary was being shot thirty years after I'd first worked with Victor. Time often does heal old wounds, and Victor and I had had a chance by then to come back together as two adults. I told a time-tempered version of the story. After the interview, the production team asked me if I would go back once again to shoot with Victor for their film. I have always loved the portraits that Skrebneski is so famous for, so I said I would love to.

I went back once again a month later, and it felt like old times. Even though it was a chilly day, I walked from my hotel up LaSalle Street just as I had as a young girl. I arrived with a wet ponytail and cheeks reddened from the wind. Victor and I greeted each other like old friends. As we made small talk in the kitchen, I noticed that not much had changed in the studio, not even the coffee cups. After a quick bit of hair-and-makeup, I made my way to the set.

As soon as I stepped into that famous Skrebneski spotlight, the years fell away. It was as if no time at all had passed, and I was an eighteen-year-old girl again, eager to please my mentor, filled with dreams of making it big. Yet, now, at age forty-eight, I possessed confidence and calm. I knew I had earned my place there.

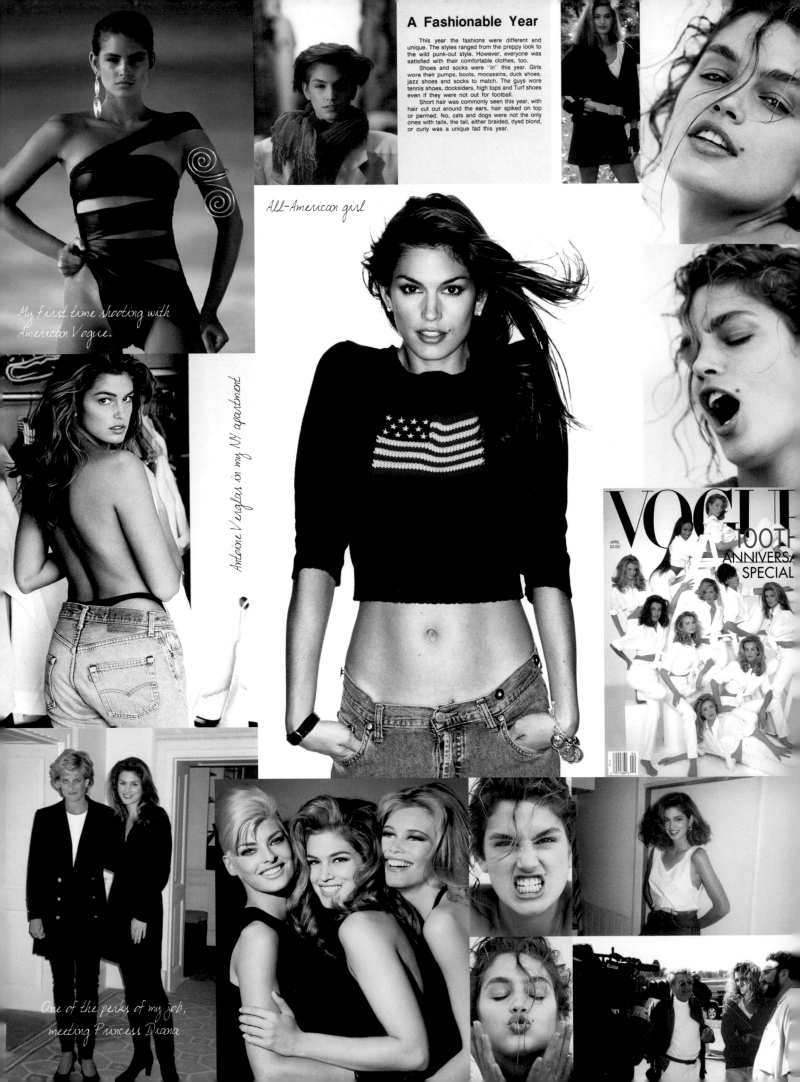

A Fashionable Year

This year the fashions were different and unique. The styles ranged from the preppy look to the wild punk-out style. However, everyone was satisfied with their comfortable clothes, too.

Shoes and socks were "in" this year. Girls wore their pumps, boots, mocassins, duck shoes, jazz shoes and socks to match. The guys wore tennis shoes, docksiders, high tops and Turf shoes even if they were not out for football.

Short hair was commonly seen this year, with hair cut out around the ears, hair spiked on top or permed. No, cats and dogs were not the only ones with tails, the tail, either braided, dyed blond, or curly was a unique fad this year.

All-American girl

My first time shooting with American Vogue.

Antoine Verglas in my NY apartment

One of the perks of my job, meeting Princess Diana

VOGUE
APRIL
$3.00
100TH
ANNIVERSARY
SPECIAL

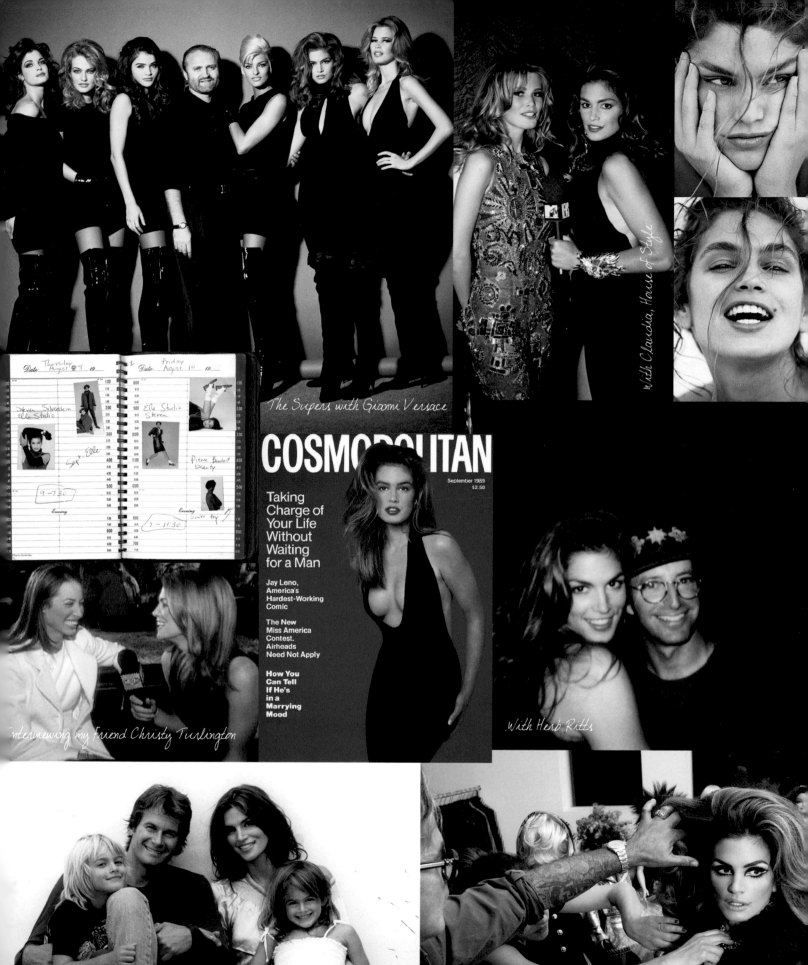

The Supers with Gianni Versace

With Claudia, House of Style

COSMOPOLITAN

September 1989
$2.50

Taking
Charge of
Your Life
Without
Waiting
for a Man

Jay Leno,
America's
Hardest-Working
Comic

The New
Miss America
Contest.
Airheads
Need Not Apply

How You
Can Tell
If He's
in a
Marrying
Mood

Interviewing my friend Christy Turlington

With Herb Ritts

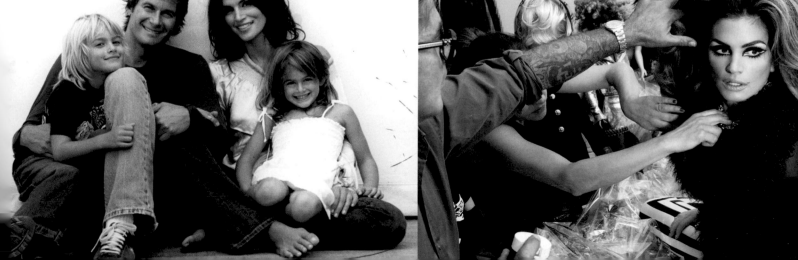

EVEN I DON'T WAKE UP LOOKING LIKE CINDY CRAWFORD

One of the things I love most about modeling is having the opportunity to be part of a great team, working with some of the most talented artists out there.

All the images in this book and, in fact, my entire career wouldn't have been possible without the people behind the pictures. So much of the glory of fashion photography is given to the photographers and to the models, but not a single shot I've ever done would have existed without the tremendous contributions of the fashion editors and the hair, makeup, and wardrobe stylists who work their creative magic to bring the vision to life.

One of the things I love most about modeling is having the opportunity to be part of a great team, working with some of the most talented artists out there. To this day, that remains a true inspiration for me and pushes me to do my best to deliver my part in the process every time I walk onto a set.

The hair and makeup people often see me at my most vulnerable—sorry I have a zit, or I was up a little late last night, or I haven't had time to get my roots colored. Magically, they transform me.

Inevitably, on any given modeling job, a model spends most of the time with the hair and makeup artists. And, much as in real life, where women confide in their hairdresser, the makeup room becomes a place where close friendships are forged. First of all, the glam squad usually includes the first people you interact with at each and every shoot. With them, the real tone for the day is set. And the hair and makeup people often see me at my most vulnerable—sorry I have a zit, or I was up a little late last night, or I haven't had time to get my roots colored. Magically, they transform me. Sometimes the transformation takes two hours or longer, which leaves us plenty of time to entertain one another. I know I have a dressing-room personality that is slightly funnier and raunchier than I might have at a dinner party. In fact, it's practically mandatory! In order to keep up with the humor of some of the biggest personalities I've ever met, I have to bring my A game.

But the makeup room is also the place where I could talk about the fight I had with my boyfriend or about feeling homesick. There, tears are dried, and friendships are cemented, so that by the time I step onto the set, I feel invincible.

There are too many great artists and true friends to list them all here, but I hope they know who they are. Thank you, each and every one of you, for turning this "girl" from DeKalb, Illinois, into Cindy Crawford!

ACKNOWLEDGMENTS

It took me a longtime to get to a place where I wanted to do a book. I want to thank my long time publicist Annett Wolf for bugging me about it every couple of years until finally we came up with a concept I got excited about.

This book never would have happened without Katherine O'Leary. Besides conspiring with Annett, Katherine saw this book through every step. Together, we wrote the initial presentation. She interviewed me on numerous occasions to help jog my memory and then would put all the thoughts together in a cohesive manner so that I wouldn't be intimidated by a blank page. She reminded me of things I had said in the past, and also offered her insight, opinions, and writing skills in the present. She kept me on track and moving forward. Katherine: thanks for everything, but especially for that weekend we spent sitting on my children's playroom floor with the book spread out all over the place. Sixteen hours and two Bulletproof Coffees later, I finally saw that we had a book.

Thanks to Kim Witherspoon, my book agent, for shepherding us through this process and helping me believe that someone would want to read what I wanted to say.

I was so happy when Kate Betts agreed to be our text editor. She helped us through the process and impressed me with her wordsmithing. Kate: thanks for always reminding me that writing is rewriting!

I couldn't have asked for a better design team then AR New York—Raul Martinez, Paul Eustace, Ian Davies, and Stephanie Sills—your professionalism and fashion savoir faire brought this book to life. Every 7:00 a.m. call was fun and a true collaboration. Thank you!

Thanks to everyone at Rizzoli International Publications—Charles Miers, Jessica Fuller, Anthony Petrillose, and Kristen Roeder—for your guidance and getting what I wanted to do right away and not asking me to write more about makeup tips or my exercise routine. Charles: you won me over when you complimented the writing first.

Thanks to the great group of women I've been lucky enough to have in my Crawdaddy offices over the past twenty-five years who've all "worked for Cindy Crawford" right alongside me. Most recently, thank you to Jennifer O Hill for keeping all the images organized and scouring the internet for photographs I've long since forgotten. You have a great eye. And to Jenni Jacobs—new to the Crawdaddy team but who doesn't miss a beat.

Having the support of Mark McKenna on this project was a great start. Thanks, Mark, for not only opening up Herb's archives to me but also for the generosity of your time and the education on what it takes to publish a book!

There isn't enough room to thank all the photographers, editors, art directors, stylists, hairdressers, makeup artists, and manicurists who were instrumental in creating these images. It's hard for me to ask for favors, but I felt so supported when I asked to use all the images that appear in this book and bring my story to life.

Even though this project was much more work than I ever would have anticipated, now that it's finished I'm going to miss it!

CREDITS

First published in the United States of America in 2015
by Rizzoli International Publications, Inc.
300 Park Avenue South
New York, NY 10010
www.rizzoliusa.com

© 2015 Crawdaddy Productions

2015 2016 2017 2018 2019 / 10 9 8 7 6 5 4 3 2 1

Book Design by:
AR New York, Ian Davies and Paul Eustace

Printed in Italy
ISBN-13: 978-0-8478-4619-1
Library of Congress Control Number: 2015941440